D0882054

KEITH HARING

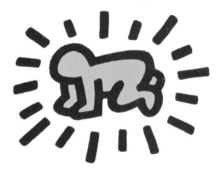

THE AUTHORIZED BIOGRAPHY

JOHN GRUEN

A FIRESIDE BOOK
Published by Simon & Schuster
New York London Toronto Sydney Tokyo Singapore

FIRESIDE
Simon & Schuster Building
Rockefeller Center
1230 Avenue of the Americas
New York, New York 10020

First Fireside Edition 1992
FIRESIDE and colophon are registered trademarks
of Simon & Schuster, Inc.
Designed by Barbara Cohen Aronica
Manufactured in the United States of America

10 9 8 7 6 5 4 3 2

Library of Congress Cataloging-in-Publication Data is available.

ISBN 0-671-78150-2

ACKNOWLEDGMENTS

For his confidence, honesty, candor, and kindness, I wish to express my first and foremost thanks to Keith Haring. Keith asked that I write this book and allowed me to share his life for many months prior to his untimely death in February, 1990. Long and intense taping sessions took place in New York and Water Mill, Long Island. We traveled together to Europe and to California where Keith introduced me to his many personal and professional friends and acquaintances. We spent time together in Kutztown, Pennsylvania, where I met Keith's family, his oldest friend, Kermit Oswald, and his boyhood teachers.

To Keith's parents, Joan and Allen Haring, to his sisters, Kay Haring, Karen Haring De Long, and Kristen Haring, and to Kermit Oswald, my deepest gratitude for sharing their memories of their son, brother, and friend.

For her deep involvement and caring concern for this project, my warmest thanks to Mary Hall Mayer, Executive Editor of Prentice Hall Editions. For her sensitive and talented eye, my gratitude to designer Barbara Cohen Aronica. For their punctilious editorial and technical help, my thanks to John Paul Jones, Susan Joseph, and Laurie Barnett of Prentice Hall.

For her generous participation in supplying archival and photographic material for this book, my special thanks to Julia Gruen, Executive Director of the Keith Haring Foundation, Inc.

—John Gruen, 1991

CONTENTS

JOHN GRUEN On February 12, 1990, Keith Haring took a turn for the worse. When I arrived at his apartment on La Guardia Place in Greenwich Village, his mother, Joan Haring, let me in.

"Keith is very agitated," she said. "Gil is with him—and the nurse. Don't stay too long."

I went down the short flight of stairs leading to the bedroom. It seemed inconceivable that Keith should have gotten so sick so quickly. Although he had tested HIV positive some two years earlier and had more recently developed Kaposi's sarcoma, a cancer that frequently accompanies AIDS, his energy was unflagging. Keith took very good care of himself. He was on the drug AZT and his doctors administered and prescribed medications that had kept Keith on a more or less normal course of activity, which for him meant hyperactivity—most of it expended on his work and career.

Almost overnight Keith had gotten alarmingly thin. His eyes of a startling, glassy blue, had sunk deep into their sockets. His face had taken on an ashen pallor. He was indeed agitated, as his breathing was coming in quick, panicky gasps, and his hands were pulling at the intravenous tubes and apparatus. He was attempting to raise himself and get out of bed.

Gil Vazquez, the nineteen-year-old boy who had seldom left his bedside, kept saying in the gentlest way, "No, Keith, no.

You've got to stay in bed—lie back, lie back!" The male nurse came to help and quickly readjusted the tubes.

Quieted down, Keith now whispered, "Pad . . . pad . . . pen." Keith had not been able to speak aloud for weeks, he could only whisper—and almost inaudibly at that. Did he want to write something?

Lysa Cooper, a friend, brought him the materials. She placed Keith's glasses on his nose. She handed him the pen and held the pad down on the bed. Slowly, Keith sat up. He began making marks on the pad—a little line, another little line—it was a faltering, tentative process—another little line. Keith stopped. Lysa Cooper quickly turned to a fresh page. "Try again, Keith." And again a line—a line like the first line—and another line . . . and it was evident that Keith didn't want to write. He wanted to draw.

Keith stopped again. He couldn't make the lines come together as he had wanted them to. Lysa turned the page. "Do it again, Keith." He drew the same lines—now added another and, suddenly, there were two little legs. (Throughout, Keith was incredibly concentrated, and his breathing seemed normal.) Still, the lines weren't right as yet. "Try it again, Keith," urged Lysa, turning to a fresh page.

And now, the lines came more confidently—and again they shaped the little legs—and the beginnings of a little

body—and the beginning of two more little legs. Amazingly, the drawing took the shape of Keith Haring's most famous symbol: the Radiant Baby. Keith Haring, deathly ill with AIDS, reached out to the life-giving Radiant Baby—the very first of Haring's tags—the potent, indelible image that only ten short years earlier, in 1980, had launched a career that would make Keith Haring an unparalleled phenomenon in contemporary American art, and the most populist artist of his time.

On February 16, 1990, at precisely 4:40 A.M., the Radiant Baby within Keith Haring died peacefully and undisturbed. Keith's death certificate lists the official cause of death as cardiac arrest. Born on May 4, 1958, Keith Haring was only 31.

For some reason, Keith told everyone he was born in Kutztown, the Pennsylvania Dutch farm community some 120 miles from New York City, where his family had been settled for many years.

The fact is, Keith wasn't born in Kutztown. He was born in Reading, Pennsylvania. The first child of Joan and Allen Haring, he was delivered by Dr. Calvin C. Widener at 12:41 P.M. on May 4, 1958—a Sunday—at the Community General Hospital in Reading. Weighing in at seven pounds, fifteen ounces, and measuring twenty-and-a-half inches long, the baby boy would be baptized seven months later—on December 28, 1958, by the Reverend Bruce D. Hatt at St. John's United Church of Christ in Kutztown. He was named Keith Allen Haring.

KEITH HARING

I

1958–1978

JOAN HARING The reason Keith was born in Reading was that there were no hospitals in Kutztown. During the last minutes of labor he turned and was born face up, which the doctor called sunny-side up. It made the birth longer. His father, Allen, was in Japan at the time—in the Marines. So through the Red Cross, I let Allen know that it was a boy. Keith and I lived with my parents in Kutztown until Allen came home. After that, Allen was stationed in California and we joined him there when Keith was almost ten months old. We settled in Santa Ana, and lived in California for sixteen months. Kay, our second child, was born there and we came back to Kutztown when Kay was a baby. Finally, Allen joined us too, and he started looking for a job, but he was having a hard time finding one. This was in 1960. Then he got an offer from AT&T, which was then called Western Electric, and he's been working there ever since.

ALLEN HARING Joan and I met in high school—right here in Kutztown. We were in the same class from about the ninth or tenth grade on. In fact, Joan was going with my high-school buddy. She was going steady with him throughout the eleventh and twelfth grades. Joan and I didn't really date until a year after high school—after I had joined the Marine Corps. A year and a half later we were married.

When Keith was around three or four years old, he was a very good-looking boy. He was cute, therefore he was getting an awful lot of attention from everyone. But

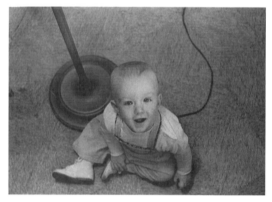

Keith, ten months old, Kutztown, PA.

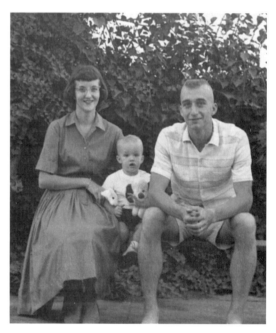

Joan, Keith, and Allen Haring, Kutztown, PA. October 1959.

3

Keith and Kay Haring, Kutztown, PA. August 1961.

make a face out of it, and put ears on it or make all kinds of animals. Or Allen would put down a line and then ask Keith to put down a line, and then Allen would put down another line—and they'd make something out of it.

So that's how it all started. Keith always wanted to do art. I could never get enough pencils and paper. He'd go through tablets—and he'd draw on everything—everything, except the walls. One time I said to him, "You were never naughty and drew on the walls." Well, one day, Keith was helping his dad paint the back roof of the house with silver paint. At the end of the day, when they were finished, Keith put his hands in the paint and placed each hand against the cellar walls—hand after hand after hand. He called down and said, "Look! Now I've drawn on the walls!"

even as a baby, people would just stop and want to say something to him. It was a little difficult for me, because I was always the bashful kind, and not much of a conversationalist. But they wanted to talk to the good-looking little baby.

JOAN HARING Before Keith was even a year old, he used to sit on his dad's lap after supper just drawing some gobbly-goo with crayons he'd been given. Then, later, Allen, who was very good at drawing cartoon things, would show Keith how to draw circles. Then, he'd make a circle into a balloon or an ice-cream cone or

ALLEN HARING We often used to draw dragons, because you could draw beautiful dragons with circles or long worms with sections that are just circles and then feet coming out of them. And I still see some of this in some of the drawings Keith did much, much later. I was often asked to draw dogs. He liked the dogs because I never copied cartoon dogs—I used to make up my own. He thought they were funny.

Ever since high school I liked art. Once, I was chosen to be the art editor of our yearbook. The theme was "The Circus," so I did a lot of circus drawings. When I was in tenth or eleventh grade, I bought myself an oil-paint set. I bought it with money

my brother and I earned trapping. We lived
in Bowers, not far from Kutztown, and
there was a stream about a mile away where
we'd go and trap for muskrats. And we
could sell the pelts. It was a pretty lucrative
business for high-school boys, because we
used to get two or three dollars per pelt,
which was pretty good money in those
days. And that's when I bought an oil paint-
ing set, and a couple of canvases. I tried
it, but I never had any formal training in the
use of oil paints. I ended up using oil paints
much the way people use watercolors—
simply to color an area of the canvas—not
to get the full effect of what you can actu-
ally do with oil paint. Still, some people
thought I was doing the wrong thing by not
pursuing my art.

In a way, I always thought Keith would
end up doing something with art. I thought
it would be neat to have another member
of the family enjoying my hobby.

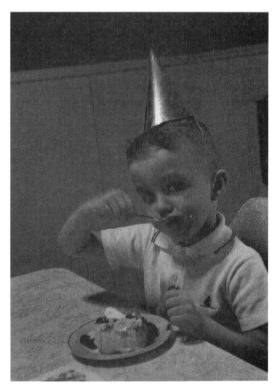

Keith, early party scene, Kutztown, PA. c. 1960.

5

JOAN HARING I started out
wanting to become a teacher, and began
studying at a local college. But as soon as
I was married I never thought of going back.
I just wanted to have babies and be a good
wife. So I married Allen, and soon after, I
had Keith. Then Kay was born, she and
Keith are twenty-five months apart. Then,
twenty-eight months later, Karen was born—
she was born at home. Then came Kristen,
who is twelve years younger than Keith.

Before Kristen was born, Keith and
his two younger sisters were always very
close, Keith being "big brother." Then,
when I was pregnant with Kristen, I went

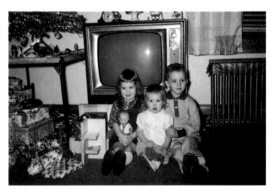

Kay, Karen, and Keith Haring, Kutztown, PA. Christmas
1963.

to the hospital and when Kristen was born, I called home. Keith answered the phone. I said, "Did Daddy tell you?" And he said, "What?" And I said, "It's a girl!" He said, "Oh!" He was disappointed, because at this point he wanted a brother—to be two against two, so to speak. The girls both sent me a card in the hospital, but Keith didn't send me a card. Well, he wasn't disappointed for long, because he soon became very attached to Kristen. We now had four children, but we only had three bedrooms upstairs, and for a while, Kristen slept in Keith's room. Then, when she needed her own room, we made the room downstairs for Keith as he was already thirteen. We did up his room the way he wanted it, with the bright colors he loved—the reds and the blues. He spent a lot of time in his room, drawing, listening to music—always, always too loud. I don't know *how* many times I used to say, "Turn that music down!"

ALLEN HARING I'm a manufacturing supervisor at AT&T, located in Allentown, Pennsylvania. It means that I supervise a manufacturing line, one of the many lines that they have. It's a first level of management, really. But I didn't start out like that. I started as an electronic technician, and after a while, I was promoted into the engineering group, and then got a promotion into management. I learned a lot of the electronic stuff on my own. I didn't graduate from college—and I never specialized in electronics. But I got my ham radio license while I was still in high school, and I went to electronics school while in the service.

When Keith was in high school, he wanted a radio. I could understand that. Joan didn't think it was necessary. You know, we weren't rich people, and we'd spend money on things that were necessary. Having loud music wasn't necessary. Of course, I remember wanting good loud music too when I was a teenager. But I always thought that it was my fascination with electronics, and my ability to amplify that music, that made me want it. But Keith wanted loud music because he liked loud music.

Well, when he was in high school and earning some money, he wanted to get a record player and a good radio, and I guided him toward buying a Heath Kit. If you bought a Heath Kit, you could put it together yourself. I thought I'd expose Keith to electronics at the same time. And I was surprised. He built it. He did it part by part—soldered things together. But as soon as it was built, that was *that,* as far as electronics were concerned. And I wasn't pushing it.

JOAN HARING When Keith was in seventh grade he had a paper route, and he was very good, very dependable. It was an after-school route, so he didn't have to worry about getting up in the mornings, except Sundays. But around that time, he also began to assert his independence. One way he did it was to get involved with these Hare Krishna people, who were around with their saffron robes and shaved heads, and handing out leaflets. Keith brought some home. We said, "What's this?" They were "Jesus Saves" leaflets, and Keith also

had these booklets, and it was almost as though he didn't know what they were about—he was only twelve—but he knew it was something different.

Soon he began making drawings in which there were Jesus symbols and other types of symbols, like a loop with two dots. Again, it was something different. I thought he was going through a phase, and would soon forget about it. But then he met some other people we didn't exactly care for. Now, we've always told our children, "Bring your friends home." But all of a sudden, he didn't want to bring his friends home. He'd rather meet them somewhere. He'd meet them in the park, and he'd stay out later than we wanted him to. He didn't really do bad things, but his school grades were beginning to drop. He thought he'd get by without studying. He'd say, "I don't want to do good. I don't want to be at the top. I want to be average." But when he was younger, he was proud to be at the top of his class.

ALLEN HARING Keith did some things that we were disappointed with—we could see he was headed for trouble. I think it's because he wanted to be part of something. Earlier on, he had the Boy Scouts—but that didn't last very long. He attempted Little League baseball, and that didn't last very long. Then he had that Jesus-freak period. He thought we were very upset about that, but we really weren't. We were much more upset when we realized he was experimenting with drugs as he was only fifteen. That resulted in him lying to us. We knew he was taking drugs, but there wasn't an awful lot that we could do about it.

Through it all, he kept up his artwork. I remember, during that period, when he was by himself and lonely, he was constantly doodling. I had made a drawing table for him, and it had a plywood top. He would doodle on the plywood top. It wasn't too long ago that I finally used that plywood top for something else. Maybe I shouldn't have—maybe I should have kept it, because it had all those drawings on it, including the things that showed his Jesus-freak period—the crosses and little sayings.

KEITH HARING When I was real little, I was spoiled rotten. Of course, I don't remember that, but it's what I was told. What I *do* remember, is being extremely disciplined and feeling extremely restrained by my parents' expectations—mostly from my mother. It was normal things, like *not* watching TV after a certain hour or *not* doing this or that and *not* wearing this or that. I remember having a trauma because I wasn't allowed to wear bell-bottoms when I was in the fifth grade. I was forced to wear my uncle's hand-me-downs for school. And I remember the total horror of going shopping with my mother, and being forced to go to the bargain basement—I mean, looking at the regular stacks, but then having to do downstairs where things were substantially cheaper—and less interesting as clothes. My mother was really into saving money. You see, my parents were brought up in the fifties, and were conservative in terms of spending.

I got along with my mother—more or less. Except, she was kind of strict and, in a way, trying to really mold me into something. Things didn't become problematic until I got to be ten, eleven, twelve, thirteen, when the whole question of my boyhood and manhood was starting to come into play. There was the pressure to do the right thing, you know, to play Little League baseball. I remember wanting to have a Ken doll and my grandmother, my mother's mother, bought me a Ken doll, and my mother was furious. Just little things like that would happen. All these things both-

Keith, ten years old, all dressed up. Kutztown, PA. 1968.

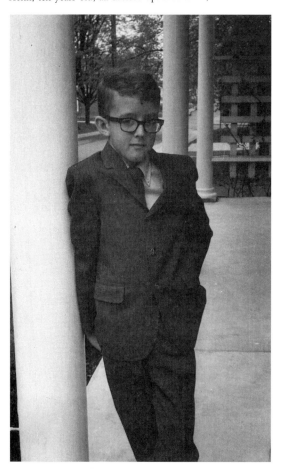

8

ered my mother more than they bothered my father. She could sense the gray areas more.

My parents got along well. Early on, my mother was kind of loud and bossy. She usually had the upper hand. I mean, she knew who the boss was, but at the same time, she could get a lot accomplished by nagging. My own uncomfortableness with my mother was about her always telling me what to do—and she'd do this to my father too. He'd take it only up to a point, and she always instinctively knew when to back down. When I got into my teens, I couldn't imagine how my father could put up with my mother—but he had a way of being quiet, of avoiding arguments as much as possible. Sometimes, I would have liked him not to let her push him around so much.

ALLEN HARING Joan and I often talk about how we reared our children. We thought we brought them all up under the same rules, ideals, and philosophy, and yet they turned out so completely different. We have four children and none are alike. I don't want them alike. But it makes you wonder why they don't end up alike.

I often felt I should have spent more time with Keith. Often we did things as a complete family, but having three girls and one boy, we ended up satisfying the majority rule—things the girls wanted to do, not necessarily what Keith and I wanted to do. So I often felt I wasn't spending enough time with him. Earlier on, I felt I

wasn't really getting through to him, because when we did do things together, we almost never talked. Then, when he was with his druggy friends, I just felt I wasn't breaking the ice. We were sort of distant. Maybe I didn't try hard enough. I couldn't get us together.

JOAN HARING I sometimes think we did wrong, because he was the only boy and maybe we . . . I was never athletically inclined, so I wasn't the one to steer him that way. My husband isn't either. Sometimes, looking back, we think we didn't do the right thing. Maybe we should have made him do more things with boys. But at the time, it didn't seem like a big thing. I mean, if he wanted to be in art and wasn't into sports, and wasn't studying that much, well, we thought he'd eventually find himself.

Of course, we had arguments. We tried to get him to change, to stay home more, to study more. At fifteen, sixteen, we thought he was wasting his abilities, not making the most of his school years, spending too much time messing around. We felt we were failing, and yet we didn't know how to cope with it. We didn't know how to change him. I have learned now, after having four children, that the more you try to change them, the worse it is.

KEITH HARING My first memories of making drawings were the drawings I did with my dad—I must have been four years old. My father was al-
ways good with kids—he liked to entertain them. Because I was the first child, I got a lot of attention, and a lot of it was focused on the drawing thing. It was the main bonding thing when I was little. My dad made cartoon characters for me, and they were very similar to the way I started to draw—with one line and a cartoon outline. They were simple line drawings.

It's weird, but I was never very interested in the funny papers. I was never into comics like Dick Tracy or Batman. However, I was really obsessed by Walt Disney. And I was really into Dr. Seuss. My father loved Dr. Seuss, and he'd read me those stories, and the way he read them to me was totally animated, which made me like them even more. So I was really into this array of Dr. Seuss characters, with their weirdness and absurdity. And I liked the early Charles Schultz, when he first came out with Charlie Brown. I used to collect all those comics.

Then, of course, there were the television cartoons. I was constantly watching them. At that time, in the early sixties, they were of incredible quality. Even Daffy Duck and Bugs Bunny were becoming really sophisticated—and with the advent of Technicolor, even more so. It was incredible—those pop colors! Well, I was obsessed with television cartoons—still am!

But everything on television seemed like cartoons—the sitcoms I grew up with, like "I Dream of Jeannie" or "Mr. Ed," the talking horse, or "Car 54" and "The Munsters," and "The Addams Family"—all those amazing stories which were totally ridiculous! Another obsession was "The Monkees." It was one of the first times I began to

9

frighten my parents, especially my father, because I was in the fourth grade and I would buy these teen magazines, which were really for girls, about the Monkees and Herman's Hermits. I would cut out the pictures of the Monkees, especially Davy Jones, who was the cute, young one. I'd cut these pictures out and make collages and books. And, I started a local fan club and I had a little clubhouse. I was always obsessed with making clubs and building clubhouses. There was so much happening in that period! It was really a dense time!

When I was a kid, one of the best things was going over to my grandmother's house, which was only four or five blocks away from where we lived. It was really my place of refuge. I could do things in her house which I could never ever do in my own home—like eating while watching television. My mother knew I was doing it, and she said I could do it there, but not at home. My grandmother was my media center. She had subscriptions to *Life* and *Look* magazines. I vividly remember reading about transvestites in *Look* when I was ten or eleven. But I read about everything, because everything that was happening in the world was in *Life* and in *Look*. It was while I was watching TV at my grandmother's that I saw President Kennedy get shot.

I had two uncles living with my grandmother, and they had a record collection. It was my first exposure to the music of the period, like Iron Butterfly and the Rolling Stones and the Grateful Dead. I didn't hear anything like that in my own home. In fact, I distinctly remember hearing my mother say that the boat that brought over the Beatles should have sunk. The point is, my parents weren't part of the sixties cultural revolution at all. They were on the other side of it—the redneck side of it. They supported Nixon and were on the side of what a lot of people were opposing. I never really felt a part of that. So, as I grew up, this became more and more of a problem at home.

Anyway, at that time, I was doing a lot of drawings with hippies in them, and I redid the classic fairy tales, but told in hip terms. I'd make drawings of Goldilocks and the Three Bears, but Goldilocks is wearing a miniskirt and knee-high go-go boots. And I redid Rumpelstiltskin and a groovy Little Red Riding Hood. One of the things I did in junior high school, which caught everyone's attention, was to develop characters called Peterson & Company, a groovy pop name for a rock band. Well, on adding-machine tapes I made this whole strip of characters with a scenario involving hippies and police cars—you know, the hippies versus the pigs. They were drawn with a black ballpoint pen and the strip was almost fifteen feet long! In between the characters were the letters spelling Peterson & Company. I put that in the student art exhibit and won an award. I still have the drawing and it's really funny looking!

KAY HARING I went to the same schools here in Kutztown as my brother Keith—elementary, junior high, and high school. But we weren't particularly close although we're only two years apart. I was

Untitled. Crayon on paper. May 1964.

Keith
may 1964

always sheltered as a child. Growing up in Kutztown I didn't know very much—even about current events. I mean, I didn't even know about Vietnam and what was going on in the world. I grew up being told to go outside and play. So I was climbing trees and riding my bike. Television wasn't a big thing in our household. I was never buddy-buddy with either my brother or my sisters—I never felt I had to be that. Anyway, we each had our different interests and Keith was always into a lot of different things. Most of all, he was constantly drawing. When I was fourteen or fifteen, I did a lot of drawing myself, and I would have liked being more a part of what Keith was doing. The distance between us always bothered me—sort of. He never took much interest in what I was doing. I was the athletic one. I liked hockey and cross-country running and biking and roller-skating—and Keith never took an interest in that.

KAREN HARING DE LONG
My brother Keith is four years older than I am. My first recollection of Keith is not particularly nice: Keith and my cousin Phil did what they called an "operation" on one of my teddy bears, to see what made it musical. They destroyed my teddy bear! Anyway, I'd say Keith and I were never close-close. He was always very attached to my sister Kristen, who was much younger and was always the little kid. Keith and I weren't hostile toward each other or anything like that. There wasn't any kind of animosity. He was just a brother. He was

just kind of *there*. We never really did things together—just the two of us.

I think we had a pretty good home life. Our parents weren't very restrictive. They kind of let each of us do our own thing. We were very family oriented. Every holiday was spent with the family and with different relatives on either side. I kind of skipped the artistic ability. I was most interested in animals. I was always the one who found the little hurt pigeon and I tried to bring it back to health. Later, I trained as a veterinary technician, but what I really want to do is work for the rehabilitation of wildlife. I'm a big advocate against pollution and the elimination of the rain forests and all.

Anyway, I like Keith's work a lot—especially his early work—his cartoon-type drawings. I mean, they didn't affect me profoundly or anything, but I was always proud of Keith—that he could do that! And I was proud that he later became so famous—for doing what he wanted to do—for doing something he was so good at!

KRISTEN HARING I think I was a happy baby. I had so much attention from my parents and my siblings, who were eight, ten, and twelve. I mean, when I was born, it was this exciting new thing, and it shook up the family. It seems they were all fighting over who was going to read to me or play with me. Then all that stopped when I got to be three, four, or five.

It turned out that Keith was the one who always had time for me. That was

12

partly because Kay and Karen were working on homework or had other activities. Keith, who was twelve years older than me, liked to paint with me and he had very creative ideas. I remember we'd sit down and we'd each have a piece of paper. We'd each do something, and then we'd say "Stop!" Then we'd switch drawings and continue on each other's drawings so that it would always be changing.

One time I went into Keith's room and he was painting, and I started pestering him. So he took my hand and started painting on it and then he stuck my hand down on a piece of paper—and he did that ten or twelve times. Then the two of us cut out the hands and hung them on a clothes hanger—we made a mobile! I remember I was six years old when we did that.

I never wanted to be an artist. But when I was nine, I wanted to be a librarian, which is also something I got from Keith. I have a vivid memory of walking with Keith to our grandmother's house. On the way, we found this little slip of paper. Keith picked it up and started reading what was written on it. I said, "Keith, it's just trash!" He said, "You should read everything you can. You should *always* be reading something, no matter what it is!" Those words have a lot to do with where I am now. I mean, I read all the time.

Right now, I'm in my second year at the University of Pennsylvania. I started out wanting to go into medicine, but I then found I had problems with the philosophy of medicine and with the fact that I considered doctors overpaid and held in too much esteem within society. I'm still convinced that America should move more toward a so-

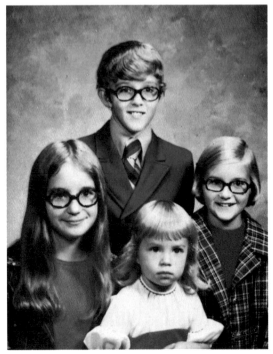

Kay, Kristen, Karen, Keith. Kutztown, PA. September 1972.

13

cialist policy in medicine. So, I decided to study bioengineering, because I was always good in math, and I thought the subject great. But then I realized that the University of Pennsylvania had this really great liberal arts school, with this incredible tradition. So I wanted to take those courses—and that's what I'm doing now, getting a liberal arts education.

I think Keith is kind of biased in thinking that I'm so bright, because we share a lot of philosophies about life, culture, art, and learning. But you see, I got those ideas from him, either directly or indirectly. So if he thinks I'm smart, it's because I've accepted his ways.

KEITH HARING For the first twelve years, it was just me and my sisters, Kay and Karen. I was encouraged not to spend too much time with them—I was supposed to be out playing with boys. So my sisters and I weren't really that close. Then when my third sister came, I had a real affinity toward her, because she was a baby and because I was starting to go in my direction and become independent. Later, when I became more rebellious, my older sisters became alienated from me. I was the black sheep. I was made to look as the bad example to them, and was kept away from them even more. They were sort of scared of me at that point. So my little sister Kristen became my real friend, because she was too little to understand any of that stuff.

14

KAY HARING When Keith got into being a Jesus freak and a hippie and a druggy, I sort of sat back and watched it all. I didn't understand a lot of it. I just always remember observing everything and *trying* to understand. I never asked about it and never talked to anyone about it. The point is, when Keith turned "bad," my parents wanted to distance Karen and me from what Keith was doing.

KAREN HARING DE LONG I don't think our parents were at fault about Keith's rebelliousness. Not at all! They let us choose our own paths, and we discovered what we wanted to discover. For Keith—well, he just went in the wrong di-

rection for a while. He wasn't into school. He didn't get the grades Kay and I were getting. Being the only boy in the family, he may have had a tougher time of it. I never really sat down and thought about why Keith did what he did.

KEITH HARING From the time I was very small, I went to camp every summer. It was a church camp. Of course, we were all going to church in Kutztown. We went to the United Church of Christ, which is Protestant. Anyway, going to camp meant being with kids from all walks of life. And you meet kids who don't know anything about your life, and you become friends. I was really good at meeting people. I'd make best friends and we'd write to each other the rest of the year. And, there were counselors. I remember one of the counselors—his name was Dave. He was there a couple of years in a row, and I thought he was really handsome! I remember seeing him in the shower, but not really knowing anything about sex at the time. But I still remember the smell of the showers—they were out-of-doors and made of wood—and you took showers all together—and it was incredible.

One time, there was this talent show. I must have been eleven or twelve and for the talent show, I decided I'd do a striptease number as a woman. I remember we built a fake cake out of cardboard, and I came out of the cake. Some girls helped me with the makeup—and we had striptease music. So I did this striptease, but I didn't take off *all* of my clothes because this was a church camp.

My first real memories of being attracted to another boy—and realizing I felt a genuine attraction—was at camp. This was when I was a bit older, maybe thirteen or fourteen. He was a light-skinned black boy who became my best friend. We never really *did* anything, but it was the first time I felt something different. We became inseparable.

Of course, there were girls—you know, in the fourth, fifth, or sixth grade. I had obsessions. And there were little parties, and I was always very good at choosing presents for girls—and making cards. There was the whole note-sending thing—writing love notes back and forth. Getting caught with love notes, and breaking up with girls.

But I was mostly with boys, and I discovered my sexuality that way. In Kutztown I had two friends, both younger than me, and their father was a wrestling coach. Well, these two friends and I would spend nights at each other's homes—and we did things like hugging and rolling around. One of my fondest memories was going with their father, the wrestling coach, to Kutztown College—where he was teaching—and watching him at practice with young college kids. After the wrestling practice, the fellows used to go swimming naked in the college pool, and we'd jump in too, and it was neat swimming in the pool with these hot young wrestlers!

And I remember going to the college dorm one day—and just being there, just the smell of the dorm and seeing these guys walking around with a towel around them—it was one of the earliest and most potent sexual memories. The male thing seemed more interesting to me, and even though I was only eleven or twelve, I was already

hanging out with college students, and through them I became more and more aware of what was happening in the world—like Kent State, which happened on my birthday, May 4th, and seeing college kids going around with black arm bands.

When I turned thirteen or fourteen, I remember, for whatever reason, wanting to be part of something. Well, the first thing that became available to me was the Jesus movement. I had gone to church and Sunday school and been taught about religion but it was taught in a very standard and mundane way.

People fell into the Jesus Saves movement because it was something to believe in. It was just like it is in the Bible, except you took everything more literally. Being born again meant that you didn't just commit your life to it, but would convince others to believe in it. Not only was it a way of dealing with your own life, but it was your duty to convince the rest of the world about it. It was a self-declared mission. And a lot of it was an obsession with the concept of the Second Coming—and the "End of the World," and that everything that was happening in the world was a sign that these *were* the last days.

So I read about all these things in the Bible and I read Revelation—about the end of the world. And I read a book called *The Late Great Planet Earth*, and I digested all this information and wanted to believe. All my art of this period was involved with these Jesus things. It was confusing for my parents, my being a Jesus person. I mean, it was along the lines of what they wanted me to believe in, but they wanted to keep it under control—they didn't want me to be

15

obsessive, and they were frightened because I *was* obsessed with it.

I was considered a freak—a Jesus freak. I tried to convince others to be born again, and it just annoyed people —they got tired of my talking about it. Finally, I myself became bored with it. I had done it for about a year, and it seemed to make less and less sense to me, and it became less pressing. In between all that, I discovered smoking pot—that, plus listening to rock music. And there was peer pressure, so the Jesus thing became really boring, and I don't know that I ever, really believed in all those things. It wasn't as exciting as it appeared to be at first. Still, all that stuff stuck in my head and even now there are lots of religious images in my work, although they're used in a more cynical way—to show how manipulative those beliefs and images can be. So, anyway, after the Jesus thing I got into drugs.

KERMIT OSWALD What interested me in Keith was that he was just a crazy kid. When you're eight or nine or ten, you look across that classroom and there are people who stand out as real dorks and some who turn out to be kind of interesting. There was always something interesting about Keith. It was the way he dressed, it was the way he talked, it was the way he would smile, smirk, and roll his eyes. It was the way he could get himself out of trouble as fast as he could get into it. But a lot of it was that we had a common interest in art. We were always known as the artists in the school. Keith was and remains my best friend.

We had a lot in common, Keith and I. We were both from Kutztown—I was born there in 1958, so I'm exactly Keith's age. I think we met at my eighth birthday party. Keith was there with a lot of other kids. We were in kindergarten together and all the way up through high school. I remember, when we were maybe twelve, sharing our first studio together, which was in my aunt's garage. We were very serious about attempting to do something with our time. So we'd get together in my aunt's garage and we'd make things. Keith was very oriented into making cartoon things, and he'd create little name tags and everything he was writing at that time wasn't in the classic Keith Haring print–style that we know today, but in these enlarged balloon letters that look like they were carved out of a block of granite. It was stuff he had picked up from his father, who did these really incredible drawings of little dogs and things—and cartoon characters. I, on the other hand, was drawing trees—birch trees in just black and white.

KEITH HARING In junior high, there were two kids I always competed with—in art. One was Kermit Oswald, who became my best friend, and the other was Kelly Ryan, who mostly drew cartoon things and who invented his own weird little characters. Kelly pushed harder with a pencil than anyone I had ever known. He drew so hard that the paper would become embossed from the other side. He had imagination, but he wasn't in the same league as Kermit. In a way, Kermit and I seemed

to be in competition from birth! By junior high school, his ability was becoming more and more obvious. There was a big difference in the way that we worked. Technically, he was very well developed, so that when we had to draw a plant or a barn, he could do it very well, and he was proud that he could do that—and he didn't let me forget it. My own ability was more on the inventive side and, by this time, I was still leaning toward the cartooning side of art rather than the fine arts idea. Later, I began making these little abstract things, with lots of little lines and patterns that I developed—little sticks and rods and circles and squares—little units that would be interconnected. So Kermit and I were always in competition, and always encouraged by our art teachers.

LUCY DE MATTEO I taught art at Kutztown Area Junior High School for sixteen years. I'm retired now. Kids are eleven, twelve, and thirteen when they go to junior high, and it's a very funny age. They think they're grownups, but they're not. You have to really do things that engage their interest—or forget it.

I had Keith and Kermit for three years. They were buddies. The thing about Keith was that he always liked working alone and on his own. I thought that if I squelched that, he'd lose interest. And, he was stubborn. I'd say, "Keith, why not try this or that," and he'd say, "I don't want to." Finally, I'd say, "OK, OK, do what you want."

But I wanted him to try different things.

I wanted him to do an oil painting. I said, "Try it, Keith. It's another medium." Well, he tried it, but he never finished it. The point is, Keith only did what he wanted to do. At the time, he was into his Jesus phase, so he made a lot of drawings with crosses in them. I didn't argue with him about those drawings. Keith was in the top section of the class—he got A's—and he was always working on something.

I encouraged him, hoping his talent wouldn't be lost. I felt that with him, it was an inborn thing. His father was artistic, but Keith had the goods to go out and do something about it. I used to say to Keith, "There's a place for you in the art world. I don't know where and I don't know what, but you'll find it." Well, when I first heard about Keith making it in New York, and when I saw pictures of him in magazines, it startled me but it didn't surprise me. I knew he could do it. Frankly, I don't think Keith's family really ever understood what he was up to. They couldn't relate to his art.

It's wonderful for a teacher to see a pupil succeed. It's really the only satisfaction you get. I was thrilled when Keith made it. I was terrifically proud.

NITA DIETRICH I taught art at Kutztown Area Senior High School for thirty-one years, and retired in 1983. Keith was my newspaper boy, so I knew him as carrying newspapers before I taught him in high school. He was a good newspaper boy—quite reliable. But one time we had new cement poured in front of our house, and Keith put his initials in it. It kind of

annoyed me, because I don't like things to be spoiled.

Our high-school art department was pretty elaborate. You could take ceramics, jewelry-making, graphic arts, drawing, and painting. Or students could elect to work on their own. When Keith came into my class, he was sort of quiet and, as far as I was concerned, he was never a troublemaker. He was diligent and often off in a corner by himself, concentrating on his work. From the first, Keith loved line. He wasn't too interested in rendering a realistic, three-dimensional drawing. But anything that lent itself to line pattern, he loved. I was really fascinated by him. I don't think he ever did an oil painting. He loved pen and ink, and he worked so intricately! His sense of proportion and his patterns just intrigued me! The way the patterns would carry you through and around and in and out. He had such imagination. I felt that anyone who liked to explore line the way he did shouldn't be pushed into areas he didn't care for. So I just left him alone.

Keith graduated from high school in 1976 which was also the year of our bicentennial celebrations for Berks County. And, a contest was held for the art students which I encouraged Keith and Kermit to enter. Well, Keith made a map of the United States which involved numerous little lines and patterns all running into each other. For each of the states he put little symbols of what the state was noted for, like for Florida he drew a Mickey Mouse because of Disney World. So, it was a total map of the U.S. and I remember it measured twenty-two by twenty-eight inches, and Keith won a prize!

Instinctively, I always knew to give Keith the freedom to work on his own. It was the best way to handle him. To let him explore whatever he wanted to explore, and not say to him, "Do this or do that." It just wouldn't have worked.

In 1982 our college in Kutztown invited Keith to come as a guest artist and show some of his slides and talk about his work. My husband was in the hospital just then, but I managed to come and hear Keith speak. I felt so very proud. He was still the Keith I knew. He hadn't changed at all!

KEITH HARING When I started going to high school, I became less and less interested in cartooning for cartooning's sake. I was wanting to become an "Artist." For me, this meant making abstract things. So I started making little shapes that together would fill whole areas. It was a little like automatic writing. Like, the negative shape of one shape would lead to the next one. Again, it became an obsession, and I used a Rapidograph and it opened me up to using a consistent line that could go on and on.

Through Kermit I became aware of what was happening in the art world—sort of. Though I looked at books, my knowledge of the New York art scene still came from *Life* and *Look* magazines. Once, during a church trip to Washington, D.C., we went to the Hirshhorn Museum, and that's where I saw my first Warhols—a group of Marilyns. So during this whole high school period I looked at art and studied art, because

I was more and more convinced that I was going to be an artist and, in fact, I thought I already *was* an artist.

But I also got into drugs, and the reason was that it meant belonging. It was about being an individual and taking charge of one's life and destiny. It was exercising, for the first time, a power over one's body and mind. But mainly, it was about being part of a group. I always became obsessed with everything I started—whether it was starting the Monkees fan club or being a Jesus freak. I wanted to do these things as fully as possible. So I treated drugs like a new obsession.

I was fifteen when I first started smoking pot, and with that, I had to change to a new set of friends—and they were mostly troublemakers, people I wouldn't have hung out with before. Well, one thing led to another, and things got from bad to worse. The problem with me was that I tried *everything* at the beginning. I was taking capsule things, like Seconals and "black beauties," speed. And acid was around and I was taking a lot of it. We were a whole bunch of friends doing this, and we'd go to concerts, like the Grateful Dead—and I was letting my hair grow longer and longer.

It was real trouble for my parents, because I'd get caught doing this stuff. Like, when I still had the paper route, one place I had to deliver was to a fire company, and at the fire company there was a social hall with a bar downstairs. So I'd deliver the paper and I'd go inside. I liked going to the bathroom there, because at that time, I was also into masturbating as many times as I could a day. Anyway, I discovered the bar was always left open, and I'd steal bottles

of liquor and I started to drink. I also went through a shoplifting period. I did it to, like, be cool. So sometimes I'd get caught and my parents were kind of devastated.

My studies at school got worse and worse. Because, I'd drink before going to school—or smoke pot. I guess the worst thing I did was running away from home—for a weekend. I didn't even leave town. I was just at someone's home, whose parents were away. So these friends and I stayed in the house all weekend and had this wild orgy of drugs and sex. There were a lot of people, mostly kids from high school, but also older people.

I did really stupid drugs—like Angel Dust, and this friend of mine was making it, and we'd have to test it out. Well, you need a very small amount before you're really high, and it distorts all your perceptions—all your muscle feelings and your sense of walking. When you smoke Angel Dust, you feel you're not human—and that you can do all these superhuman things. People have killed themselves smoking it, because it's one of the most dangerous drugs that exists.

My parents were in a state about me. One day they invited our minister to our house, because I had been close to him before all this stuff started happening. They thought maybe I'd listen to him. But on that day, my friends and I were hanging out again. We were drinking beer and popping pills—some really strong downers. I could hardly walk and I had no idea what I was saying. Well, instead of letting me sleep it off or keeping me where I was, my friends dropped me off in front of my house. First thing, I fell into the bushes in front of the

19

house, and some neighbors came running. I must really have been out of it, because I was saying really terrible things—and swearing and trying to run from the house and falling in the garden. It was the worst mess I was ever in.

The worst part of it was that I started saying the most horrible things to my mother—it just all came out—and I don't think she ever got over that. When I finally came to, she was really, really crying. And that was the only time my father ever hit me—I mean, *really* hit me. He just didn't know what else to do. He was totally at his wit's end.

Now, of course, I totally sympathize with my parents —what it must have been like to see your kid totally turning into this crazed thing, and having no handle on how to deal with it. They *did* try to talk to me—to help—but I didn't want to hear anything, I was completely closed to them. Even seeing my mother crying . . . it had an impact, but it didn't stop me.

KERMIT OSWALD While Keith was doing drugs, I was hanging out with some really serious people at school. One of them is now deep in the State Department. Another is a brain surgeon in California—and these people were *not* doing drugs. So, no, I didn't reach out to Keith and say, "Get away from drugs!" And I didn't, because the people Keith hung out with were really trouble. They came to school high. They'd get high in the parking lots.

I'll never forget: I was in the principal's office one morning, and in walks Haring—

late again. Now, of all the people we went to school with, Keith was the one who lived closest to the high school—only one block away. But Keith would get to school late day after day after day. Well, on this particular day, he marched into the principal's office and in all earnestness told them that he had been taken prisoner by these rabbits—these terrorist rabbits! Maybe this was Keith high on Angel Dust or something, but I'll never forget his having this flippant attitude. He could use whatever extravagance was at his disposal to kind of gloss over the whole thing.

KEITH HARING I was now sixteen going on seventeen, and my doing drugs and drinking and fucking up was also a way of breaking out of the conformity of Kutztown—I felt suffocated by the town, because everything I did was in the spotlight. I was being more and more alienated by the town, more and more talked about, more separated from it.

Little by little, after the recklessness, which didn't last all that long, but which was really intense, I started to grow out of it, and I started having a much more mature attitude toward the whole thing. I started hanging out with more intelligent people and started using drugs in a more productive way. Things like hallucinogenic drugs had started to show me things in myself and in the world that had more value. I was around people who had another idea about drugs—having a much smarter way of doing things.

Anyway, I quit my paper route and got

a job as a dishwasher in this place called *Glockenspiel*, which was just a bit out of town. I made some new friends—all of them college students. The bad drugs I had been taking scared me sufficiently to want to drop them—and I did. I wised up. I should mention that at the time I was taking drugs, Kermit, my best friend, became completely alienated from me. He had girl friends, and was on the track team, and he was still being a good kid. He wasn't experimenting with drugs at all. Later, he did start smoking some grass and doing some drugs—and we began to be together again. This was during our last year of high school—we were now seventeen.

The year before I graduated from Kutztown High School was a very important one for me. In the summer of 1975, I really needed to leave home. So I met this kid and he was going to get a summer job in a place called Long Beach Island, which was off the coast of New Jersey. I asked my parents if I could go there too—to work there over the summer. Well, they were totally, dead set against it. They felt I should stay and get a job in town. But I decided to go anyway.

I had saved up some money from my newspaper route—buying savings bonds (my mother always got me to buy savings bonds), and I took one of my $1,000 savings bonds and cashed it in. I got $700. With part of the money, I bought half-a-pound of marijuana, which I temporarily buried somewhere—and I got everything sort of ready for my departure. One night, I moved everything out the back window. How I did this without making a noise or waking the family dog or my parents, I'll never

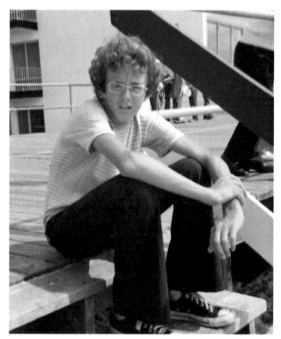

Keith, sixteen, Ocean City, NJ. 1974.

know. Anyway, my friend brought his car around, and I moved everything in his car, and I left a note for my parents, telling them I was going to the shore for the summer. So we drove to the shore with my half-pound of pot, and when we got there, we moved into this boarding house, and being there for the summer was probably the most wonderful experience of my life.

The boarding house was about a block away from the beach and was run by this couple named Ted and Trudy, and the whole house was just full of kids from New York and from Pittsburgh, and there were a lot of Jewish kids, who seemed very alien to me because I grew up in this really WASP town. Most of the kids found summer jobs, but since I had all this money I didn't really need a job. Still, I got a job as a dishwasher in two different places.

It sounds weird, but I really grew up in this place. For one thing, I was trying to make it with girls. For another, I really made some good friends, like this Jewish kid, Morty Fishman, and, of course, this kid from Kutztown who was my roommate in this place. Anyway, we'd always hang out at the local shopping mall, trying to pick up girls. I had a terrible time, because I could never get to meet the girls I wanted to meet. So I'd just wait there. And the cute guys would always be there, and the girls would talk to the cute guys. But I wasn't cute. I mean, I just wasn't. I was skinny and I had glasses and I looked sort of like a nerd. So I'd wait, then walk around and walk around and *not* meet someone.

I was trying with girls, but it didn't happen—not that summer. Then there was my roommate, and he was sort of cute. I still don't understand why I never did anything with him. I must have still been so scared about the gay thing—or so inhibited by it. The fact is, I hadn't even considered it—and it was right there in front of me! We slept beside each other in separate beds every night. And he was cute. I would sleep with him now if he looked the way he did then.

Anyway, throughout that summer, I learned about everything—from receiving rejection from girls to making all these new friends to taking good care of myself to being more responsible about taking drugs. I did smoke pot all the time and took acid now and then. I remember several incredible times; taking acid on the beach and staying up all night, having amazing conversations with friends and watching the sun come up at six in the morning, and sit-

ting on the lifeguard chair. It was just heaven! It was this totally artificial world, because nothing mattered except the day-to-day life. I mean, I didn't have to worry about my parents, and I was making a lot of drawings, and I had all these friends and I was probably in love with my roommate—and I didn't even know it. So I spent the summer just growing up and learning how to deal with people, and how to deal with myself.

At the end of the summer everybody went back to school, including me. I had a sort of tearful reunion with my parents, who, because I had gone away, had developed a kind of respect for me. So, during my last year of high school, I became more responsible—and I even got my driving license, because earlier my parents didn't trust me with the car.

That's when I also became friends with Kermit again—and we smoked pot and had this really intellectual relationship, where we talked about everything—about life and the universe and the meaning of it all. And I got even deeper into the Grateful Dead—their songs—and had these amazing experiences with hallucinogenic drugs. I'd lie in the fields and see these beautiful patterns and colors and shapes, and how the sky and the trees turned to different colors—and there were just these beautiful geometric shapes, and it was great. I never really had a bad trip. I came to realize that if you were comfortable with yourself, then that would be reflected in the trip you had. Well, more and more, I became comfortable with myself and had a better understanding of myself. I understood who I was and what I wanted.

I graduated from Kutztown High School in 1976. It was fine and I had gotten my shit together and after that, two very important things happened: I lost my virginity with a girl and I made the decision to go to art school.

KRISTEN HARING I was six years old, and I cried at Keith's graduation. We were sitting in the high-school auditorium and my mother said, "Why are you crying?" I said, "It means Keith is leaving, doesn't it?" I cried because Keith had spent a lot of time with me as a child, and I knew he wouldn't be doing that anymore—and it was hard.

KEITH HARING I lost my virginity with a girl named Susan.

From the beginning, when I was a kid, I always thought I'd be with a girl. It's true that when I looked at *Penthouse* magazine and there was a guy and a girl fucking, I was just as interested in looking at the physique of the guy as I was of the girl. But I always knew I was supposed to be with a girl—and I enjoyed it.

Susan was the first girl I ever slept with—and I fell in love with her. Before Susan, it was very difficult to find a girl who thought I was attractive or cute. I always knew that I could make someone fall in love with me if they saw some other side of me. No one had ever given me that chance. But Susan saw that other side of me and she thought I was cute. I was eigh-

teen and wore my hair very long, in a braid or a pony tail. I considered myself a hippie, and I considered myself in love with Suzy. We were together for quite a long time, and I kept sleeping with her. I liked the sex, and I was good at sex, and we had sex all the time. I met Susan in Pittsburgh, which is where I went to art school. After I graduated from high school, my parents and my guidance counselor convinced me that if I was still serious about being an artist, the only way I could realistically think about it would be if I went to study commercial art. In that way I could make a living from it. I wasn't totally excited about the idea, but after looking at various brochures and catalogs, we found a school in Pittsburgh that supposedly offered commercial art and fine art. This was The Ivy School of Professional Art, which has since totally disappeared. So that's when I left home to live in a real city.

Suzy and Keith hitchhiking to Pittsburgh. July 1978.

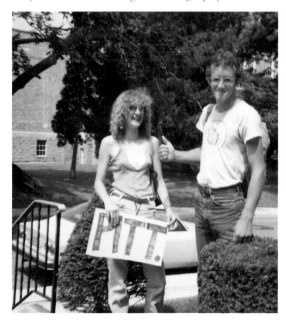

JOAN HARING I remember when Keith left for Pittsburgh. It was early in September of 1976. His father drove him there. They left Kutztown at four o'clock in the morning. I remember standing at the kitchen door crying and crying and crying. I was just so relieved that when he left he wasn't the problem he had been six months earlier. I'll confess it was also a relief not to have the loud music going all the time. But I missed Keith terribly. Still, I was busy with the Women's Club, and the girls were growing. By this time, Kay was a junior in high school, Karen was in the ninth grade, and little Kristen was in first grade.

KEITH HARING The Ivy School in Pittsburgh wasn't great, but it had its compensations. First, the situation of being among other art students of the same age and for more or less the same reason, made it a good environment for me. Second, I was treated like an equal by the older students and even by some of the teachers. My work hadn't strictly developed as yet, but a specific style was emerging. I had developed this linear thing and I had these little shapes that filled up space, and it looked kind of obsessive but interesting. I felt I already had a kind of vocabulary and a kind of style. My problem was finding out what to do with it. So I brought all that to the school—and the school was OK as far as it went. I mean, it had the basic fine arts courses in painting and drawing, and it had courses in commercial art, like graphic design, illustration, advertising art, and silk-screening.

Within six months I came to realize that no matter what, I wasn't going to be a commercial artist. I mean, a lot of the students and a lot of the teachers were saying that they were becoming commercial artists only to support their own work as real painters and sculptors. But I saw through that right away. I realized that if I spent the whole day doing mechanicals and pasteups, I wouldn't have any interest left in doing my own work afterwards. Well, I decided that if I was going to be an artist, *that's* what I was going to be! So I finished my second semester at Ivy and then decided to leave school.

One of the deciding factors about my leaving Ivy was a book I accidentally found in a flea market back in Kutztown, when I returned for Christmas. Just by chance, I picked up this book, opened it and after reading only one or two sentences, it was talking to me like a friend. It turned out to be *The Art Spirit,* which was written in the 1920s by the American artist, Robert Henri. Well, this book changed my life completely—literally—because it's about the idea of making art, and the concept of being an artist and a teacher. He had written it while he was teaching at the Art Students League in New York, and everything he talked about was *exactly* what I had been thinking about and questioning. After I found this book, I *knew* I had to leave the Ivy School.

Ever since I was a kid, one of my fantasies was to hitchhike across the country. When I became a hippie, this dream became even stronger and, after quitting Ivy, I inveigled Susan into hitchhiking with me. The pretense was to go check out other art schools that I might want to attend, like the Minneapolis College of Art and Design, which had an interesting curriculum, and

other places. Susan was game, and we packed backpacks and took a little pup tent and proceeded to leave Pittsburgh. The Robert Henri book came with me, because that was the handbook—that was the Bible.

So we first headed toward Minneapolis, which took us through Ohio, past Chicago, through Wisconsin and up north into Minneapolis. Because we had very little money, we camped everywhere. I had brought along a whole duffel bag full of T-shirts which I had silk-screened and which I would sell whenever we needed money. I made two separate designs. On one batch of T-shirts I made the logo of the Grateful Dead, which has the skull with a lightning bolt through it. Within the space of the lightning bolt were my little line drawings, which by now had become more sophisticated—it was an overall pattern that had real life to it. The other batch had a big photograph of Richard Nixon lifting a kilo of marijuana to his nose and sniffing it. It came from a photograph I had seen in a marijuana magazine. Underneath it, and using my commercial art training, I laid out the words SAN CLEMENTE GOLD. In the frame where the head was, I again drew my little designs.

When we got to Minneapolis, I went to see the Minneapolis College of Art and Design—and I was impressed. A counselor showed us around, and we were even given a room in the dorm for the night. I thought the school had real possibilities, but we moved on, taking the northern route to California. We went through South Dakota and Montana and we looked up a school in Seattle—seeing the country was just beautiful! Eventually, we got to San Francisco,

and immediately headed for Berkeley—to the university campus. We looked up the student center and on the bulletin board found a place where we could crash for the night.

The place we crashed in was run by a minister, and he was very generous and friendly. He introduced us to this really cute Spanish-looking guy, his assistant, who gave us dinner and showed us where we could sleep. He then asked if we'd like to take a walk, and he proceeded to take us to the Castro district, which turned out to be totally gay. This was 1976, and the gay scene in San Francisco was really coming into its prime. Well, this cute guy was being incredibly friendly toward me. I was so naive! I had no idea this kid was coming on to me, and he was taking me there to make his intentions even clearer. It made me cling even more to Suzy! Little by little it became obvious to me that while I was still sleeping with Suzy, I'd been fantasizing more about men.

We continued hitchhiking down to Los Angeles, then decided to head back to Pittsburgh. Again, we crossed the country and arrived back in Pittsburgh almost penniless. For a little while I had to go on welfare, which I really hated, but we were broke. Finally, we found a small apartment on Atwood Street, which was right in the heart of the campus area, near the University of Pittsburgh and the Carnegie–Mellon University. The apartment was right over a health food restaurant, where both of us worked for a while. Later, I found a job working in the cafeteria of the Fischer Scientific Corporation, a company that produced chemicals. I worked in the corporate office cafeteria as an assistant cook. I took

these kinds of menial jobs because they were easy to get and I could be sure of my food. What I liked about Fischer Scientific was that in their executive dining room they had murals about alchemy—there were pictures of alchemists, instruments and objects, and all kinds of quotations that related to alchemy. One of them has stayed with me to this day. It was a quote from Dr. Louis Pasteur, which said, "Chance favors the prepared mind."

A terrific thing happened at Fischer Scientific. In the cafeteria where I worked they had a large wall devoted to changing art exhibitions. Well, I was making small drawings at the time, and I was invited to put them up. I remember they had this menu printed on a single sheet of paper. That week, the menu included the announcement of my show. It said, "Keith Haring, Lithography, Ink and Other Media—opening Tuesday, December 13, 1977." Then, at the bottom, it said, "Keith is employed in our cafeteria." It was my very first show.

I don't remember whether I left the job at Fischer's or whether I was fired. But what I did next was to find a CETA program, which was a government-sponsored program that gives employment to youth. The CETA program had an opening in the Pittsburgh Arts and Crafts Center, which has since been renamed Pittsburgh Center for the Arts. I applied and got the job immediately. It was a maintenance job, which entailed everything from painting the outside of the building to doing roofing and all kinds of repair work. Well, I was apprenticed to this guy named Rom, and he had this crew of young guys who would assist him around the building.

As it turned out, the arts and craft center was the only art center in Pittsburgh besides the museum. It was *the* active place where local artists showed their work. The center had galleries and there were art and ballet classes as well as children's programs. Well, I proceeded to take advantage of the place in every possible way. I started taking printmaking classes and I made lithos and etchings. I became friendly with several Pittsburgh artists and I embarked on this mission to educate myself. Because I was more or less living on the campus of the University of Pittsburgh, I was behaving as though I were a student there. I'd go into the student union and use the libraries and I'd sit in on classes whenever possible. Of course, I wasn't enrolled in the university—but I took advantage of it.

KERMIT OSWALD When Keith and I graduated from high school, Keith went off to Pittsburgh, and I enrolled at the Kutztown State Teachers College, which is now called Kutztown State University. I never really gave too much thought about wanting to be an artist. My feeling has always been that it's something you're either destined to be or you're not. I've always believed that you don't have much choice in becoming an artist. You can't really go *after* art. It's more like *it* wants you. The fact is, art has claimed Keith almost as much as he'd claimed *it*.

Anyway, I stayed in my hometown—Kutztown—but I did pursue being an artist, certainly throughout my college years. Around 1977, I was into chalk drawings,

which is part of a well-kept secret. I did them all over the university. I did them on every wall. For me, they represented rebelling against authority. I was getting sick of working in the classrooms. I was sick of making objects that nobody was paying attention to. So I decided to take my art to the streets. In addition to the chalk drawings, I did chicken-fat drawings, which I did on the cafeteria steps. I did salt water drawings on the gymnasium floor, to represent sweat. I was making paintings with salt. I was carving wax. I was experimenting all over the place. So these were pretty aggressive works which I did all over the campus, and I was nearly thrown out of school. I lost my student job. I was stripped of financial aid. I have nasty letters from the president of the university. Well, when Keith came to visit, I showed him my stuff, and he said, "This is urban guerrilla art!" It really raised the hair on the back of his neck—like, all of a sudden, something clicked. And he said, "Kermit, on this one you're years ahead of your time!" And it scared the living shit out of me, because for the first time in my life the person I really looked up to and respected for having the balls to go after what he really wanted, was slapping me on the back for something he admired. I kept thinking to myself, "What the fuck am I going to do to top this?"

Anyway, what I'm saying is that even though Keith and I were separated and doing our different things, we still kept up our friendship. In fact, he'd come back from Pittsburgh and so we'd be in contact every thirty or forty days. And, we were always writing to each other. I mean I have these really beautiful letters from Keith and

these incredible drawings that he'd send me. The letters didn't make sense, somehow, but I wasn't aware of the gay issue—and I think that entered into it. I dealt with it as humbly as I could, because, hey!, all of a sudden this guy I've been spending my whole childhood with turns around and has an attraction for me.

The point is that growing up in a small town, I didn't really know what being homosexual was all about. I didn't think much about it. It wasn't something that came into my vocabulary until he brought it there. I mean, Keith brought my understanding of gayness to me. It wasn't something that I ever dealt with. I love women. I mean, I love them to death. I mean, there's nothing I would rather be doing than *it*, whatever *it* might be, with a woman. I've never had those urges with a man. So when I started receiving these really beautiful letters and drawings I said, "What is this?" I mean, what does this suggest? Because part of it was experiencing some sort of guilt about what people might think about me. I mean, they'd obviously assumed that Keith and I must have had our moments. But I would point out that we had done absolutely everything together *but* that! So it is what it is.

KEITH HARING At the arts and crafts center in Pittsburgh, I started to do printmaking. I not only took classes, but used all kinds of other facilities to do my own work. Around this time, 1977, I had a real obsession with paper. As I started to expand and do bigger things, I had this real

aversion to canvas. I didn't want to do things on canvas. I wanted to work on paper, partly because paper was inexpensive, but partly because it was interesting.

Also, I felt this strong need to get to know what other artists had done. I spent a lot of time at the library and came across Dubuffet. I was startled at how similar Dubuffet's images were to mine, because I was making these little abstract shapes that were interconnected. So I looked into the rest of his work. And I became very interested in Stuart Davis, because one of his teachers was Robert Henri, and also because he was interrelating his abstract shapes. And I began relating to Jackson Pollock—especially the early abstract stuff—and to Paul Klee and Alfonso Ossorio and Mark Tobey—and suddenly seeing the whole Eastern concept of art, which really affected me. Of course, at the time, I didn't in any way consider myself an equal to those artists. But each of those painters had something I was involved with, so I investigated them, trying to find out who they were, so I could figure out who I was—and where I was coming from.

A lot of things happened at that time. For one thing, working with these guys at the center—doing my job there—I realized that they were mostly black, and mostly from Pittsburgh's inner city. Their backgrounds were completely different from mine. I was working very intimately with maybe five or six of these black guys, and I realized I felt sexually drawn to some of them. With others, it was a camaraderie sort of thing. But what was also important, was that I was being exposed to a whole other culture, which was completely

different from the sixties, the leftover hippie thing that I was still living out.

Then, one day, this seemingly insignificant thing happened. On the way to the local McDonald's, I look down and see this piece of note paper. Something made me bend down and pick it up. On one side of it was written, GOD IS A DOG, in big letters. And on the other side was written, JESUS IS A MONKEY. I don't know why this affected me so profoundly, but it did . . . like, it was this New Wave, Punk thing—this different attitude, which I was starting to be exposed to, but which I didn't completely understand. I mean, it was now 1977, and Punk was already starting to come from England. I was beginning to feel very *un*hip as guys I was working with seemed very hip. I mean, they were listening to cooler music. They were kind of funky. And I, even as a white boy, wanted to be more up-to-date. Somehow, that piece of paper saying GOD IS A DOG and JESUS IS A MONKEY, was like a sign. It was like finding that book by Robert Henri, and it all meant it was time to make a change—a big change! First, I cut my long hair very short. I started going to record stores and I bought the Devo album, *Q: Are We Not Men? A: We Are Devo!* which was considered cool. And I started becoming better friends with the black kids I was working with at the center—and I listened more to Punk music and to black music. I remember a song called "Flashlight," and it was a great song which ushered in this whole new funk music period.

Then, even more importantly, it was the time of the Carnegie International, which was this huge show given in Pittsburgh, at

the Museum of Art at the Carnegie Institute. That year, in 1977, the show was an enormous retrospective by Pierre Alechinsky. I had never heard of him before, and all of a sudden there were something like two hundred paintings and drawings tracing his career. And there were videotapes of him working. And I didn't know *who* that was!

I couldn't believe that work! It was so close to what I was doing! Much closer than Dubuffet. It was the closest thing I had ever seen to what I was doing with these self-generative little shapes. Well, suddenly I had a rush of confidence. Here was this guy, doing what I was doing, but on a huge scale, and done in the kind of calligraphy I was working with, and there were frames that went back to cartooning—to the whole sequence of cartoons, but done in a totally free and expressive way, which was totally about chance, totally about intuition, totally about spontaneity—and letting the drips in and showing the brush—but big! And this huge obsession with ink and a brush! And an obsession with paper! And all those things were totally, but totally in the direction I was heading.

I went to that exhibition I don't know *how* many times. I bought the catalog, I read Alechinsky's writings. I watched the videos of him painting these enormous canvases on the floor! For him, it was like an Eastern thing, with the importance of gravity having great meaning. And he had rigged up these boards in his studio so he could lie on top of them in order to get to the middle of these big paintings on the floor. Well, Alechinsky totally blew me away. From that point on, it changed everything for me.

Right away my work started getting bigger and bigger. I found a place to get paper where they had cardboard tubes, left-over pieces from Styrofoam cuttings, and rolls of paper from printing plants. I'd haul the paper to the arts and crafts center and, after work or during lunch breaks, I'd be doing these paintings inspired by Alechinsky. I began working on the floor. The drips from the paint would be incorporated into what I was doing. My things were different from Alechinsky. They didn't have the fluidity of his abstract line. Mine had a boxy edge to the line—a sort of constrained look, but still liberated.

The main thing that I was acquiring was confidence. I felt I was doing something that was worthwhile. My boss at the center, Rom, always encouraged me in what I was doing—he kept pushing me on. There was a big room in the basement, and Rom let me work there. He said, "You can do your big stuff here." Rom also told the director of the center about my work. Her name was Audrey Bethel, and she really seemed impressed.

As chance would have it, one of the scheduled shows in one of the big galleries fell through. Miss Bethel invited me to exhibit there. So, I was having my first real show in one of the most coveted spaces in Pittsburgh. Besides the museum, it was the most important place to show.

The show was actually in two rooms. In the smaller one, I hung about thirty black-and-white Rapidograph ink drawings. They were very exact and dealt mainly with positive and negative space. In the large room I hung all the big pieces I had done— the floor pieces and also a construction of a

room made out of paper. It was all very close to Pierre Alechinsky, but you could see the seeds of everything that would come later. I consider this my first really important show. And I was only twenty. I hadn't even finished school yet!

KERMIT OSWALD Of course, we all drove to Pittsburgh to see Keith's show. I took a group of friends, and I'm probably the only person who has a record of that exhibition, because I made a black-and-white movie of it. The exhibition was incredible. There was Keith Haring in Pittsburgh, and the culmination of all his ambition was right there, in that exhibition, which just blew everybody's mind. You could tell he was on his way.

DREW STRAUB I was one of the friends Kermit took to Pittsburgh to see Keith's show. Though I was going to college in Kutztown, I didn't really know Keith, because Keith didn't hang out with us. But I knew Kermit, and I used to see Keith's huge paintings in Kermit's house. Keith could paint like a son-of-a-bitch at age seventeen! In Kutztown, I was into minimalism—you know, Conceptual Art and Minimalist Art—so that *not* doing something was, like, a big deal. Anyway, I briefly met Keith before he went off to Pittsburgh. He was really like the long-haired hippie with a braid down his back who was taking acid and going to Grateful Dead concerts all the time. He was doing his

own thing, and wasn't involved with us at all. Several years later we became roommates in New York.

My thing in Kutztown was being bad and doing weird art. Kermit was great! He had fabulous artistic technique, but he never, like, found his niche. Whatever visiting artists would come to Kutztown, he was kind of working in their vein. I guess that's normal for a student. For myself, I was into doing chalk circles. I did chalk circles for five years. It started in Kutztown, because there's so much space and land there—and no traffic. I'd squat and turn and draw circles around my body—and they were based on the Vedic Square pattern—it's an Islamic ritual. I did these chalk circles everywhere, from outside Kermit's studio in Kutztown to outside all the New York galleries. And I did them in front of the SoHo lofts of artists. Sure, Keith knew about these chalk circles I was making on the streets, because for a long time, that was my thing.

KEITH HARING A few months before my show in Pittsburgh, I was realizing that I *had* to sleep with a man. It really started on the trip back from California with Suzy. I had this one *Penthouse* magazine, where they had this male–female thing together. Well, there was this really hot guy doing it with a girl, and I was much more interested in the guy. I kept using him as a source of fantasy.

When Suzy and I got back to Pittsburgh, I began to have the nerve to buy more male magazines—not *Playgirl*, but *Mandate* and *Playguy*, real male homosexual

magazines. Also, I convinced myself that I had to, finally, go downtown, go into a gay bar, and find someone. At the time, I had a job frying chicken and fish in the Diamond Square Market in downtown Pittsburgh. It turned out that the fellow I was working with was gay. He sort of educated me about it. Sometimes, he and his lover and Suzy and I would go out together—we'd have dinner at our place or go out somewhere.

Suzy could see what was happening. But I was still sort of keeping it from her. One night I pushed myself to go and find someone. I went to this bar and just waited until somebody came up to me and asked me to go home with him. And I *went* home with him. At the time, it didn't matter to me what he looked like—at that point, I would have gone home with anyone.

So I went home with this guy—and I liked it. I knew *that* was what I was supposed to be doing in the first place. I didn't even like this particular person all that much. I slept with him a couple of more times. And he turned out to be really sneaky, like calling my house and exposing me to my girlfriend. But the point was, I knew what I preferred and I began to pursue it. Between our apartment and the art center was a big park which had a gay cruising area in it. Now this was 1977 and 1978, before AIDS. For me, cruising became more and more of a thing. I'd become more and more open—and it was a whole planned thing, where you went through this thing of "the look" and followed this or that person. In this park I started meeting really interesting people—and people who were physically attractive to me—and more of what I wanted.

I also started going to the only gay bar on the campus, and there was a cruising spot for cars. And I'd walk around, and meet people, and go with people in cars. I was very quickly falling into the whole thing. And I was happy, because I suddenly found that my art was blossoming as was my sexuality and opportunities seemed at hand. I wasn't sure of any of it, but believed in the fact that whatever was happening was, again, happening for a reason. So I went along with the flow—and I let whatever happened happen.

During my last year in Pittsburgh there was one other really important thing that occurred, and that was my hearing a lecture given by the artist, Christo. After the lecture, he showed a film made about one of his works called *Running Fence*. It affected me profoundly. It fulfilled all the philosophical and theoretical ideas I had about public art and about the intervention of an artist with the public and with real events.

I mean, to see these people—these farmers—who resisted Christo's project getting up early in the morning to see the sunrise reflected in the *Running Fence*—and standing there and saying it was the most beautiful thing they had ever seen! I mean, totally transforming these people, who were farmers! And seeing them affected and challenged by and inspired by a work of art! No matter how contemporary it was, and no matter how alien it was to everything they knew—somehow, that forced intervention by an artist made them see things in a whole other way.

Well, it impressed me incredibly. I had no idea how I could do anything similar—how I could involve other people—how I

31

could engage the public like that. I had no idea how to do that.

So everything was happening at once. And all of it was pointing me toward the realization that I had to make a major break. I needed inspiration, an involvement with peers, with people my own age who were stimulating.

And the whole thing with Suzy. It just wasn't going to work. I mean, I was spending more and more time sleeping with men. She was doing everything she could to try to make me stay with her. She even accepted the fact that I was sleeping with men. But I could see she was going kind of crazy. It just made me feel terrible. But I told her I was leaving—I had to. And there were fights in the streets, and she'd come crying after me—and clawing at me. There were horrible, horrible things in the street, because she *was* in love, and she didn't want to let it go. So it was a really, really difficult and horrible breakup.

Obviously, the only place to go was New York. It was the only place where I would find the intensity I needed and wanted. I wanted intensity for my art and I wanted intensity for my life. In the meantime, I had looked into schools, and the one that seemed incredibly interesting to me was the School of Visual Arts. I had been out of school for two years now, and I had no home support, and I had income tax forms to prove it, and that made me eligible for grants and student loans—which is how I paid for my schooling in New York. For me, 1978 was a totally fresh beginning.

II

1978–1984

KEITH HARING My father drove me to New York, where my first residence was in the McBurney YMCA on Twenty-third Street near Seventh Avenue. My father left, and I unpacked my things and set up my stereo. At this point I knew not one person in New York. I had arrived on a Friday and had the weekend ahead of me. School would begin on Monday.

On Saturday night I ventured out for the first time. I walked around, discovering the neighborhood. I wandered down Seventh Avenue as far as Fourteenth Street, and there discovered a gay bar called The Barbary Coast. I stood around and had some beers but I didn't meet anyone. That was the extent of my excitement on that first Saturday night.

The next morning I got up and walked much further down Seventh Avenue. All of a sudden, I found myself in the middle of the West Village. I was on Christopher Street, and it was like landing in a candy store or, better, a gay Disneyland! So I walked west on Christopher Street and ended up at the Hudson River piers. It was at the end of the summer and still warm, and the piers were full of people hanging out. I was completely mesmerized—and shocked. I ended up meeting someone on the pier. He wasn't all that attractive, but he was interesting. So we went back to his apartment and we played around. His place was on Tenth Street right off Bleecker. At one point, he introduced me to his landlord, and to some of the other people living in the building. It was all very friendly. After talking to his landlord, who was a wonderful old gay guy, I decided I'd like to live there too. So I became that kid's roommate. The next day, a bunch of his friends came to the YMCA and helped me move my things to West Tenth Street—I had lived at the "Y" only two or three days.

The day I moved was also the day school began. The School of Visual Arts was great. I took basic foundation classes, which meant classes in drawing, painting, sculpture, and art history. And everything was very exciting at the beginning—the apartment, living in the Village, and going to school. And the whole gay thing was everywhere. I mean, it was almost too much. You couldn't go to the post office without cruising or being cruised—without being totally aware of sex.

So I fell into this whole thing very easily. And remember, this was 1978—again, there was no thought of AIDS. The scene was still that you went from bar to bar, and little by little I discovered where the interesting gay places were, including the back-room bars, like The Stud, where they had porno movies playing and a more or less dark room with people groping and having anonymous sex. In the beginning this was all strange to me, but ultimately it became a way of life—and it lasted for a long time, certainly for the first several years in New York. It just became part of the nightly routine.

JEANNE SIEGEL I'm the head of the Fine Arts Department at the School of Visual Arts, and I don't really recall interviewing Keith when he first came here. But I do remember him distinctly working in the classrooms. At that time, we

had an area on Twenty-second Street between Second and Third avenues which was a marvelous space that opened into the street. We kept the doors rolled up so you could work inside and outside.

My first vision of Keith was in that space, hanging these enormous scrolls on the doors of this area. He was into this idea of large pieces of paper coming down on which he drew these big patterns. At one point, he came to me and asked to use a certain other space. I said, "What are you going to use it for?" He said he wanted to make an installation. Well he ended up covering every inch of that space with his patterns—the walls, the ceiling—top to bottom—just these patterns, and it was spectacular.

Right from the beginning the thing that struck me about Keith was that here was a young man who was very directed and very determined. He knew what he wanted. He came in and worked hard. He was serious. There was no fumbling around. He knew what he wanted to do and then he did it. And he was producing eccentric works as compared to the other students.

I might add that his grades were quite good. In Performance Art with Simone Forti, he received an A, as he did in Sculpture with Barbara Schwartz and with Margerie Strider, and in Video Art with Barbara Buckner. With Lucio Pozzi, who taught a painting class, he received a B. He took courses in Art History with Connie Beckley and courses in Semiotics with Bill Beckley. He also took a course in Performance Art with Keith Sonnier. He took Theory Art Workshop with Joseph Kosuth, a course in Aesthetics with Tim Binkley, a course in

Avant-Garde Film with Amy Taubin, and a Video Art Workshop with Mary Lucier. In most of these courses he received A's.

With Keith Haring, it was a blending of talent and effort—he was a compulsive worker. And he got along with people and made friends. I remember he first met Kenny Scharf here and Keith was always pushing Kenny. He was wonderful in that he was always trying to make people aware of Kenny's talents.

KEITH HARING At SVA, I met Kenny Scharf, and he became one of my closest friends. Kenny was cool because he would continually find things in the streets and drag them to school and into the sculpture studio, especially abandoned or broken television sets, electronic tubes and all that stuff. He had this hot glue gun and he would just glue all these things together. So there was Kenny—this nut—gluing all these things—and for whatever reason, we instantly hit it off.

Kenny had just come from California, where he had also been a hippie. He had long hair and had been a surfer, and had gone on to study architecture in Santa Barbara. Kenny had come to New York for similar reasons as mine—to look for peers, and to find something different.

KENNY SCHARF I guess Keith and I sensed the craziness in each other and kind of veered toward each other at the School of Visual Arts. We met in Barbara

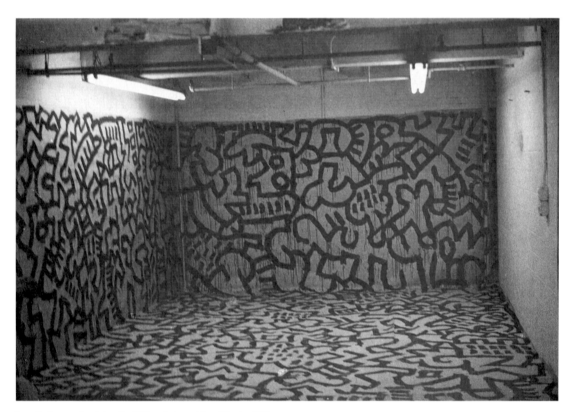

Installation at the School of Visual Arts. New York. 1978.

Schwartz's sculpture class, and right away I remember feeling he was the only interesting guy there. So we began hanging out together.

Keith was incredibly directed—his energy was phenomenal. He always knew exactly what he wanted to do—and just did it. And he really upset people at SVA, because he took advantage of just everything he could. While everyone was just going along, Keith would inquire about an empty room so he could do something in there—cover it with drawings or whatever. If he was in a student show, he'd make hundreds of Xeroxes announcing it and hand it out to everybody and put it up every-

where. Some people thought, "What *is* this guy? He's just promoting himself." A lot of people were really appalled by Keith Haring.

BARBARA SCHWARTZ

I rarely get involved with my students, but Keith had something special right away. Keith had problems with the sculpture class he was assigned to. I said, "Come to my sculpture class." And he came, and that's where Keith met Kenny Scharf.

When I found out he had come from Pittsburgh, I responded right away, be-

cause I also went to school there—at Carnegie–Mellon. Initially, Keith seemed like this poetic lost soul. Mostly, he'd do lots of drawings. He'd roll out these rolls of paper and fill them up with endless drawings. I mean, *horror-vacuii* had no better example than Keith Haring! And he worked nonstop. His stuff had a syncopation, a kind of beat he must also have found in the clubs he was going to at the time. Keith was never truant. He did not shirk responsibility. He had inner direction. But he was also responsive to outside ideas. I'd give assignments, like "Stand in one spot, then return to that area at different times of the day and night, and develop imagery." It was a way of getting students to keep notebooks. Keith did all that. But he also was on his own beam. One time, I said to the class, "Choose a subject and develop it." Keith brought in 300 drawings of penises! And they were good. They were witty.

At the time, Keith's strong suit was line, and his weak suit was color. But when he came into my class, it was instantly clear to me that he had a tremendous reserve of natural talent—he had this inner muse, and he had this need to work—always. As far as ambition is concerned, I would say that Kenny Scharf was always more ambitious than Keith. Kenny had his mind on a career. Keith was more of a primitive. Kenny had a more conscious desire to succeed. But they were both adorable in class—very endearing. They were good energy to have around. I think that what Keith got out of the School of Visual Arts was a sense of community—a sense of other people who participated in a like way. Keith always loved interaction.

KEITH HARING One of my teachers at SVA, Barbara Schwartz, once assigned us to make a drawing of any student in the class, and I immediately gravitated to this one girl, whose name was Samantha McEwen. She had incredibly beautiful long hair and she was from England and she seemed wonderful. So we started drawing each other. I was petrified, because I didn't want another girlfriend—I didn't want to fall in love. I mean, everything was perfect about her. But I immediately started the relationship from another standpoint—I just wanted us to be friends.

SAMANTHA McEWEN The picture Keith drew of me in Barbara Schwartz's drawing class was completely abstract. I was hoping he'd draw something really flattering. I said, "Can I see it?" And it was this really bizarre thing—like a Picasso profile. Keith was really sweet but, for some reason, I found him utterly intimidating.

From the beginning, he was leagues ahead of anyone else in our year. He had the ability to speak his mind—a confidence, though not particularly verbal, that was demonstrative in a completely extraordinary way. Within a month of being in classes with him, it was completely clear that his level of concentration was incredible. Amazingly, his whole focus wasn't really on the classes per se so much as working with outside influences which were incredibly far-reaching. Keith seemed to have a big problem with staying within the confines of his classes. In a way, he took over the school.

I was there only nine months, but by the time I left, you couldn't open a broom closet that he hadn't painted or transformed. You couldn't walk down some passage that he hadn't employed for some video location. I mean, it was completely out of control. Nobody knew what to do with Keith Haring!

KEITH HARING At SVA I began working obsessively. I mean, this was the first time I was in a school full-time—and I just worked.

I was also kind of combining what was happening at night and what was happening at school, which meant that the subject matter of many of my drawings was completely phallic. All those little abstract shapes I was doing became completely phallic. It was a way of asserting my sexuality and forcing other people to deal with it. Also, there were a lot of guys—kids who had just come from high school, from Long Island and New Jersey—who didn't really know why they wanted to become artists. Because of my drawings, and because of how friendly I was, they were sort of forced to respect me and deal with me. I consciously flaunted the fact that I was interested in dicks. So I was becoming friends with these kids through these drawings, and it wasn't about making sexual advances, which I didn't. It was really that I spent 90 percent of my time being totally obsessed with sex and that became the subject of my work.

Sex became the subject of a lot of my video work as well. The first tapes I made were all self-referential. The first time you see and hear yourself on video—and look at yourself from outside of yourself—is an incredible psychological lesson. Since then, I've maintained that schools should teach video *not* as a video class, but as a psychology or philosophy class. Video really gives you a whole other concept of self and ego, and an objective way of looking at and being comfortable with yourself in a way that might not have existed before. Especially important is the way the camera is set up, so that it's live and you react to what you're seeing yourself do at the same time that you're doing it. I mean, you can see the back of your head while you're doing something else—you can see yourself from the side. So I looked at video, and started thinking about the meaning of this concept of self and ego.

39

KEITH SONNIER During the late seventies I taught a class at the School of Visual Arts having to do with performance and media—it was on how to approach art making from a performance intent. Most people didn't really understand what I was getting at until much further into the class. Keith Haring understood what the class was about—instantly! By that time, Keith was already an artist.

At one point, Keith brought in some videotapes. They were of a very sexual nature—really incredible! It was very interesting, because everybody was sort of shocked by the content. The images were of himself—his body parts—his cock and ass. It's curious that by having that kind of content in the media, it completely wipes

out all of your obsessions about video. You know, the narcissistic eye—the self-indulgent kind of narcissism or the voyeurism.

So we talked of television as this kind of narcissistic tool. Of course seeing these works by Keith was very interesting, because earlier on, I myself worked between two mirrors that were two meters square, and I filmed in this kind of infinity-trough. In other words, I too became interested in television as a narcissistic vehicle. Later I moved to other aspects of television—the political aspect, the transmissional aspect, the computerized aspect of it.

Anyway, the class met once a week, and, basically, I only remember Keith's work in it. I liked Keith right away. He always had this "just hatched" look which he still has. And, there's a very tender side to Keith. I remember, very recently, having Thanksgiving dinner with Alba and Francesco Clemente. Keith was the only person sitting with all the children—all the little ones. You saw him basking in a kind of special comfort. It was delightful to watch, and very moving.

KEITH HARING At SVA, I was producing lots of things in quantity. Like, I found a place where someone had put out on the street these huge rolls of paper, which were about nine feet tall and they turned out to be photographic backdrop paper. I dragged those rolls back to the school, laid them down on the floor in the sculpture studio, and proceeded to do these ink paintings similar to Alechinsky's, but bigger. This time, though, I became

very intrigued with the *act* of doing this. It was the idea of making the movements I was doing into a kind of choreography—a kind of dance. I was thinking that the very *act* of painting placed you in an exhilarated state—it was a sacred moment.

Eventually, the whole choreography idea got sort of formalized when I met this really interesting modern dancer, Molissa Fenley. I had heard about Molissa from Kermit, because Molissa had been invited to go to Kutztown to work and perform. I first met her in Kutztown, because she was hanging out with Kermit and Drew Straub. Also, she had a boyfriend who lived in Allentown. All this must have been in 1977. Then, I met her again in New York, and we became friends and did some videotapes together.

MOLISSA FENLEY Keith, Kermit Oswald, Drew Straub and I became really close friends back in Kutztown, where I had been invited to be a guest artist by James Carroll, who ran the art department at the University of Kutztown. When I got back to New York, Keith would come see my dance performances. Then, by the end of 1978 while Keith was at SVA, we began to collaborate. It was interesting, because at the time, I thought that dance and video weren't really meant to be together—and, of course, that was before Twyla Tharp and Charles Atlas were doing really interesting things with video.

Keith wanted to put video and dance together, and we worked on these pieces, and they were tremendous fun to make. As it

turned out, Keith had just finished a video piece he called *Now, Now, Now!*—something his mother always said—and it was this tape loop that he played over and over and over, and it became part of our video. We made this video at SVA very late one night, because it was the only time Keith could get a free moment with the camera. Anyway, it was a piece I choreographed with a dancer called Jane Frost. We were responsible for making our own music—we had maracas, little ankle bells, little sandblocks, and we would clap. So it was all about rhythmic cacophony. Keith videotaped the whole thing. Juxtaposed with the dancing he incorporated shots of me talking—mouthing words—and showing a headshot of me. Then there was the loop of this voice repeating "now, now, now!" And it was just great! I mean, for not knowing anything about dance, Keith came to it with a fresh and very caring mind.

At the time we collaborated, Keith was really into performance art. I remember a performance piece he did at SVA, which was really intriguing. He had found this little room—it was like a cell—and had painted it all white. And he sat in this room dressed completely in red, wearing a blindfold. People could enter the room, and Keith had provided seating along the walls. So you'd watch this person who was really being totally inside himself—and Keith would sit there absolutely still and blindfolded for three hours at a stretch. I remember one time going in, sitting down, and watching him. Of course, he didn't know I was there. Then, when everyone was out of the room, I went over and took his blindfold off. So he took a rest and we had a nice chat!

The thing about Keith was that he was completely curious and totally non-judgmental. He just wanted to try everything, do everything, know everything. What I liked so much about him, was that he was basically this incredibly energetic street kid. And I always say, once a street kid, always a street kid.

Dancer Molissa Fenley. New York. 1978.

41

KEITH HARING My first year at the School of Visual Arts was coming to a close. It was 1978 going into 1979. I never stopped working and I never stopped producing. I kept absorbing everything, because tons of things were coming at me from everywhere. I was going to galleries and to museums. At night I was going to the bars and to the baths. At school, I was beginning to get noticed. The fact is, I was already stepping on some people's toes, and making some people jealous, because I was starting to be too active and doing too much.

But I was making tons of drawings, and I wanted people to see them. I would sometimes take my drawings from the sculpture studio and hang them in the hallways of the school. One time, the drawings were taken down and torn up and just left on the floor. I picked them up and hung them back with the torn pieces just dangling from the walls—they looked even better!

And I was doing videotapes and performance pieces, and I had begun to do a lot of writing. I also met tons of people. So by the end of that first year, I was asserting my presence in the school, and it pretty much continued in that way.

It was around this time that my friend Drew Straub came to visit me in New York. He had been going to the University of Kutztown, and he was really a brilliant kid, heavily into post-minimalism and post-conceptual art. Well, he decided he had had enough of Kutztown, and wanted to live in New York. I was still living on West Tenth Street, but Drew and I decided to find a place together. We found one in the East Village. Just by coincidence, the building was directly across from the Club Baths, which I had been going to all along. The baths were literally twenty steps from my front door.

Drew Straub. March 1982.

DREW STRAUB I moved to New York, because I got a job being the assistant to this really great sculptor, Kent Floeter. (He showed at Mary Boone's gallery for a while until she went off the deep end for some of her other artists, and he left the gallery.) So, I helped install Kent's shows and I'd get his slides together—and this was, like, 1979. Keith and I decided to become roommates. We were the same age, and we were both into art. Neither of us admitted to the other that we were gay. That was the surprise. But we'd run into each other at the Club Baths, which was just across the street from where we lived. Keith was there a lot. I was there a lot too,

I must admit. But I was never involved with Keith sexually. We were friends. I mean, we would go out with the same people, and we would occasionally fight over the same people, but we never had anything together. Later, when I went to share a loft with Molissa Fenley, I'd end up sleeping with Kenny Scharf and John Sex and Keith Haring—the four of us would be in bed together. But it was never, like, just me and Keith. It was pretty wild back then.

What was it like living with Keith? Well, he wanted to be a famous artist. I already thought he *was* a great artist. And, see, he was into a lot of things. Like, one of the things was to go and see the B52s. We went to see them all the time. It's funny, the B52s are a big hit right now, and they have the number-two song in the country, called "Love Shack." But back then they were just this fun band. They had big hair, loud clothes, and they were really silly. You could dance to their music like crazy.

Keith would be sitting in our kitchen and he'd put on this 45 of the B52s' "Rock Lobster"—and he'd sit there and draw, and he'd leave that record on for, like, eight or ten hours! And he'd draw these penises in a kind of all-over pattern—and then ended up looking like butterflies. I've got his rudest art. You know, the stuff that nobody would show? Well, he gave it to me, and I've got it. These days, I always wonder what my maid thinks when she looks at this Keith Haring painting of a spaceship and the spaceship zapping a dog and the dog getting fucked by a man and the man exposing his penis to the crowd! Anyway, we lived together on First Avenue between First and Second streets for about a year.

KEITH HARING About the baths—especially the Club Baths, where I used to go all the time: The Club Baths weren't really private clubs. Anyone who could pay for a locker belonged. So they had Buddy Nights on Monday and Friday, which meant that two people could get in for the price of one. People would line up outside, and you could just meet someone on the line and say you were their buddy, and by the time you got to the window, you paid a single admission. You didn't necessarily have to stick to the guy you walked in with. What it meant was that for five bucks you could go inside, walk around wearing a towel, and meet anyone you wanted.

The more I went to the baths, the more I preferred this atmosphere to the cruising scenes at the bars. First of all, everyone at the baths was sort of on an equal level. I mean, everyone was just wearing a towel, so you weren't judged by what you were wearing, and there would not be the same attitude you encountered at the bars. The point is, all class distinctions were gone. You were a common, united, connected group of people. And I liked that situation. And it seemed I did better cruising people without clothes than *with* clothes! Also, in the baths, it was a totally unrealistic situation. When you left, you were back in reality. You left that unreal part of you there—it didn't have to be with you all the time. So I preferred the baths more and more.

KEITH HARING Almost immediately upon my arrival in New York in 1978, I had begun to be interested, intrigued, and fascinated by the graffiti I was seeing in the streets and in the subways.

Often I'd take the trains to museums and galleries, and I was starting to see not only the big graffiti on the outside of the subway trains, but incredible calligraphy on the inside of the cars. This calligraphic stuff reminded me of what I learned about Chinese and Japanese calligraphy. There was also this stream-of-consciousness thing—this mind-to-hand flow that I saw in Dubuffet, Mark Tobey, and Alechinsky.

The forms I was seeing were very similar to the kinds of drawings I was doing, even though I wasn't making the voluminous letters and the aggressively fluid lines, which were done directly on the surfaces, and without a preconceived plan. They were really, really strong. Well, I felt immediately comfortable with this art. I was aware of it wherever I was. So the time spent en route to a gallery or to a performance or to a concert was just as interesting and educational as that which I was going to see. Sometimes I wouldn't even get on the first train. I'd sit and wait to see what was on the *next* train.

Graffiti were the most beautiful things I ever saw. This being 1978–79, the war on graffiti hadn't really begun yet. So the art was allowed to blossom into something amazing, and the movement was really at its peak. These kids, who were obviously very young and from the streets, had this incredible mastery of drawing which totally blew me away. I mean, just the technique of drawing with spray paint

is amazing, because it's incredibly difficult to do. And the fluidity of line, and the way they handled scale—doing this work on these huge, huge trains. And always the hard-edged black line that tied the drawings together! It was the line I had been obsessed with since childhood!

So I was exposed to all that and there was so much happening, you just couldn't keep up. For one thing, kids from all over America were coming to the East Village—and the streets really came alive. This was a whole new generation superseding the previous generation—the hippie culture that had fizzled out.

The whole punk-rock scene was starting up—it was coming over from England, and a lot of kids came to New York wanting to form bands. There was a moment there when everyone you met was starting a band! That was partly because there was a whole sort of artsy side to the New-Wave music scene, and it was personified by the Talking Heads, because they had all gone to art school in Rhode Island and then started a band in New York. And there was CBGB's on the Bowery, which was this rock place where everyone like the Talking Heads, Patti Smith, Blondie, and the Ramones played. Because of CBGB's and the new music scene, there was this new climate where anyone could participate.

And, there was a whole new nightclub scene that blossomed at the same time. Even before I had moved to the East Village, I had heard of the Mudd Club down on White Street. Hurrah's existed uptown. The Danceteria had opened on Thirty-seventh Street (where I worked as a busboy for a while), and then there was Club 57,

44

At Club 57, back row from left: Katy K., Keith, Carmel Johnson Schmidt, John Sex, Bruno Schmidt, Samantha McEwen, Juan Dubose, Dan Friedman. Front row from left: Kenny Scharf, Tereza Scharf, Min Thometz Sanchez, Tseng Kwong Chi. New York. c. 1980.

which became *the* neighborhood hangout. It was totally unique, and a whole bunch of us kind of ran it. It was called Club 57, because it was located at 57 St. Mark's Place in the East Village. It was in the basement of a Polish church, which had a small stage and was also used as the social hall for the church. We hung out there almost every night, and it could get pretty wild. But for me, Club 57 not only meant dancing and drinking and sex and fun and craziness, but the beginning of a whole career as the organizer and curator of some really interesting art shows.

Kenny Scharf at the Mudd Club. New York, September 1980.

DREW STRAUB It was such a *Zeitgeist!* The Club 57 scene could never happen again. We were all so young! Just twenty or twenty-one. Ann Magnuson may have been twenty-four, but she was like our mom. And we just wanted to have fun. In retrospect, it was such a brilliant bunch of people. The Mudd Club was like that too, except we were creative and they were destructive. At the Mudd Club it was all about how bad you could be. But at Club 57, it was all about how much fun you could have.

Every night was different. On Tuesdays, it was Monster Movie Club. So you'd go over at 9:00 P.M. and they'd show the really worst monster movie that they could find. And everybody would scream and drink and carry on. I was the house critic of the movie, and whatever had to be said about it, I would say it. I was known for that, and it used to gain me free admission. Everybody there was either living together or sleeping together. It was great!

KENNY SCHARF At Club 57 there were drugs and promiscuity—it was one big orgy family. Sometimes I'd look around and say, "Oh, my God! I've had sex with everybody in this room!" It was just the spirit of the times—and it was before AIDS. We'd also go to the Mudd Club, but Club 57 was really our turf. We classified the Mudd Club as being cool, while we considered Club 57 to be groovy. You see, we weren't afraid of making fools of ourselves. We liked making fools of ourselves and we were very successful at it!

SAMANTHA McEWEN At the School of Visual Arts I met all my friends. There was Keith, who I really adored, and there was Kenny Scharf, with whom I would have an affair, and there was Bruno Schmidt, who came from Brazil—and I had a huge crush on Bruno. And there was Bruno's wife, Carmel, who was a model in our drawing class. And I also met John Sex, who was in my printing class and who, in a way, was very like Keith, because he was far ahead of everyone else. And, through these people, I met Drew Straub and Ann

Magnuson, and we were this group who became best friends. Every night, we'd be at Club 57.

But that period—the end of the seventies—was so loose, so free! Individually, everyone in our group had fantastic identities. And the unclarity of being young in an adult world just dissolved! Everyone was strong, yet we could each be what we wanted to be. We all looked after each other. There was an incredible feeling of security although almost none of us had any money. I mean, Keith had almost no money at all. And Club 57 was run on a shoestring. It was run on sheer energy.

think you're the best one here." And we started a conversation—and it was Keith.

We had numerous theme nights. One was a Beatnik Night, and Keith came in with some bongos and a beret and recited poetry. On another night, Keith organized an erotic art show. Now, this was in the basement of a church, and the place was now littered with erotica. As luck would have it, on that particular night the rector of the church, whom we called Bishop John, came to see the club. I thought, "Oh, my God!" because this erotica was *everywhere* and there was a giant silver phallus at the entrance!

Actually, quite a few people complained

ANN MAGNUSON I ran Club 57 for two-and-a-half years. The Mudd Club was always jealous of us, and Steve Maas, who ran it, often asked us to come and do things there. He was jealous of our enterprise because it was so creative. You see, the Mudd Club was more into coolness and being hip and shadowy and mysterious, while Club 57 was about being loud and bright and colorful and kooky and silly—and doing mushrooms.

A lot of people started hanging out there, and quite a few of them attended the School of Visual Arts. Keith Haring was the first person I met from that group. One night, we had poetry readings. I was tending the bar and being basically bored when this fellow got up on stage to recite a poem. It was a free-form chanting of sorts. I was intrigued, because it was much more interesting than anyone else's poetry that night. So afterwards I said something like, "I

Ann Magnuson at the Mudd Club. New York. 1980.

to the church about our rowdiness and noise and such. They'd talk to Bishop John and say, "Why are you letting these evil people in your church?" And he'd say, "That's where evil people *should* be—in a church!" The fact is, at Club 57, every night was Halloween. And the charm was that it was totally illegal. You weren't supposed to be serving alcohol, it wasn't designed for anything more than little church meetings. But here we were, being completely spontaneous, not really looking for any greater reward than the sheer fun of it all!

KEITH HARING A lot of people gravitated to Club 57 and they became the central figures of the scene. At the time, there was Kenny Scharf, John Sex, Drew Straub, and me, and we became inseparable. Drew was my roommate and by this time he was working at the John Weber Gallery, when Weber was still at 420 West Broadway. He had also worked for Larry Gagosian, when Larry was partners with Annina Nosei and had a space on West Broadway. Drew was serving drinks there when I first saw a David Salle painting, and when David had just moved here from California. And I also saw my first Julian Schnabel painting, when Julian was just being recognized as a painter. And it was before the Mary Boone Gallery ever existed.

Well, into our circle came Tseng Kwong Chi. One day, in the spring of 1979, I met Kwong Chi. He was standing on a street corner on First Avenue and Fifth Street, and he was wearing these really high white corduroy pants. He was so eccentric looking that I knew I had to meet this person. I ended up sort of cruising him, but then we became friends. He showed me his photographs, which, at the time, was a series of guys in stripper outfits called *Slut for Art*. I remember a photograph of this male Puerto Rican bodybuilder—this huge guy in this little feathered stripper outfit. Kwong Chi asked if he could do *me* in a stripper outfit. I said, "Of course!"

So Kwong Chi came into the picture, and he was part of the Club 57 scene. We also had a female deejay, Dany Johnson and her girlfriend, Ande Weyland, and they were also a part of our group. There was a very open sexual situation because, at that point, everyone was pretty much bisexual anyway, so it didn't really matter whether you were gay or not.

TSENG KWONG CHI I met Keith on First Avenue, not far from where I lived. We had a brief conversation on the corner of the street. We exchanged phone numbers. Soon after, I got a call from Keith. "Would you like to go to a poetry reading tonight?" he said. I thought, "A poetry reading? Oh, dear!" But I said OK. He gave me the address, and when I got there it was in the basement of a Polish church on St. Mark's Place. And there were all these people drinking and dancing and carrying on. I thought, "This isn't at all what I expected." So I made my way toward the stage and there was René Ricard reading poetry and being all over the place

and very exaggerated. I thought, "Gee, I never saw anything like *this* before."

I met up with Keith, and he handed me this Xerox with lines of poetry on it. He said, "You're going to have to help me read my poem on the stage." I said, "What? I've never done this before!" He said, "Just read it. It's no big deal." So we went on stage and we took turns reading Keith's poem, which made no sense at all, but I had the greatest fun. And that was my introduction to Club 57.

I was born in Hong Kong, where I attended a strict Catholic school, and where I was raised very traditionally until I was sixteen. My father was an executive in a shipping company, and my mother was an English teacher. For various reasons the whole family emigrated to Vancouver, Canada. I went to the University of British Columbia. I have a sister, Muna Tseng, who is a dancer and choreographer, and one of the first choreographers to have collaborated with Keith, and a younger brother, Raymond. I studied physics at the University as my parents wanted me to be an engineer. However, I wanted to be an artist.

Several years later, I decided I had to go to Paris and become a full-fledged artist. I applied at the Académie Julien and submitted four years of my artwork. Even though I was accepted, they said, "This is nothing. You have to start from scratch." And so I did. But very soon, I discovered that the Académie Julien had this great photography department which was wonderfully equipped but little used by anyone there. And there was this really marvelous photography teacher, and he had

Tseng Kwong Chi. New York. October 1982.

almost no pupils. Well, I really got into it—and this teacher inspired me to become a photographer. After working with him for three years, I graduated with honors in photography.

In 1979 I arrived in New York to pursue a career in photography. It was very difficult finding jobs. Someone recommended that I go see an art director named Dan Friedman at the rather important commercial art agency, Pentagram. I went to see him and he turned out to be very nice. He couldn't offer me anything, but on that day we started our friendship. Later, Dan Friedman would become an interesting link in Keith Haring's career—and so would I.

49

DAN FRIEDMAN I came to Club 57 through Kwong Chi—but I was out of place because I was in my late thirties, and everyone there was more than ten years younger than me. I had gone through the seventies as a successful graphic designer. I went to the same college in Pittsburgh as did Andy Warhol—the Carnegie Institute of Technology. Then I went to school in Europe—in Germany and in Switzerland—and I did that for about four years. Then I came back, and started teaching at the Graduate School of Art at Yale University. I did that for three years, then went to teach at the State University of New York at Purchase, which at the time was a completely new university.

I got frustrated with teaching and decided to pursue my professional career as a designer and was offered a position in New York to oversee the redesign of the corporate identity of Citibank. I designed the Citibank logo, along with identities for lots of other corporations. In the late seventies, while I was doing this sort of work, I teamed up with a British firm that opened an office here in New York. It was called Pentagram.

But I found a degree of frustration in my own personal need to express myself, so what I would do was work all day, then come home and paint my walls—I would express myself on my walls—pushing the possibilities of what you could do in a rented environment by personalizing it in some way. I was doing this at the same time graffiti artists were expressing *themselves* on the city walls. At one point I realized I was having more fun at four o'clock in the morning painting my walls and hanging out at clubs than I was during the day—so I thought, why can't I reverse this? Why not do what I like during the daytime? So I proceeded to work toward that goal ever since.

I must say, Club 57 was very special. What I couldn't get over was that these kids were all plain decent kids but, when perceived by most people, were considered to be deviants or highly misguided or "sick"—or something. But I didn't see that in them. When it came to art events, Keith Haring was the leader of the pack there. By that I mean when it came to a Day-Glo exhibition or a black light exhibition. But with other events, say, Ann Magnuson would organize—like Celebrity Bingo Night—where a whole activity would occur around one particular theme, and everyone would arrive fitting into that scenario, Keith was certainly a willing participant but not a leading participant.

JOHN SEX John Sex isn't really my name. My real name is John McLaughlin, and I'm from Long Island. I went to School of Visual Arts to become a graphic designer. That was before I was John Sex. At SVA I met Keith Haring and Kenny Scharf. There was this little gallery space on the first floor, and Keith had painted it from floor to ceiling. I looked at it and said, "This person is really doing something!" As we all know, art school is made up of people who are mostly just taking up space. So when I looked at what Keith was doing, I said, "This is a *doer!*" Kenny Scharf was also a doer and very ambitious. He always had his finger on the ball.

My thing at SVA was doing graphics and posters. A lot of the posters I made were for parties or shows in which we were all participating. But they were also about promoting myself. I'd do these posters of myself that said, "Coming Soon!"

After a while, I gave up the graphic stuff, because I wanted to be a performer. My first performances were at Club 57, where Keith and Kenny and Drew and a whole bunch of us were hanging out. At the time I was very into the Dada movement, and I read about all those Dada artists creating this really fun scene. They became very historical. So I started putting together some events at the club, like getting people to do things they weren't known for. I'd ask a painter to tap dance or a poet to sing. And I put together crazy burlesque shows. The club was so neat! Ann Magnuson ran it, and she put on shows that were so good that the Mudd Club asked her to put them on *there!*

Anyway, my own performances at the club were a lot of tongue-in-cheek songs and numbers. I'd sing stuff that was a combination of Tom Jones and Bobby Darin. First, it was all parody, but then I got more serious, and I made a couple of records and a lot of videos—and I started traveling around. I got into disco music, and I talked to the audience and made jokes. And I got famous. People described me as being slightly absurd, because I had this huge, oversized blond pompadour, and I'd wear dinner jackets and pants that would light up. People just loved that. I wasn't exactly a comedian, but I made people laugh.

So I performed at Club 57 and at the Mudd Club and at Danceteria. One time I performed at Paradise Garage for Keith's birthday. Madonna was performing there too. Much later I performed at Palladium, and for me that was the height. It was in 1985—and after that it was all kind of downhill. But Keith was always around. He was everywhere and he had this amazing energy and his stuff had this art energy and we were always together. It was me and Keith and Drew and Kenny . . . it was the four of us!

BRUNO SCHMIDT I met Keith at the School of Visual Arts. My first glimpse of him was on the roof of the school building where he was photographing a huge painting of his on the street. The painting was so huge it could only be photographed from the top of a building.

I had just arrived from Brazil, where I was born, and my English wasn't all that good. To me, Keith was my idea of a quintessential American. Here was this guy with these big sneakers and long skinny legs—and he turned out to be a real character—and right away I loved him.

At the time I wanted to be an illustrator—a commercial artist. I didn't want to be an artist with a capital A, because I thought that was very pretentious—very arty, very boring. But when I showed Keith my work, he said, "But this is art too!" He made me see things in my work that I couldn't see. He was very supportive of what I was doing.

When I met Keith, he was the poorest of the poor. But then, nobody had money. But we certainly had fun! Especially at Club

Carmel and Bruno Schmidt. New York. Early 1980s.

the world. From then on, we always had a special rapport.

I must say, I fell in love with Keith. A lot of girls fell in love with Keith, and that's because he represented a sort of archetypal male. He had those heroic qualities of pushing for what's good and true and fair. And he was a real boy! And he always had this incredible sweetness and generosity. There was no question about any relationship with Keith, because I was with Bruno—it wasn't on that level—it was much more of a falling in love of souls.

57. We'd go there, and Drew Straub was at the door, charging according to who was coming in. If it was somebody he didn't like, he'd say, "It's fifty-five dollars." And if a friend walked in, he'd say, "Oh, give me ten cents." And then the party started, and after two hours everybody would have to go out because it got so smoky—there was absolutely no ventilation and the ceilings were very low. You just suffocated.

CARMEL SCHMIDT I remember meeting Keith at a Klaus Nomi concert at Hurrah's. All the Club 57 boys were there—and they happened to be right around me. Drew Straub and John Sex and Keith— they were all embracing —to put it nicely— and right in front of me. So there was this wild scene, and finally I said, "Let's dance!" And Keith and I danced and afterwards we had this really intense talk—about America, about culture and what was happening to

KEITH HARING As I was coming to the end of my time at the School of Visual Arts, there started appearing on the streets this graffiti which said SAMO. It appeared for almost a year, and I had no idea who this person was, but I began to religiously follow the work, because it was appearing where I was living, walking, and going to school. It was the first time I saw what I would call a literary graffiti, one that wasn't done just for the sake of writing a name or for making a formal mark. These were little poems, little statements—they were non sequiturs—and they were conceptual statements—and they were on the street. For me, it was condensed poetry which would stop you in your tracks and make you think.

Well, SAMO, which some said stood for "same old shit" turned out to be Jean-Michel Basquiat. I had heard that Jean-Michel was attending an alternative high-school program, that he was part of the Mudd Club scene and that he lived wherever he could

crash. Actually, I still hadn't met Jean-Michel—I had only heard about him. Well, one day a kid came up to me just as I was going into SVA, and he asked if I could walk him through, past the security guard. He wanted to get inside the school. I said, "Sure," and we walked through. I disappeared into a class. When I came out an hour later, I noticed there were all these fresh SAMO poems and tags in places they hadn't been an hour ago. I put two and two together and realized that the person I had walked through was Basquiat.

Later that day, I ran into him again and I asked him if the tags at SVA were his, and he said yes. Jean-Michel was a light-skinned black kid. I forget whether he wore dreadlocks or not, but I know his hair was severely cut. He always stood out as being uniquely different and interesting. It turned out he had already met John Sex and Kenny Scharf, and, like the rest of us, was working on these color Xeroxes, because color Xerox machines had just come out and everyone was making them. Jean-Michel would later try to sell his Xeroxes and postcards in front of the Museum of Modern Art.

From the moment I saw Jean-Michel's drawings and the things he did in the streets, I knew he was a great artist. The early drawings are really simple, yet aggressive and intense. A lot of them had this scrawling language at the bottom, and there was something hauntingly real about them. Somehow, the messier Jean-Michel's things were, the better they looked.

I began seeing a lot of Jean-Michel—I'd go see the things he was working on. He never really had a studio, but he'd move from one place to another, staying wherever he could stay. He had a real disdain for material things and objects. He treated them with no respect whatsoever. And he had a way of intimidating people, but in a way that made them rethink whatever they were being protective about. For example, if Jean-Michel came to your apartment and he was sort of handling your records and just sort of picking them up and laying them on top of each other and mixing them up, you'd begin to get mad and bothered. But somehow, you'd also begin to realize that they're *only* records—just material things—and, in the end, what does it really matter? So, a lot of the time, his disdain for objects and for authority served to remind you of your own pettiness and hangups about these things. And so, Jean-Michel had a way of revealing things and confronting people and forcing them to see things in a different way.

Anyway, I invited Jean-Michel to be in this invitational I organized at Club 57. I invited all these people that I got to know to bring one work to the club during the afternoon. Then I would hang up all the works—there would be an opening that night—and the next day they'd come and pick up their work. The idea wasn't to sell anything, but to make it into an event—a one-night opening. Well, Jean-Michel came in, and he didn't have anything with him. I asked if he was going to participate or not. So, he reached into his pants pocket and fished out a completely crumpled-up drawing, which he proceeded to put up on the wall!

When Jean-Michel and I spent time together, we'd usually smoke pot. We didn't

talk all that much, because there wasn't anything to talk about. I mean, I knew what he did, and he knew what I did. At a certain point we grew away from each other. After 1981, when we both started to exhibit more, we more or less went our separate ways. Our relationship had some strain in it, because we were forced into a competitive thing. Anyway, we continued to have a mutual respect for each other—and we were around each other—until he overdosed.

MOLISSA FENLEY In 1979, I choreographed a piece called *Mix,* which was performed at The Kitchen. Afterwards a whole bunch of us came back to my place, which was a loft on Grand and Mulberry streets. Well, SAMO came, and when I wasn't looking, he had made graffiti on my wall and had signed it. I was furious! I threw him out. I threw him down the stairs and I threw Coke bottles after him. First of all, it wasn't my loft, and I screamed at him, "How dare you defile this place?" He said, "I'm just having a good time. It was just a joke." I said, "Well, take your jokes elsewhere!" He was just a weird guy. People would say, "Oh, no! There's SAMO!" If you weren't careful, he'd come up to you and graffiti your head or something. You had to really be on the lookout for Jean-Michel Basquiat!

KENNY SCHARF Jean-Michel Basquiat was an amazing character. The unbelievable energy that attracted me to Keith

Haring, attracted me to Jean-Michel. We became very close friends. Keith and I would see him all the time. But our friendship faltered rather soon. It was over a show I had at the Italian clothing store, Fiorucci, which was very big in the seventies. Well, Jean-Michel couldn't stand my having a show there, and one day he walked into the store with this wet canvas he had just painted, and he started screaming, "Hey, I'm an artist too, and I want a show here!" And he proceeded to cover all the clothing on the racks with oil paint. It was *so* Jean-Michel! He had this reckless, spastic kind of energy that always got him into trouble. So they kicked him out. It was humiliating for him. And he really hated me after that.

KEITH HARING Although I didn't know it, 1979 turned out to be my last year at SVA. A lot of things were happening. At school, I was studying semiotics with Bill Beckley. Semiotics is a science that's applied to language—it's an analysis of language. People like Roland Barthes and Umberto Eco and a lot of the French Structuralists were looking at language, picking it apart, deciphering it, and were debating how meaning is attached to words and how signs gained meaning.

Because this was an art course taught by a visual artist, we were looking at semiotics in ways that applied to visual things—to images rather than to words. But language still entered into it. Anyway, one day, my roommate, Drew, and I stumbled onto something called The Nova Convention, which was a three- or four-day

Keith in his own performance piece during the Acts of Life Art Show, Club 57. New York. June 1980.

symposium at the Entermedia Theater on Twelfth Street and Second Avenue, and it tied right into a whole semiotics thing I was studying. The Nova Convention proved to be a turning point.

William Burroughs, Allen Ginsberg, John Giorno, René Ricard were all participating, and it started to fill in gaps in our education—things we'd be thinking about in terms of chance and coincidence and how to bring these elements into our work. It somehow tied together all sorts of things that I was seeing—the way SAMO was using

language on the street, the way Jenny Holzer was using language—and the whole performance aspect of language. More and more, it was becoming the subject of all my thinking, and William Burroughs and Brion Gysin became my models.

Little by little, videotape and performance and writing started to replace painting and drawing. Because my paintings and drawings were abstract, they didn't really have an immediate connection to the world around me. They were my thoughts, but who cared? The world could live without

them. So with all this happening, I thought, "How can I make all this work for me?"

KEITH HARING During the summer of 1980, my life and my art went totally berserk. It all started when my roommate, Drew Straub, moved out. He decided to go live with Molissa Fenley, who had this huge loft on Grand Street, and needed a roommate. When Drew moved out, I had trouble paying the rent, and so I moved into this really crummy and very cheap boarding house on Second Avenue and Twelfth Street. My room was the size of a postage stamp.

I needed to find a summer job, and in the *Village Voice* I saw an ad that sounded quite bizarre. It called for someone to harvest wildflowers! I called and got the job. It consisted of my getting up at seven o'clock in the morning, going to this garage in the Village and meeting this guy in a van. In the back of the van were these big plastic buckets in which we would put wildflowers. There were also a couple of young guys who were part of the team.

Well, we'd get into this van and drive over to New Jersey, and at certain spots, we'd stop, get out, and start picking flowers, like Queen Anne's lace, which would grow along the highways. So, we'd go from place to place, accumulating these flowers, and putting them in the plastic buckets which were filled with water in the back of the van. Sometimes the boss would enter private properties and ask if we could cut some of the wildflowers—and that way, he

got this really beautiful variety of blooms.

We would then drive back to the city and the boss would stop at all these expensive flower shops and sell the wildflowers we had just picked. He made a fortune, yet he never paid a penny for the flowers! This episode was really important to me, because when we took a break from cutting wildflowers, I'd sit in the fields and contemplate things. It was very calming and beautiful and there was time to just *think*. What I was thinking about was what to do with my life and with my art.

I was beginning to be frustrated about doing only these word things and performances and videotapes—I had been doing this for almost a year. Now, I had this longing to draw again—to create things physically on paper. The question was how to incorporate that into what I was already doing, because if I were to start drawing again, it had to have a reason. There would have to be a purpose. Also it could no longer be abstract drawing, because that wasn't really communicating to the outside world. More than anything, I wanted to communicate!

While I was contemplating all this, I did my very first street pieces. One was a collage of something I found in a book called *Sex and Guide to Married Life*, which was written in 1941. Well, it had all this hysterical information—and misinformation about sex. One chapter was devoted to male and female homosexuality—and there were these totally cockeyed definitions of what constituted homosexual sex.

My friend John Sex and I made a collage of these definitions and we Xeroxed them and plastered them all over the West

Village—just in time for the Gay Pride Parade.

Another piece was a stencil I made that read CLONES GO HOME! I would spray-paint on the stencil and leave those words on the sidewalks that separated the West Village from the East Village, because we didn't want the preppy types of the West Village invading our territory—the East Village. We felt the East Village was a different kind of community which we didn't want cleaned up in the way of the West Village. Even though the West Village had a large gay population, they weren't quite our type of gays— so I made CLONES GO HOME! a definition of the border between the East and West Village. It went on for blocks and blocks!

The most notorious of my street pieces were the ones that looked like the front page of the *New York Post*. I'd cut out letters from the *Post* and rearrange them to make fake headlines, like REAGAN SLAIN BY HERO COP or POPE KILLED FOR FREED HOSTAGE or MOB FLEES AT POPE RALLY. I Xeroxed these in the hundreds and I'd paste them on lampposts and on newsstands. Because they looked so real, people were forced to confront them. They were completely confused—and the posters really made a mark, because they got into people's consciousness.

As the summer of 1980 was progressing, the urge to return to drawing became overwhelming. And, one day I asked this artist that I had met, Bernd Naber, if I could borrow his studio for the day. He agreed, and I went out and bought a roll of oak tag paper, which was about four feet wide, and I cut it into pieces, which I taped to the floor.

I laid out about twenty different lengths of paper and I started painting and drawing on them. For the drawn lines I used sumi ink. What I was doing was abstract— reminiscent of the things I had done before. But on some of the spaces I started to make these drawings that consisted of flying saucers that were zapping these animal figures, which sort of looked like cows or sheep, but they had very square noses and really looked more like symbols of animals as opposed to specific animals.

Suddenly, all these other scenarios began to unfold. I drew humans who were having sex, and who became incredibly activated when being zapped by these flying saucers. The flying saucers looked like Mexican *sombreros*, but they were my archetypal vision of what I thought a mythical flying saucer would look like. The saucers were zapping things with an energy ray, which would then endow whatever it zapped with this power. So these zapped things or people or animals would have these rays coming out all around them.

Several of the drawings were done in sequence, and they looked rather primitive, because I hadn't drawn in such a long time. But I went on and on. I drew a picture of someone fucking an animal from the back—the animal that now had the glowing rays of power. After the person had fucked the animal, his dick would have the glowing power on it. Then, the dick would be worshiped by the crowd. And I did a whole series of these images in different configurations.

Out of these drawings my entire future vocabulary was born. I have no idea why it turned out like that. It certainly wasn't a

57

conscious thing. But after these initial images, everything fell into place, and after that, everything else made sense.

Right away, I thought of showing these pieces at Club 57, and it turned out to be a one-night exhibition. Not many people saw that show, but it was the beginning of something that would communicate some visual information. I had made these symbols that were nonverbal, but were signs that could have different meanings at different times. And everything was a cross-reference to everything else. It was what I had learned from the cut-up works of Burroughs—and it felt great!

In the meantime, I had submitted a proposal to a school called P.S. 122, which was on the corner of Ninth Street and First Avenue. This was an alternative space for artists who could work there on all sorts of projects without any hassles or pressures. Initially, my proposal was to do a video installation, but having just rediscovered the world of drawing, I decided that I'd use the space for this purpose—I'd make a top-to-bottom installation of my drawings. Well, my proposal was accepted and the people at P.S. 122 said I could have the space for two months beginning in October.

While all this was going on, I obtained another job as a gallery assistant to Tony Shafrazi, who was this really notorious art dealer. In the mid-seventies he had gone into the Museum of Modern Art and had spray-painted Picasso's *Guernica*. It was *the* scandal at the time. Later, Tony and I would have lots of discussions about that.

Anyway, Tony had this gallery, which was really his apartment, on Lexington Avenue and Twenty-eighth Street. Whenever

he had a show, he'd hide the mattress and the bed so that it looked like a full-time gallery. During the five months I worked for Tony, I never once talked to him about my art. It just never came up.

As Tony's assistant, I was doing everything from helping to write press releases to mimeographing to buying glasses for the kitchen and serving drinks at the openings. I didn't mind any of that—I could easily handle it. What I *couldn't* really handle was the neurotic way Tony went about doing things.

Still, I gained an incredible respect for Tony Shafrazi because of his commitment to his artists. Tony showed me how to handle art, how to wrap paintings, and what to be careful of with a painting or a piece of sculpture. And he really believed in the art he was representing. Also, I observed that he never did anything sneaky behind anyone's back. He was totally honest.

Working at Tony's was my introduction to the gallery world, and right then and there I started becoming cynical about what that world had to offer—the art world that I was supposedly becoming a part of through school and the underground scene. Ironically, it was at Tony's gallery that I experienced the most terrific disillusionment.

As it happened, Keith Sonnier, a really great artist and also one of my teachers at SVA, was having a show at Tony's, and I helped install it. During the opening, I was behind the bar serving drinks, and I watched how the people were reacting to Keith's work—and I heard what they were saying. It suddenly struck me that they were all being ridiculous and stupid. I mean, there stood Keith Sonnier, about whom I had

Tony Shafrazi in his 163 Mercer Street Gallery. New York.

read in Robert Pincus-Witten's book, *Post-Minimalism*, even before I came to New York, and which had become the textbook of art at the time, and Sonnier had created this really wonderful art, and all those people who just stood around and shuffled back and forth and said these asinine things and . . . for some reason, my whole dream of what I thought the art world was going to be, was shattered. Not that I

knew what the art world *ought* to be, but the feeling I got was a tremendous letdown.

At one point during the opening, I went out of the gallery and sat on the stairway and just cried and cried. It lasted for almost twenty minutes. And, I remember thinking that even if you got to be a success, it didn't mean very much. There seemed to be no answer at the end of the rainbow. Afterwards, I went back into the gallery and continued my tasks as though nothing had happened. Even if Sonnier's opening had been successful, it just didn't seem very fulfilling. And when I looked at Keith Sonnier—standing there—he didn't really seem very happy either.

It wasn't that I wanted out of the art world. I just felt that the whole gallery situation was incredibly confining and it seemed very false. I mean, the whole idea of getting approval from the art world seemed very empty to me. There was no point searching for that, because there wasn't going to be any reward. I mean, the reward was as empty as the search. So I lost the myth and idealism that this was going to be any kind of an answer. There had to be a whole other reason for making art beside looking for success within the art world. Of course, I kept all this more or less to myself.

TONY SHAFRAZI I asked Keith to help prepare the Keith Sonnier show at my gallery on East Twenty-eighth Street, and I remember being immediately taken by his energy. At the time, Keith was a student at the School of Visual Arts and he admired Sonnier's work very much. Well,

Keith had the same kind of enthusiasm and drive that I felt necessary for the preparation of a show and for creating a festive feeling for the opening! What also amazed me about Keith was his work ethic, because his sense of procedure was so clear. He would do things rather rapidly, but systematically and with absolute concentration. There was no lounging around and waiting to be told what to do. His commitment was immediately captivating.

Keith was always in high gear—always up to something. While he worked for me, never once did he bring up the subject of his own work. It was extraordinary. He always represented a pillar of strength, rather than someone who needed help. And he had this momentum of going from one thing to the next and the next—all of it terrifically clear and programmed. One became more and more curious about Keith Haring. I mean, what was he going to do next?

One day, Keith handed me a little announcement of an exhibition he had put together. I thought, "Here is this twenty-one-year-old coming to help me in my gallery, and at the same time organizing exhibitions of his own!" So, it was something called *The Club 57 Invitational*, which was an extraordinary assemblage of downtown art—as lively as it could be. Some months later Keith invited me to a show of his own works that he had installed at P.S. 122. I also went to this and it was unlike anything I had ever seen before.

These were drawings from floor to ceiling and right away, I thought the work looked rather jarring. The originality was obvious and the vocabulary was almost like a dictionary of images. There was no refer-

ence to any form of decoration—it wasn't art that was going to sit on the wall, it was art in movement. What was really important to me—and I couldn't put it into words at the time—was that there was really a conceptual base behind it. There were no words there, but what was said was incredibly animated. The work that one was experiencing did not come from an art-historical background. It was absolutely original. I couldn't really place it within a gallery context. It was too alive for that!

KEITH HARING When I finished school in the spring of 1980, I fully intended to go back again in the fall. It was now time to go and register, and I met with the fine arts chairman, Jeanne Siegel. We were going to talk about what my fall program was going to be. During the course of our meeting, I told Miss Siegel about all the things I had done during the summer—the people I had met, the things I was working on, and about the P.S. 122 installation. I then asked her if I could get credit for the work I was doing outside of school

Well, she said, SVA didn't give credit for that sort of thing, and suggested that perhaps SVA had nothing more that it could offer me—that perhaps I was becoming so active outside of the school curriculum that there was nothing more they could do for me.

All of a sudden, it dawned on me! What am I doing going to school? I was totally hooked up in the underground art scene, and I was involved in the New York art scene. I had worked for Tony Shafrazi. I knew art-

ists like Keith Sonnier, and I had discovered the graffiti artists. Furthermore, I was discovering my *own* work in a way that was just starting to totally explode. So I thanked Miss Siegel, and told her that I was not coming back to the School of Visual Arts. And that was the end of my formal schooling and of my art training.

JEANNE SIEGEL Keith has always said that I was, in part, responsible for his moving out into the art world—of giving him the feeling that he was ready to do it—and encouraging him to do so. What actually happened was that he came to me and said he wanted to leave SVA without graduating at the end of the third year. I really tried to encourage him to stay. I might have ended up saying that he should leave, because he was so determined. He kept saying, "I don't think there's anything more here for me." Well, in his terms he was right to leave. He couldn't do anything else.

In 1988, we began a Visiting Artist program, and I invited Keith to come and speak to the students. He was marvelous. He gave his lecture, and he showed his slides, and afterwards, everyone went up to him and asked for his autograph. By the time he had finished, he had signed everybody's jackets and radios—and was handing out buttons. SVA has always been proud of Keith Haring!

61

KEITH HARING Leaving the School of Visual Arts seemed the natural thing to do. The school fulfilled many things for me. I really, really loved the video experience and the semiotics experience. And there is no way I could have been introduced to New York as easily, gracefully, or as quickly than through the school. School was sort of an artificial situation where you're somewhat protected and buffered from the sharpness and harshness of the real world. But at the same time you're easing into it. For me, it was the right way to start in New York.

Of course, my parents weren't thrilled about my quitting school again, but they had to come to terms with it. The point is, I was totally ready to be on my own. Now there was the question of getting another job. I had quit working at Shafrazi and had taken a job being a bicycle messenger, which lasted about three days. I then got a job making sandwiches in a place on Seventh Avenue and Seventeenth Street. Later I worked as a busboy at Danceteria—the club on Thirty-seventh Street, and while I worked there, the club was busted, and all the help, including me, spent a night in jail! So then, I got *more* menial jobs.

All the while, I was organizing all kinds of group shows at Club 57. You see, this was the period in New York where people were trying to do things *outside* the gallery system—doing things more in the community. So there were shows like *The Real Estate Show*, which was very political, because it was about landlords and real estate. And Jenny Holzer put together a show called *The Manifesto Show*, which was made up of a lot of writings and statements, all of them politically conscious.

After I had done my *Club 57 Invitational*, I did several other shows there. One was called *Erotic and Pornographic Art*, another was *Xerox Art*, and another was called *Anonymous Art*, which was made up of things I myself had collected—things done by children and by insane people and stuff I found on the street. Dubuffet would call it *Art Brut*. While all that was going on, I was also installing my show at P.S. 122.

One day, Steve Maas, who ran the Mudd Club, approached me and said he wanted to buy the talent of Club 57—he wanted to put fresh blood into his own club. This was good, because people at Club 57 really needed jobs. So Steve hired bartenders from there and Samantha McEwen became the coat-check girl and, best of all, I was hired to coordinate the art gallery. This was a space on the fourth floor of the club—and it was great because I now had a job I really liked!

When my show at P.S. 122 opened, it got reviewed by the *SoHo News*, and they said that mine was the only interesting installation. They also published a picture of some of my drawings and, it being the *SoHo News*, they printed the dirtiest ones they could find—the ones showing people fucking dogs. Because it was the very first press I ever got, I sent the clipping home to my parents in Kutztown. Well, they were so embarrassed! They wouldn't let my little sisters look at it, and they certainly couldn't show it off to the neighbors. Still, they said they were happy I was in the paper.

KENNY SCHARF Keith and I continued to be great friends even though he had quit the School of Visual Arts—we saw each other constantly. I continued to attend school, and doing my stuff—the super-realistic images of things you couldn't photograph, like objects from outer space. It was all imaginary subject matter which I'd paint in a photo-realistic way. But during that period, I was also into "customizing" appliances, which really meant decorating them in Day-Glo colors—sort of "dressing" them. I'd go into people's homes with my customizing kit and I made my living that way. In fact, I gave myself the name of a company, Van Chrome Customization, and I'd appear and say, "What would you like done?" And the customer would say, "My telephone, my TV, and my blender." And I'd say, "OK. That will be $200 for the telephone, $200 for the TV, $100 for the blender, and for another $50, I'll throw in your hairdryer." So that was the kind of art I was making.

Anyway, at the end of 1980 I moved into a very big loft between Thirty-ninth and Fortieth streets on Sixth Avenue. It had belonged to the photographer, Jimmy De Sana, and it was real funky, with two floors. It was an incredible find. Keith decided to move in with me, and we had our separate areas where we worked and slept. I might add that by this time, I had met Samantha McEwen at the Mudd Club and I fell in love with her. She was an artist, and she knew Keith and we partied all the time. So Samantha would be at the loft too—and now it was the three of us. Often it would be the three of us in bed watching TV. It

was real cuddly—and like a little family. The fact is, Samantha and I loved Keith. And he needed love.

The problem with Keith was that he just fell in love every day—but he went after the unattainable. I mean, he liked this boy or that boy, but mostly, he was rejected. He was often desperate about it, because he thought he wasn't good looking and that he couldn't attract people. He had trouble with his self-image. So he made this scene of sex for the sake of sex, going to the bars, going to the baths, cruising—living in a world that was then. It was only after he got famous that he could get the boys he couldn't get before.

SAMANTHA McEWEN I had an apartment on Broome Street in SoHo. Kenny was living in his loft near Times Square. We had been going out since the fall of 1979. Very soon, Keith moved into the loft with Kenny and, although I actually never moved in, I spent my entire time there—and it was really like "our time."

The loft had two floors. The bottom floor was Kenny's and it was chaos. The top one was Keith's and it was pristine—neat as a pin. He completely repainted his rooms, and in the studio area, he had a little row of chairs for guests to sit on. He had a few bookcases. And he was the first person I knew who would put specific magazines on a low table and display them. He was precise and meticulous about his living quarters.

Samantha McEwen holding a customized telephone by Kenny Scharf. New York.

I always adored Keith—always wanted to go out with him. But it never worked. The fact is, I was completely in love with Keith. At the same time, I was sort of scared of him—he was just so daunting! I was in awe of him from the very beginning. Finally, we became very good friends—and the three of us, Kenny, Keith and me—we just had a wonderful, wonderful time together.

KEITH HARING When I moved into the Times Square loft with Kenny, it was the most space I ever had—and we had some of the best and some of the worst times there. Samantha was living on Broome Street, but she was practically parked in our loft, because she and Kenny were having this big affair.

Living so close to Times Square was really interesting. I began buying a lot of pot there. I smoked pot all the time—more or less. When I lived in the East Village, you had to go to various doors to get the grass, like you'd slip money through the blue door or the black door or the red door, and somebody would hand you this little brown envelope with pot in it. The police would shut these places down, but the next day they'd be open again. And you'd also know where the new places were located. For a while there was a delivery service. You just called up, and they brought you the stuff.

When I started living in the Fortieth Street loft, I'd get pot on the steps of the Forty-second Street library—you could buy either loose joints or nickel bags. Anyway, because I was now working at the Mudd Club, I'd usually stay up until four o'clock in the morning. At the time, I was also doing a lot of coke, because everybody who worked in nightclubs did coke—and if you were working the door, as I sometimes did, people would just *give* you coke.

After you finished working at the Mudd Club at 4:00 A.M., you'd still be awake and pretty high on coke. So you'd be wired, and you'd go to the Anvil, this S&M place near the piers, and stay there until maybe five or six in the morning and then stumble home for some sleep. Kenny and I would often be together, and we'd go home and sleep for most of the afternoon, and then go have breakfast in this little coffee shop on Seventh Avenue called The Pop Art Coffee Shop. Imagine! The Pop Art Coffee Shop!

KEITH HARING It was during the winter of 1980 that I started to actually draw graffiti on the street—and I did that with a marker. My only other street works were those Gay Parade posters, the *New York Post* fake headlines, and the stenciling of CLONES GO HOME!

Well, now that I had done all these drawings at P.S. 122, I felt there was a reason to draw on the streets, because what I was drawing was communicating information. I had developed a language made up of pictographs, and I'd draw these with a big black Magic Marker, which was what other graffiti artists used.

The way it began, was to draw my tag—tag, meaning signature or what graffiti artists called their name. So my tag was an animal, which started to look more and more like a dog. Then I drew a little person crawling on all fours, and, the more I drew it, the more it became The Baby. So on the streets, I'd do various configurations of the dog and the baby. Sometimes, the baby would be facing the dog—confronting it. Sometimes, it would be a row of babies, and the dog behind them. I was using these images, always bearing in mind the Burroughs/ Gysin cut-up ideas. And I juxtaposed these different tags or signatures or images, which would convey a different meaning depending on how you combined them. But those first things I did on the streets were just these rows of babies and dogs. I would add that I made these drawings where I saw other people's tags, and I did them so that they would be acknowledged by other graffiti artists. So if there was a place that was covered with tags, I'd somehow find a place to fit mine in too. Of course, I would never do a tag on top of someone else's tag.

It was around this time that a downtown group calling itself Collaborative Projects or COLAB organized a show called *The Times Square Show*. They had found this sort of abandoned building on Seventh Avenue and Forty-first Street which used to be a massage parlor. They rented it for very little money and invited all these artists to do installations and hang their works there. As it turned out, *The Times Square Show* was a turning point for the art world at this time. It really made a mark, because it was the first time that every kind of underground art could be seen in one place—and that included graffiti art. It was the first time that the art world acknowledged that the underground existed.

We all had pieces in the show. Jean-Michael Basquiat caused a scandal, because one of his pieces was the show's outside signboard—and on it he had printed in very big letters, FREE SEX. The COLAB people took it down, because they thought it would cause trouble. Anyway, Kenny did his customizing things, I had a piece with lots of pink penises in it, and one of the best graffiti artists, Lee Quinones, hung a piece.

Also in the show was Fab Five Fred, who was infamous among graffiti artists for having done a subway train covered from top to bottom with Campbell's soup cans. It was a reference to Andy, of course. So graffiti was becoming much more sophisticated, with its references to the real art world. As a result, the art world started paying much more attention to the graffiti world.

I now began to become very friendly with graffiti artists, like Lee Quinones—his

tag was LEE—who, among them all, was the real master of movement. But I became especially close to Fab Five Fred, whose real name is Fred Brathwaite. Now, Fab Five Freddie was the liaison between the downtown scene and the uptown graffiti scene. The graffiti artists were evenly mixed between blacks, whites, Hispanics, and Chinese. It was a racist myth that graffiti artists were only blacks and Puerto Ricans. Some of the biggest names in graffiti were white kids. But Fab Five Freddie was this tall black kid, and he and I started hanging out together. It was great, because Lee and Fab Five Fred were the kings—the kings of this graffiti world.

FAB FIVE FRED (Fred Brathwaite) When I was a teenager, I got some publicity, because I was part of this group called The Fabulous Five. We were known for painting the Lexington Avenue subways—particularly the No. 5 train. These were fabulous murals which covered the entire side of the cars. Lee Quinones, who was our virtuoso, was part of this group. But the Fabulous Five soon stopped painting, because it had reached its creative peak and because it was an adolescent activity. Also, it was a means to a very little end. There wasn't much at the end of the tunnel, except maybe . . . another train.

In studying art—and the meaning of art—I quickly saw that graffiti art and the way it was functioning was 100 percent art. What I learned in the books was that art

wasn't supposed to be about money. It was supposed to be for the people. It was about man having a need to decorate and embellish his environment. So that was true from the beginning of time. Well, graffiti art fit every one of those criteria. It was what real art was supposed to be.

So I was getting strength from that, and I realized that I was part of something. And I hit the scene with that. I had my arguments ready. Of course, when I would roll up on people, being from Brooklyn and being a B-Boy and a Hip-Hop and a street person, people never expected that I had my shit together. But I did have my shit together, and I made my moves on the scene. Hence, I entered the downtown club scene, and that's where I met Jean-Michel Basquiat and Keith Haring.

Actually, we were a sort of a posse—Keith and me and Jean-Michel and Kenny Scharf—and also this kid, Futura, who was this cool graffiti artist. So we were tight. And we all showed together at *The Times Square Show*, and in shows curated by Keith at the Mudd Club. It was Keith who had the idea of having an all-graffiti show at the Mudd Club. It was called *Beyond Words*. The point of the show was to make people realize that graffiti went beyond words—that it wasn't just tags—that graffiti artists were also trying to develop as painters.

When I met Keith, he was already drawing his little baby. One of the things we would do together was walk around the streets and look at people's tags. One night—it was real hot and sultry—we decided to walk in Alphabet City—avenues A, B, C, and D, the real Lower East Side. It was a time when *nobody* walked over there, be-

cause it was drugs and shit—it was scary! People would say, "Fred is this big, black dude—he ain't scared of nothing." But I *was* scared. So we'd walk over there and get into the whole vibe of the neighborhood, and Keith would be in ecstasy.

So we walked on A, B, C, and D, and were coming down by Houston Street, when all of a sudden I smell spray paint. I say, "Yo! Keith! Somebody is piecing." See, that's what graffiti artists do. When they do a piece of art, they go out piecing. So we walk closer to the smell of spray paint—and we're off Avenue D—when we come to this school called P.S. 22. We walk all around it and, right there in this courtyard are all these local guys doing graffiti—and Keith went crazy! That's when Keith plugged into this whole graffiti thing, and he wanted to be part of all that.

Keith looked at these kids doing their stuff, and he looked up and saw this concrete band running all around the walls of the school courtyard and, right away, he wanted to fill it with his tags and stuff. So the next day he came with a ladder and got up there and started painting his stuff. And it was there that Keith met LA II, this kid whose tags Keith went crazy about, and with whom he later collaborated.

So Keith got into this whole graffiti thing, but he wasn't really that much a part of it. See, it was the media that placed the label "Graffiti Artist" on Keith and on Jean-Michel. But it wasn't really so. Keith and Jean-Michel and Kenny Scharf too only did a few things on the streets—but it wasn't the main thrust of what they wanted to do. They didn't make any incredible contribution to the genre.

Me? I went on to show my graffiti paintings in galleries—I had a show in the Fun Gallery in the East Village—and the stuff sold. Later, I showed at Holly Solomon, when she had her uptown gallery. It was great, but none of my friends came. You didn't have the home boys boppin' in from the street and say, "Yo! Fab!" You know, it was like all very staid and boring—and it scared me. I mean, to be on the corner of Fifty-Seventh Street and Fifth Avenue . . . it was, like, "What kind of corner *is* this?" So I started looking for something else to do. I directed some music videos and I was into rap music and part of all this Hip-Hop culture—and, you know, I was always into music. I even got some fame, early on, because I was tight with Debbie Harry and this band, Blondie, and Debbie Harry recorded this song, "Rapture," and she mentions my name, Fab Five Fred, in the song—and, wow, that was cool!

Now I'm the host of the most popular show on this MTV television channel. I play music and interview people—and the show is called *Yo! MTV Raps*. And it's watched by about 2 million people every week!

KEITH HARING It's getting to be Christmas 1980. I'm working at the Mudd Club and I'm hanging out with the graffiti artists, and I'm living in this big loft with Kenny Scharf and Samantha McEwen. I never go anywhere without my big black marker. One day I see this blue-jean ad on the street, and it says CHARDON JEANS. The reason I see it, is because some guy was

crossing out the letter *C* in CHARDON. So it now reads HARDON JEANS. I just thought that was brilliant, and although I saw someone do it first, and because I conveniently have my marker in my pocket, I start to cross out the letter *C* on every CHARDON JEAN ad I can find.

Because I was riding the subways every day to go to work and also to look at graffiti, I started noticing all the Christmas ads in the stations. One of them was a Johnny Walker scotch ad—and it showed a peaceful, snowy landscape. There wasn't anything I wanted to alter in the ad, but I saw all that great white space where the snow was. It was a perfect place to draw my row of babies—the ones I had been drawing on the streets above ground. There was also room—up in the corner—to do one of my flying saucers, which would be zapping down into the snow to hit the babies. And that was how the baby with the rays originated. When the flying saucer zapped the babies, I put rays all around the babies, because they had now been endowed with all this power. Later on, this image became misinterpreted. People wrote that the baby has radioactive energy. That wasn't so. The rays from the flying saucer gave this glowing power.

It was also at this time that I saw my first empty black panels. These black paper panels were used to cover up old advertisements on the subway platforms. I first noticed them when I took the F Train on Sixth Avenue and Forty-first Street, which was my subway entrance, and I immediately knew I had to draw on top of them. The panels were covered with a soft matte black paper, which was *dying* to be drawn

on. If it had been shiny paper, none of this would ever have happened!

I also immediately knew I had to go above ground and buy chalk. Now at this time, there were also white markers which were very popular with graffiti artists, but I knew that if I used that marker on the black paper, it would soak in—it wouldn't have that tactile, really sharp, crisp, white line that I wanted. So I ran up to the street and found the closest stationery store to buy chalk. I drew on one of the panels and . . . it felt incredible!

As I kept seeing these black subway panels everywhere, I realized what I had discovered. Suddenly, everything fell into place. All that I had been watching and observing throughout the two years I was in New York made perfect sense. Now I found a way of participating with graffiti artists without really emulating them because I didn't want to draw on the trains and sneak into the yards and cover the sides and insides of the subway trains. Actually, my drawing on those black panels made me more vulnerable to being caught by the cops—so there was an element of danger.

I knew I had to be careful. I thought, "Even if a cop catches me, I am only using chalk, and I can wipe it off." Within weeks, the idea of doing this started to define itself and I started these drawings by getting off the train every time I saw an empty panel. So I'd get off, do one, and continue on my way.

Several amazing things happened. One was that when I did a drawing and went back a week later, the drawing was still there. It was neither smudged nor did anyone try to clean it off. I mean, the drawings

New York City subway panels. 1984.

seemed to have this protective power that prevented people from destroying them. Another thing was that I realized how many people were seeing these things. Within a week, when I'd be doing another drawing, people would come up to me and say, "So *you're* the guy who did these drawings!" Because, see, there was never a signature. Nobody knew who was doing this stuff.

And I started to realize the power and the potential of what I was doing. Well, I started spending more and more time in the subways. Now it wasn't a question of

going to work and getting off whenever I saw a black panel. I actually developed a route where I would go from station to station to do *just* these drawings.

From the beginning the drawings were quite simple. They started out as configurations of the flying-saucer theme. You saw the flying saucers zapping animals or babies or men with holes in their stomachs. Actually, this image of the man with a hole in his stomach came after I heard of John Lennon's assassination. Someone came into the Mudd Club and told us that John Lennon had been shot. People couldn't believe it.

It had this incredibly sobering effect on the entire city. I woke up the next morning with this image in my head—of the man with a hole in his stomach—and I always associated that image with the death of John Lennon.

So the drawings continued to be very simple, and every two weeks, I'd add new elements. Sometimes, from station to station, I'd invent new drawings. Often, I'd do thirty or forty drawings in one day. At times I'd do a panel that was about the poster along side of it, like the time there was this Idi Amin movie poster, and the drawing I did next to it was of a guy standing on top of a whole pile of bodies—so it was *about* the poster next to it.

At the same time, the baby with the rays became almost a kind of signature. In the beginning, it appeared in almost all the subway drawings. Instead of signing my name—the baby would appear. In the back of my mind was this idea of wanting the respect of the graffiti artists. It was much more important to me to have their respect for the work rather than that of the art world, because it was more of a challenge to obtain. So that was another reason I did the subway drawings.

From the beginning, I had been friends with Kwong Chi, who was this great photographer, and Kwong Chi saw the potential of what was beginning to happen with the subway drawings. He volunteered to start photographing them. When I did these route trips, I'd call Kwong Chi up and tell him where I'd just done the drawings, and he'd go there and photograph every one of them.

TSENG KWONG CHI It was while Keith was working at the Mudd Club that he started drawing in the subways. At first, he told no one, so I actually missed photographing the earliest ones. Finally, he told me what he was up to. I took the subways and saw some of the panels. I thought, "This is absolutely amazing! Here's this guy dispensing all this energy and effort in the subways!" I wanted to be a part of that and I volunteered to photograph his work.

At that time, Keith had very little money so I paid for the film and processing and I then gave him the photographs. At first I went down into the subways only once in a while. But then, the drawings were just *everywhere!* Finally I said, "Keith, you've *got* to tell me where the drawings are. I can't just ride through the entire subway system looking for them." So after that, he called me to say where he had made the drawings.

We started collaborating on this, and I recognized the importance of what he was doing. Frankly, for me, these photo sessions were torture, because it was no fun riding the subways for four or five hours every other day. And always, I had to work very fast, because I'd often be stopped. Cops would say, "What are you doing? You need a permit!" Of course, I'd then go into my Japanese tourist routine and say, "New York subway very interesting!" I did this for nearly four years. By the time Keith could afford to pay me for this work, I didn't mind doing it all that much. Later we made a book together called *Art in Transit*, and our friend, Dan Friedman, designed it. Henry Geldzahler wrote the introduction.

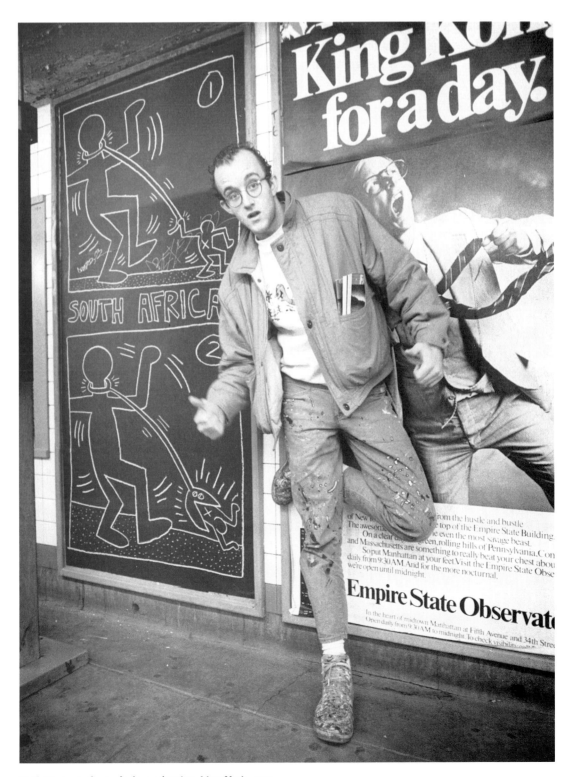

Keith Haring in front of subway drawing. New York. 1984.

HENRY GELDZAHLER I met Keith while I was still the Commissioner of Cultural Affairs for the City of New York. I met him through Diego Cortez, who had organized a show called *New York/New Wave* at P.S. 1, and a lot of underground artists were exhibited. This was 1981, and though I had already been aware of Keith's subway drawings, I had not yet met him. When I went to Keith's studio, I saw genius. I saw someone in complete control. I saw someone with a signature style—a style he seemed to be born with. He seemed to me to be like Andy Warhol, someone who knew that what he was doing was important, and he didn't care if he worked fourteen or sixteen hours a day. His work *was* his entire world because he knew that only his efforts from such and the recognition gained would really allow him to establish contact with the outside world.

KERMIT OSWALD Back in Kutztown, Drew Straub was making chalk drawings on the chalkboards and all over buildings and classrooms—and people had to deal with these drawings. When Drew moved to New York in 1979, and later moved in with Keith, he was doing chalk drawings on the sidewalks of New York. And, of course, I was working with materials and mediums I would plaster all over Kutztown campus—and Keith saw that and knew that.

So to fully understand where Keith came from—and why he did what he did in public . . . well, a lot of it came from Drew Straub and a lot of it came from me and,

of course, he took it to the fucking sky! I mean, I give Keith all the credit in the world for taking our ideas to the universe. But he'll say in interviews that he went into the subways and saw the black paper panels and calmly went out on the street to find a pack of chalk on Times Square . . . well, it's not as though he hadn't been seeing it for two-and-a-half years with us! I'm making no bones about it. It only is what it is. Drew was even more responsible than I was, because Drew lived with Keith—and they were best friends.

KEITH HARING It's 1981 and I'm heavily into subway drawings. Every time I'm doing a drawing people come up to me and say, "What's this for?" or "Are you getting paid to do this?" or "Is this an advertisement for something?" Well, I felt I should give them some explanation. But then I thought that wasn't such a good idea. Instead I had a flash: Why not hand out buttons? Don't say anything—just give them buttons.

I look in the *Yellow Pages* and find this button place, B & R Promotional Products, and I design a button with the baby and the rays. I order 1,000 buttons—it was a black baby drawn on a white one-inch button, with a lock-pin on the back, because I didn't want a cheap button that's going to fall off. Later, I order the dog as a button—it's a red button with a white dog on it—and he's barking. So I start carrying handfuls of these buttons every time I'm in the subways—and I hand them out. People started wearing them and it was the coolest

Keith with Kermit Oswald at Westbeth Painter's Space show. New York. Winter 1981.

thing you could do to have one of these buttons. People wearing them started talking to each other. I suddenly realized the power of a button!

In the meantime, I'm still working at the Mudd Club and by the spring of 1981 I'm not only getting a lot of attention for the subway drawings, but also from all the graffiti artists I wanted to attract and be friends with. Through Fab Five Fred and this really talented kid, Futura 2000, I'm introduced to this uptown graffiti group called Soul Artists. They had recently received quite a bit of attention from Richard Goldstein, who wrote a large article about them in the *Village Voice*—and there was also a large story in the *Daily News*.

It occurred to me that a big graffiti show should be organized down at the Mudd Club, and so I put Fab Five Freddie and Futura in charge as guest curators. Well, it turned out to be not just a graffiti exhibition, but a graffiti convention! I mean, graffiti artists came from all over the city. These kids didn't understand that this was a place to come and *look* at art, not just a place to *be* every night and hang around and do graffiti. But more and more people came. It got completely out of hand, because the entire Mudd Club was getting "signed"—they just covered every wall and staircase—and pretty soon the entire neighborhood was covered with graffiti!

The Mudd Club started getting com-

plaints from the neighbors. Steve Maas, the owner, and the guy who is supposed to be so liberal and funky, started getting more and more conservative. He became really worried because all kinds of tensions were building. See, there were all kinds of wars being waged within the graffiti world—and that whole world was converging on the Mudd Club. We would have to lock the doors, because somebody outside wanted to kill somebody inside. There were real scares.

So every night things would get more and more intense, and I'm meeting at first hundreds, and now thousands of graffiti artists! Well, this eventually freaks out Steve Maas. He finally had enough. He started painting over the hallways—covering the graffiti. He was also at the point of firing me, because I had completely disrupted the club, and I had gotten him in trouble with the neighbors.

Suddenly I realized I *could* quit, because weeks earlier I had sold some of my drawings—and I had been paid well. I realized I could probably start living from my work. I also realized I didn't ever have to do menial work again. And so I quit. I think that because of the graffiti show, I went out with glory. I didn't know it then, but working at the Mudd Club would be my last job where I would ever have to work for someone else!

FUTURA 2000 (Leonard McGurr) When Keith created the *Beyond Words* graffiti show at the Mudd Club—the show that Fab Five Fred and I curated—people in the art world realized the genius, naïveté, sim-

plicity, and simple truth of graffiti art. It wasn't about traditional ideas—it was a fresh spirit—something people hadn't seen before.

I think that most graffiti artists will agree that Keith Haring probably gave the movement its greatest exposure—he kind of pushed it forward right from the start. Without Keith there at the beginning, a lot of this wouldn't have happened the *way* it happened. I'll say this, Keith affected our lives single-handedly. It wasn't Andy and it wasn't Jean-Michel. Keith was the catalyst!

KEITH HARING My drawings begin to sell, and collectors start coming to the loft I was sharing with Kenny Scharf. One couple in particular becomes my first collectors: Donald and Mera Rubell. He's a doctor—a gynecologist; she's in real estate. Donald is the brother of the late Steve Rubell, who was the co-owner of Studio 54, Palladium, and other clubs and hotels. The Rubells have an amazing eye, and they're famous for buying art that's way ahead of its time. Actually, they're the only collectors with whom I've stayed friends— they're like family to me.

So the Rubells come to the studio and they're buying my stuff, but not Kenny's which is all over the place. This is now putting a wedge between me and Kenny. I try to show the Rubells Kenny's things, but they don't want to see it—they walk right past it. Kenny is starting to feel insecure— starting to feel that I'm overshadowing him—and it's starting to cause problems with our friendship and relationship. Other peo-

ple come to the loft, and *they're* buying my stuff. Kenny gets more and more upset.

KENNY SCHARF All these people were coming to the loft, and it was exciting because I thought they'd look at my work too. But it turned into this horrible experience. Everybody went right to Keith's work. It was really hard on me. I felt just terrible. Keith was riding this fan-

tastic wave—he was excited—he was roaring! But I was in pain. I kept thinking, "What can *I* do to make people notice me?"

SAMANTHA McEWEN People would come to the loft and Keith's work would sell, but Kenny's wouldn't. It was a nightmare for Kenny. There seemed to be no justice. As Kenny's girlfriend I was there and watched him become more jeal-

Keith with Futura 2000 and Kenny Scharf. New York. Early 1980s.

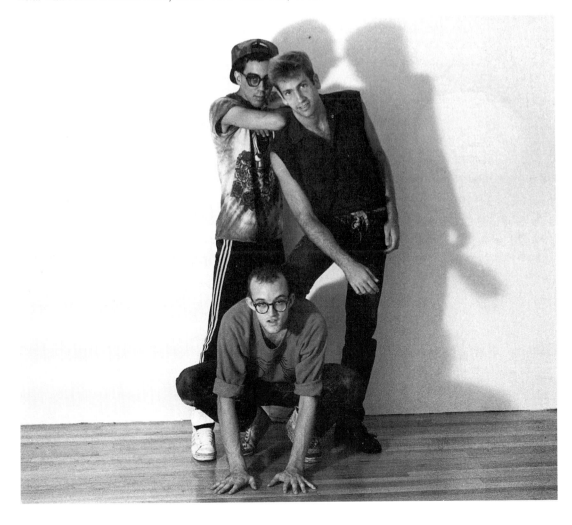

ous and miserable over Keith's success. But one morning, Kenny got up and sat at the edge of the bed and said, "OK, I'm going to make a list of what it is I actually want out of being an artist."

So he made a list, which said things like "I want a show," "I want people to like my paintings," "I want people to buy my paintings," "I want to be successful," "I want to be taken seriously." Well, in a way it clarified things for him. You see, he thought that everything that happened to Keith would happen to *him*—just like that! But that list, which was trivial enough, nevertheless set him on course—he realized he had to do things for himself. And I never heard him complain after that.

DONALD RUBELL One day, we heard about a show of graffiti art at a downtown place called the Mudd Club. We decided to go there. We were wandering around when, in the back of the gallery space, we noticed someone sitting on a swing. We asked if he had anything to do with the show, and he said, yes, he had organized it. And he proceeded to show us around. We asked his name . . . it was Keith Haring.

MERA RUBELL What we witnessed at the Mudd Club that night was really the whole underground graffiti scene. We actually came face-to-face with the humanity behind the subway train-decoration movement. These were real people, real art-

ists. These were not criminals. These were young people who made a decision to communicate with the world. They decorated the trains because the art was addressed to their own peers—their own social class.

DONALD RUBELL We asked to see more of the work, and Keith took us to the studios of these individual graffiti artists. On the way back, I asked him, "What do you do when you're not curating?" He said, "I draw."

MERA RUBELL This was not a bold announcement. It wasn't like a Julian Schnabel, "I'm an artist!"–kind of thing. We said, "Where do you draw?" He said, "Well, there's some stuff in the subways." In other words, he was very vague and very modest. Having seen the show at the Mudd Club and having experienced this studio tour through Harlem, we certainly felt there was something special about this Keith Haring.

DONALD RUBELL We said to him, "When you have something to show us, will you let us know?" He said, "OK." We didn't hear another word for six or eight months. Then, one day, we receive a call. It was Keith, and he said, "I'm going to have a show at Club 57." I said, "That's terrific. What's Club 57?" and he explained. On the appointed night, at around nine o'clock, we entered Club 57, and it was the most as-

tonishing thing we ever saw. It was an original moment!

MERA RUBELL Our initial reaction was that which we always feel whenever we get excited about an artist. What we saw was a new vocabulary—a new idea. It was an artist showing us something very intimate. We were really, really moved by what we saw.

DONALD RUBELL We were so moved that we tried to buy the whole show. I remember Jeffrey Deitch had been there before us, and had bought one or two pieces—so we bought everything else that was for sale. Not everything could be bought, because Keith had decorated the walls and the record player. From then on, we collected Keith Haring. To date, we have some eighty pieces.

MERA RUBELL And, we developed a close friendship . . . and it's love. It's about different territories. You see, his life and Steve Rubell's life were totally intertwined. Steve and his clubs and his exuberance! Both had that same energy and that love of public, love of young talent, love of the street, love of the urban experience! And they loved the night . . . the music, the freedom, the sexuality! Really, it was *all* about the breaking of boundaries!

KEITH HARING It's 1981. I'm twenty-three years old. I'm frustrated about my personal life. I'm continually searching for something—for someone. I feel it's terrible not to have found a lover in all this time. I'm really tired of only doing the baths, and not having someone I can *really* be with. But one night, I meet this person. We have great sex. I decide this is the right person for me—he's black, he's thin, he's the same height as me, and he's almost the same age. So he gives me his number which was written on the stationery of the St. Mark's Baths. It is Juan Dubose, and I fall madly and totally in love with him.

SAMANTHA McEWEN When I met Juan Dubose, he was the quietest, the most unassuming, beautiful, gentlest, and really mysterious guy. Before Juan, Keith would bring home all these people—I mean, the place was mostly just packed with guys— or there'd be a different guy there every night.

Keith was already becoming quite well known, and a lot of the guys didn't know who Keith was until he had gotten them home. They'd see the art, and they'd say, "Oh, you're Keith Haring!" To many of them you just wanted to say, "Go away!" They all wanted something from Keith—they all took advantage of him. That seemed to be the extent of Keith's private life. Then, Juan Dubose showed up. He seemed to genuinely love Keith, and Keith absolutely adored him.

Now, even though I was living with Kenny Scharf, I always kept my little apart-

ment on Broome Street. One day, my Broome Street landlord called and said he wanted to convert my entire floor, which consisted of several apartments, into *one* apartment. I was offered the choice of continuing to live in this much bigger space—once renovated—or move out. In the meantime, Kenny's loft, which had always been a sublet, had also to be vacated. So *everybody* had to move. To complicate matters, my relationship with Kenny was coming to an end. For whatever reason, I could no longer handle it. Finally, Kenny found an apartment for himself. I was wondering about Broome Street, because I couldn't afford the new rent. Well, Keith offered to move in with me. We were roommates for quite a long time—and then, Juan Dubose moved in. It was now the three of us.

KEITH HARING Juan Dubose had a job in Brooklyn installing and repairing car stereos. And he was also into music. He was a deejay, and had all this great equipment. Having found this person—having finally found someone I was completely crazy about—I felt as if I was starting a whole new life. After we saw each other for about a month, I asked Juan to move in with me. In order to have some privacy, and so Samantha can walk to the bathroom without disturbing us, we bought a camping tent. It's a big tent—for four people—and we had a foam-rubber mattress—and it's our bedroom—and it's great. And it turns out Juan's a great cook so we had these terrific meals. And he moved his deejay equipment into the apartment, so we had this great music going. The three of us got along famously. We become this happy little family—Samantha, Juan, and me!

Keith with Juan Dubose in Montreux. July 1983.

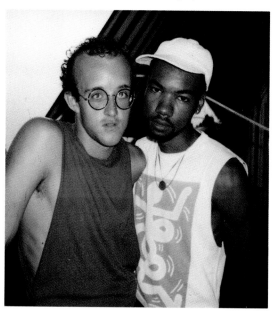

SAMANTHA McEWEN About the tent: You see, the apartment was a railroad flat. My part was the kitchen and the bedroom and the bathroom, which we, of course, shared. Keith and Juan's part of the apartment was to the rear and consisted of a bedroom and another small room. Well, it turned out that Juan Dubose was constantly in the kitchen, cooking these wonderful meals. What was happening, was that not only did Keith and Juan have their own rooms, but they had the kitchen. They would always have to walk through my bedroom to get to the bathroom, and I felt this was a real invasion of my space. Luckily, I hate cooking—I was never in the kitchen. So I

said, "We have to switch the whole thing around." So I moved to their end of the apartment, which of course meant I had to walk through their *bedroom* to get to the bathroom. And that's where the tent came in. It was for privacy—and the tent was about the most private bedroom you could find.

CARMEL SCHMIDT Samantha was my best friend. We spent endless time together. When I visited her on Broome Street, she was designing jewelry at one end of the apartment, and Keith would be working away at the other end. And, Juan Dubose would be there. He and Keith were just wonderful together—they were *so* in love. Sometimes, Keith would be in the bathtub, holding court, and we'd all hang out in the bathroom, which was the nicest room in the apartment. It was all kind of camp. Sometimes we'd watch Keith getting ready to go to a party. He was very particular about which shirt he was going to wear—and the way he'd put on his cologne. And Juan would be watching him, exuding this very quiet dignity. He was just adorable.

SAMANTHA McEWEN Keith and Juan and I shared the Broome Street apartment for about a year and a half—through 1982. At one point, my father died and I had to return to England to be with my mother. Keith kept the apartment and, because he was now earning more money,

The Broome Street apartment of Keith, Juan Dubose, and Samantha McEwen. New York. January 1982.

Interior hallway. Broome Street apartment showing door tagged by Jean-Michel Basquiat and Kenny Scharf. New York. January 1982.

he was able to also rent space in the basement—which was partly a storefront. This became Keith's first real studio—where he could be completely on his own. By the time I returned to New York, I had a new boyfriend and we got an apartment together. But I would visit Keith and Juan. What I began to notice was that Juan was becoming more and more introverted. I mean, he was always monosyllabic, but this was something else. Of course, there were always lots of drugs around. If you'd go there during an afternoon, Keith would be in the basement working, while Juan would be sitting in a neon light at three in the afternoon, watching TV. Juan was *so* hard to talk to! And he was very, very shy. He just never, never talked about himself. God only knows what was going on inside him! The point is, that as Keith was getting more and more active, Juan just retreated into himself—and it was a very sad thing to watch.

KEITH HARING When Juan and I began living together, my life seemed to be more or less settled. I now had a home and Juan was taking care of it—cooking and so forth, and I could really just concentrate on work. At the time, I was still going around the streets with my marker, tagging my baby and my dog. I was still very active with my subway drawings. Mostly, I was hanging out with Fab Five Fred and a lot of the other graffiti artists. And that's how I discovered LA II.

LA II was a graffiti signature that I began seeing all over my neighborhood—I'd see it on the streets, I'd see it on trucks going by, I'd see it everywhere. It stood out because it was absolutely perfect and beautiful. It was like discovering SAMO all over again—it was like finding another Jean-Michel. So of course, I wanted to meet this LA II. My friend Futura knew who this was and one day we got introduced. So, it's this very young kid! He's fourteen years old, he's short, he's totally adorable and sweet. We just immediately hit it off. It's as if we'd known each other all our lives. He's like my little brother. From the beginning, it's a paternal or fraternal sort of relationship—that's all it is.

LA II (Angel Ortiz) One of the kids from my neighborhood was telling me that the person with the baby was looking for me. I said, "Who's having a baby?" And it was Keith, whose logo was the baby and dog. He was in the schoolyard of P.S. 22, doing a painting all around the schoolyard, and he was high up on a ladder. I couldn't see him. Then I saw him, *boom!* So when he came down from the ladder, I was kind of scared. I said, "Excuse me, is it true you're looking for LA II?" He said, "You *know* LA II?" I said, "Yeah, it's me!" I was, like fourteen. I was a baby! He said, "Prove to me you're LA II." So I took one of his markers and wrote my signature. And *boom!* Right there, he said, "I can't believe it's you!"

KEITH HARING I was so crazy about LA II's tag that I asked him to collaborate with me. So I invited him to my Broome Street studio and I found pieces of wood and metal shelving and we would draw on them together. The images consisted of his signature and my own, nonspecific little marks embellishing and covering the surface. And we'd do enamel pieces together, and they came out looking incredibly beautiful. So the lines and squiggles I'm doing take me back to the abstract period I had left behind—this, inspired by LA II. One day, one of the works we collaborated on is sold for $1,400. When I got the money, I handed LA II half of it—$700. The next day, LA II called to say he wanted me to meet his mother.

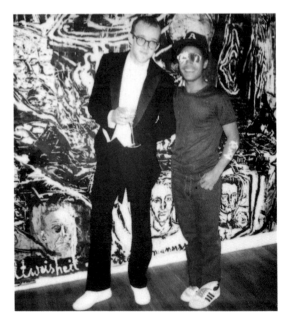

Keith with LA II at Anselm Kiefer exhibition. Mary Boone Gallery. New York. 1982.

LA II People want to know what LA II stands for. I tell them my real name is Angel Ortiz, but that LA stands for Little Angel, because my name is Angel and I'm only five foot four inches. So I'm little—I'm a little guy and I'm not gonna grow no more than this. I put the II, because the real LA is Los Angeles, California—and that's LA I. So LA II—it's me.

Keith Haring asked me to come to his studio one day. I said, "Can I bring a friend?" because I didn't know him that good, 'cause I was kind of scared and 'cause I was young. So I bring a friend over. There was this metal sheeting at the studio and he said, "If you don't mind, can you write your name on this?" So I wrote my name all over it. Then he did drawings on it, and he blended my stuff with his stuff, and it

looked real nice. He called me a week later and said he had sold that piece for $1,400. He told me to come over and get half of it.

So, again I bring my friend with me, and Keith gave me $700. I couldn't believe it. It was big money for me at this very early age of fourteen. So this friend, Ritchie—that was his tag—we went to the movies that same night. And I gave some money to my mother, and she didn't believe that this man gave me $700 for selling a painting, 'cause a lot of things were happening, like a lot of junk kids they were snatching pocketbooks and stealing chains.

So I called Keith and told him, "Can you come to my house and explain this to my mother?" So my mother cooked dinner that night and they talked. My mother liked him. And he liked the Spanish food she

fixed. He tried to talk a little Spanish to her. When they started talking together, I went to the other room—this was after dinner—and I let them talk 'cause they were the grownups and I was too young. So then my mother understood. Keith called me out and said, "Would you like to keep on drawing with me?" I said, "Sure!" And I went to his studio—and he and me, we just clicked—and we worked there a lot. There were rats that would run across the pipes, but it was real nice working together. So then, Keith says he wants to meet my friends from my neighborhood—and they were all graffiti kids.

KEITH HARING I started hanging out with all of LA II's friends, but they were all fourteen, fifteen, sixteen. When I was with them, I felt like the Cub Scout leader, because I'm much older and I'm white and I'm also much taller. So, it didn't feel right. But I wanted to be with LA II and his friends, because, like Fab Five Fred and Futura, LA II was the veritable graffiti king of the Lower East Side. He was king by virtue of the amounts of tags he had drawn. The sheer numbers alone were staggering, and they assured him a permanent place in the graffiti universe.

So, although I decided to continue collaborating with LA II, I also drew a lot of stuff on my own—drawings of every size and wood pieces that I'd drawn on and, of course, I was continuing my subway drawings.

More and more people keep coming to my studio, and my work continues to sell—and I keep on exhibiting in a lot of group shows. As it's now the end of 1981, I start thinking as to how I can control my art situation and I begin to wonder if I shouldn't go with a dealer.

KEITH HARING I began to become very frustrated by collectors who come to my studio, look through everything, and often haggle over prices. Then there are people I don't even want to talk to, because they're creeps. I can tell they want to get the work so they can resell it for more money—and they're trying to rip me off.

Suddenly, I hear dealers fighting over me—from a flame there was a fire, because people saw the potential. Annina Nosei, who has a downtown gallery and is very intelligent, wants me to come with her. Brooke Alexander is responding to my work. And there was Tony Shafrazi, for whom I worked as a gallery assistant. Tony was getting some investors together so he could move from his Twenty-eighth Street gallery, down to Mercer Street in SoHo, where he had found this really interesting space.

I had always maintained I would not take the path of other artists—I would not be like my artist-teachers at the School of Visual Arts, and go with a gallery, because galleries were going to corrupt me. I was going to be my own dealer, and sell to whomever I wanted so that I could maintain my integrity and my separateness from the art world.

However, I didn't come to a decision right away, because I was too busy work-

ing and collaborating with LA II and doing my subway stuff. I was also meeting a lot of people. One of them was Henry Geldzahler, who had looked me up and came to visit me at my studio. He got excited about my drawings and bought one or two of them. Because he's still the Commissioner of Culture, I dragged him down to P.S. 22, where I had made my graffiti project around the school courtyard. Although his boss, Mayor Koch, was declaring war on all graffiti work, Henry was—and still is—very, very enthusiastic. I felt I had found a real champion of my work.

HENRY GELDZAHLER The day I met Keith Haring at his studio, I went back to my office at Columbus Circle, and I invited the entire staff of sixty people into my office. I held up the works I had just purchased and said, "This artist is twenty-three years old. His name is Keith Haring and he's a genius. If you can do it, go out and buy yourself one of his paintings. If not, just keep him in mind." What I wanted to do, of course, was to make people aware of someone who would soon emerge as vitally important in the art world.

KEITH HARING At around that time, the subway drawings turn into this phenomenal thing. There's a following, and more and more people are watching me make these drawings. Well, what now starts to happen, is that I begin to get caught. Now, a lot of the transit cops have seen

the drawings going from station to station—they were familiar with them—but most of them still didn't know who drew them. When some of them caught me they still had to give me a ticket, which was a summons not much worse than a parking ticket, even though they seemed to like my drawings. All you had to do was send in the fine, and there's no record. Well, over the four or five years I drew in the subways, I probably had over a hundred of these summonses, all of which I paid.

One time, I was in the Fifty-first Street and Seventh Avenue subway station drawing, when this cop comes up behind me. He did not seem to be familiar with the drawings and seemed determined to make a big deal out of my doing this. He arrested and handcuffed me with my hands behind my back. I later learned that the minute anybody is handcuffed, they have to be brought to the precinct and issued a summons *there*.

Now, the nearest police precinct is just one stop uptown from Fifty-first Street—at Fifty-ninth Street. But the cop isn't allowed to take me there by train, only by patrol car. So he has to go upstairs and call a patrol car and, instead of taking me with him, he locks me inside the bathroom on the Fifty-first Street platform. So I'm sitting there, completely petrified, thinking that if this cop sees someone being held up and gets shot, I'm locked in this bathroom and nobody knows where I am. I'm thinking ten years later somebody will come in and find this skeleton wearing handcuffs and little wire-rimmed glasses!

Luckily, he's gone only fifteen minutes, and I'm led out in handcuffs to this waiting patrol car and taken to the Fifty-ninth

83

Street precinct. There, all the cops are wondering what this nerdy white boy could possibly have done. So the cop who arrested me says, "I caught him drawing in the subway on those black panels." The cop at the desk says, "So *you're* the guy who does those drawings—hey, Joe, hey Mike . . . this is the kid who does the subway drawings!" So cops are coming out and they want to meet me. They take off my handcuffs so they can shake my hand, 'cause, see, it's almost a year that I've done the subway drawings and I'm a celebrity. The cop who brought me in felt like a total fool. Of course, I was still given a regular summons.

TONY SHAFRAZI Keith was proceeding at a tremendous pace. He had this preprogrammed drive. I remember going to his studio on Broome Street, and the work and the energy were spectacular. Of course, many galleries were already interested in his work. He had already placed a number of pieces with various galleries. I myself had been looking for an opportunity to move to SoHo and finally, I found at space at 163 Mercer Street. I had to try very hard to get Keith to join my gallery. I had to win his confidence with my commitment and my dedication to his work. I identified with Keith's tremendously pure connection to the source of art, which was coming through him. It wasn't an acquired thing. He was a vessel.

KEITH HARING I began to realize that being my own dealer wasn't going to work. I just didn't want to deal with all the people who were coming to my studio—it took too much time—it was too distracting. So now I realize I must choose a dealer, someone who would be an exclusive dealer and keep me away from all these things. The point is, I saw my control slipping away, even though I had control over everything.

Making the decision to go with Tony Shafrazi wasn't difficult. He now had good gallery space in SoHo and, of course, I had not forgotten his awareness of art when I worked for him two or three years earlier. If I had a problem with Tony Shafrazi, it was over this whole business of the *Guernica* and the Museum of Modern Art.

Being an artist, and loving Picasso, I couldn't justify his having spray-painted the work, especially with paint that wouldn't easily come off. I mean, it was a real assault, and I wasn't comfortable with that. Of course, I had read many articles and interviews as to why he did it. It was a very conscious act, and, in a way, I respect his basic motivation, which was to bring *Guernica* back to its original function as a symbol for the horrors of war. Don't forget, this was during 1974, when there were still very strong anti-Vietnam feelings. Tony felt the power of the painting wasn't functioning anymore. The painting became part of the art establishment and lost its original shock, power, and potency. By just hanging there at MOMA, its message became very passive. So the concept of this one act of vandalism, and the painted message, "Kill Lies All," made sense to a degree because the

painting was immediately brought back onto the front pages and regained the effectiveness and power that it was supposed to have had in the first place. Even though I didn't like the idea of somebody assaulting the painting, it's still a great work of art. However, I join the Shafrazi Gallery in the spring of 1982, and Tony has been my dealer ever since.

Tony and I decided that I would have my first one-man show in his new gallery in October of 1982. It became an incredible event. Now, during this time, I had just been drawing, and for the show I wanted to do some big paintings, which I had resisted doing all along. The reason was that I had an aversion to canvas. I always felt I would be impeded by canvas, because canvas seemed to have a certain value before you even touched it. I felt I wouldn't be free, the way I was working on paper—because paper was unpretentious and totally available and wasn't all that expensive. Also, for me, canvas represented this whole historical thing—and it just psychologically blocked me.

One day, I observed some Con Edison men working on the street, and they were covering their equipment with these vinyl tarpaulins, which had these little metal grommets in them. So I went up and inspected them and wanted to buy some of these tarpaulins. Well, I located a place in Brooklyn called the Acme Rope and Canvas Company, which I partly chose because in Bugs Bunny cartoons, whenever Bugs Bunny has to get a product, it's always made by Acme! Anyway, I go to this place by subway—drawing on black panels along the way, of course—and they show me all these many-colored tarpaulins—and they can make them up to size—and I order a whole batch of them, and I tell them how to space the grommets. I then investigate which medium will bite into the surfaces, and discover it has to be a kind of silk-screening ink that's made for plastic. The ink is mixed with some lacquer thinner, and it can bite and sort of melt into plastic. So I order several gallons of it. The tarps I order are mostly yellow and bright red.

So I begin to paint on these tarps, some in my studio on Broome Street, and some in the basement of Tony's gallery, because they're very big—twelve by twelve feet. And I prepare for the show. First, I cover the entire gallery—from floor to ceiling—with drawings, leaving room for the tarpaulins, which are hung in strategic places. Then I add a whole series of baked enamel things, which I had constructed and then painted on. Then, in the basement, I did an entire black light installation, because I was becoming interested in fluorescent paint. The main piece was a giant reproduction of the *Venus on the Half Shell*—a sculptured figure—which LA II and I covered completely with drawings. There were also giant pillars that LA II and I drew on. And there were other three-dimensional objects, which I covered with fluorescent enamel paint.

By this time, I had become really skilled at hanging a show. CBS-TV asked to come and tape me preparing for it, filming as I complete a big painting, covering the opening, and this is to be shown on the "CBS Evening News" with Dan Rather! Well, the opening was incredible. That night, there were thousands of people—everybody I knew from the club scene, the art scene, and

the graffiti scene was there. It was this big mix-match of people, which had really never existed at a gallery opening before. I had girls serving Coca-Cola in little bottles, because Tony and I were obsessed by Coca-Cola in little bottles—and I didn't want alcohol at the opening.

And all these artists came! There was Roy Lichtenstein and Bob Rauschenberg and Sol LeWitt and Richard Serra and Francesco Clemente. I had people hand out stickers of my *3-Eyed Face*, which had become a sort of icon—and people were sticking it all over each other. And I gave away posters and buttons—there was a real party atmosphere.

Tony and I had prepared for this show on all fronts and we both worked constantly. Tony decided *not* to have just a regular catalog, but a real book, which would contain a lot of Kwong Chi's photographs and several essays and would be designed by Dan Friedman. The book cost $40,000, which was partly my money and partly Tony's money. I was very happy with it, except for the essay that Robert Pincus-Witten had written, which I really disliked because it was noncommittal. What I objected to was that he had written several critical escape hatches, so that if my work *did* bomb, he wouldn't look like a fool. So I never reprinted the book because of that reason. However, the essay by Jeffrey Deitch was exceptional. Also included were a series of questions posed by David Schapiro, which I was to have answered. But there was no time, and so we just published the questions *without* the answers, because the questions were very complicated and obscure and abstruse—and they made a statement all their own.

DAN FRIEDMAN It was by Keith's insistence that I was chosen to design the catalog/book for his opening show at Tony Shafrazi's. I thought it would be interesting to do a book on a young artist, who was basically quite unknown—so I approached it in the same way that I would approach creative corporate image-making. Tony realized that this publication would be the vehicle that would give Keith Haring instant international credibility. Indeed, I feel that the catalog was instrumental in launching Keith's career, because shortly after his show and the publication of the catalog, he became a recognizable talent throughout the world.

JEFFREY DEITCH Some people know me as an art writer. Some, as an exhibitions organizer. In another world, people know me as an art dealer. And in still another world, people know me as a connoisseur of modern art. So, I combine the traditional roles of curator and art critic with the role of the art dealer. To be more precise, I'm a private curator.

I was probably asked to write the essay in Keith's first show catalog because we are friends. But also because I admire him tremendously. I've known Keith since 1980 or 1981, and one reason I admire him so much is because he's not just a product of his own time, but has, in fact, shaped his time. In him I see an extraordinary convergence of street style, rap music, and graffiti art that sums up the spirit of the early to mid-eighties. It was an era of greater sexual openness, a greater openness to differ-

ent cultures, and interchange between races—a lot of "downtown" kind of esthetic moving into the mainstream. And Keith typifies that, as does someone like Madonna—there's definitely a parallel between them and, of course, they're friends.

What also drew me to Keith was his entrepreneurial energy. I mean, it's really so pitiful to think of artists having to go around to established galleries and beg for someone to show their work when the whole world is right there! Why should you have to beg to get into the Mary Boone Gallery? So, from the first, Keith leapfrogged all over the small-minded art world system. He really thought big!

Just look at the subway pieces! During the 1980s they really became part of the history of New York City. They were incredible—and the mystery of them—and thousands of people standing on the platforms looking at them!

The thing about Keith—he has a really wide constituency. There just is no other artist who has a constituency of street kids like Keith. And that's so great, because it shows that the art really cuts through the pretentiousness—and really reaches people!

daughters, and they turned out to be Keith's parents and sisters from Kutztown, Pennsylvania. I looked at them, and they were in a complete state of bewilderment. We felt that Keith had invited them because he was desperate to have them recognize what all this meant. But it was too overwhelming for them. I felt they were asking themselves, "Is this dignified? Is this the proper behavior at an art opening? Is this what success is about?" Because this was surely something they'd not seen before. And Keith desperately wanted to show them something they couldn't even comprehend. Not that they were insensitive, but, to them, this entire event was incomprehensible.

So we met the entire Haring family, and Don and I thought we'd take them back to our house for dinner. We suggested this to Keith, and he loved the idea. So, we took Joan and Allen and the three girls uptown. When they walked into our town house, they saw many art objects and among them, in a place of honor, hung their son's art. I had the sense they were thrilled. So we had spaghetti, because it's the food of life, and we had a wonderful time just talking.

MERA RUBELL Don and I had become friends with Keith, and had already bought works from his studio and from Club 57, and now came this first one-man show at Tony Shafrazi! Well, I'll just never forget that opening! It was an event. It was wild. It was a madhouse. And at the height of this madness, into the gallery walked these people—a mother, a father, and their three

JOAN HARING We never knew whether what Keith was doing would ever be anything big. But after he had been in New York for two or three years, he came home to visit. He reached in his pocket and pulled out ten $100 bills. I said, "What's that?" And he said, "I've sold some more things. And this is to pay you back for some of the money you've given me over the years." I said, "My goodness!" He said,

"Things are good!" Well, at this point we still didn't know *what* he was doing. But it was clear that there was a lot going for him—the subways, the clubs. Then that show at Tony Shafrazi—we thought it was just great. And that's when people started going up to him and saying, "Wow! You're Keith Haring! Will you sign this?"

ALLEN HARING I'm very proud of what Keith has accomplished. I think he has done the thing I haven't done—and maybe that's a reason that makes him do it—seeing that I had talent and didn't use it. But he has it, and he *did* use it!

KEITH HARING My show at Shafrazi is this fantastic success. Four thousand people see it. People begin to know me. I've had this giant SoHo show—I'm a SoHo artist. And now, it's getting to be 1983. Juan Dubose is still my lover—we've been together for nearly a year. We're not completely monogamous, but pretty much so. We have a perfect home life. He's deejaying and making tapes, which I'm listening to while working. We still live on Broome Street—Samantha McEwen has moved out—and just before my Shafrazi show, I find a new studio, at 611 Broadway.

I'm terrifically comfortable with Juan. But then, I'm always comfortable with people of color—much more than with white people. It isn't something I specifically look for, but from the time I was a little kid, I had this tremendous guilt about what white people have done to people of color. I mean, in eighth grade I had done a report on Geronimo, who was one of my heroes, and I was appalled at what we did to the Indians. And I learned about the Japanese in California during World War II, and how we put them in camps. And the whole Civil Rights movement . . . well, from the very beginning, I felt a much greater affinity to the culture of people of color than to the culture of white people.

I felt like Brion Gysin, who wrote that he was just put in the wrong skin—that he probably belonged in black skin, but ended up in white skin. I feel that way too, because my spirit and soul is much closer to the spirit and soul of people of color. And, yes, I have an erotic attraction for people of color, because there is no better way to be wholly a part of the experience than to be sexually involved. I firmly believe that a sexual relationship—a deep sexual relationship—is a way of truly experiencing another person—and really *becoming* that other person.

So I had that with Juan Dubose, who was a black person. And I became a part of his life. We'd have Thanksgiving dinner and Christmas dinner at his mother's house in Harlem, and I'd eat all these different foods. I was totally accepted as part of that family.

The love I had for people of color was the reason Juan and I hung out at the Paradise Garage. It's a disco that absolutely blew my mind. I mean, I have never been the same since I walked into Paradise Garage!

Actually, I discovered Paradise Garage while I was out walking one night with Fab Five Freddie. It was maybe 2:00 A.M.

and we were high and in the West Village. We came to King Street, just off Seventh Avenue and there's this place. It's packed, and maybe 70 percent of the kids are black, 20 percent are Spanish, and 10 percent are Oriental and white. The place is only open on Friday and Saturday—Friday is straight night and Saturday is gay night. But on gay nights, it's nothing like other gay discos, because the kids here are gay but they're really tough street kids—and they're incredibly, incredibly, beautiful!

It got hot at the Paradise Garage. It got hot because of the dancing, because of the music, because of the lights. And people wore these short-shorts and little outfits and they were sweating. The music was phenomenal—and a guy named Larry Le Van was the deejay there and he was like a god in his deejay booth. I was totally mesmerized!

Juan and I go there every Saturday night for five years! It's a ritual. We dance and we drink fruit juice, because there's no alcohol being served—and the juice is free. But many, many people are on hallucinogenic drugs—and it's the closest thing to being at a Grateful Dead concert, except that it wasn't this hippie thing, but taking place in a totally urban, contemporary setting. The whole experience was very communal, very spiritual.

I'm so crazy about the Paradise Garage that I ask the owner if I could do an installation there. He says OK. So I use a roll of six-foot-wide paper and I do these complex and detailed drawings in black and white with sumi ink. We have an opening night but people pay very little attention to the drawings, and I'm kind of hurt.

Still, on that night I meet this incredible person named Bobby Breslau. He comes up and introduces himself to me. He's this short, interesting-looking Brooklyn guy, who offers to share a joint with me. It turns out Bobby knows Larry Le Van, the godlike disc jockey, and he introduces me to him. Bobby Breslau, who happens to be white, also becomes a friend.

I learn that Bobby worked as a designer of handbags for Halston, that he hung out at Max's Kansas City, and he's a friend of Andy Warhol, and knows absolutely everybody. Bobby is an older guy, but he becomes one of my closest friends and supporters. In fact, Bobby becomes part of my life—he becomes my Jewish mother!

It's now the spring of 1983. A gallery opens in the East Village called the Fun Gallery, which was named by Kenny Scharf. It was run by Patti Astor and Bill Stelling and it was the very first East Village gallery. Its opening really marked the beginning of the whole East Village art movement.

Now the Fun Gallery was mainly a graffiti gallery, and their first few shows were by spray-gun graffiti artists. Still, Kenny had a show there, and Jean-Michel Basquiat and I were asked to have shows there too. I didn't really need to have a show, because my big Shafrazi show was just six months earlier. Even though I was more and more *dis*associating myself from the graffiti scene, I wanted to show my support of the gallery and the artists and I agreed to participate.

I wanted to show something new, and so I decided to work with leather hides. Bobby Breslau, who had worked with leather when he designed handbags for Halston,

took me to leather places and introduced me to this whole world of pelts and hides. I bought all these strange pieces of leather and did drawings and paintings on them. Some, I covered with marker, and some, with acrylic paint.

For the opening, my little graffiti pal, LA II and I, spray-painted the entire gallery, which was located on East Tenth Street. I hung all the new leather pieces, and also showed these tables that my best friend, Kermit Oswald, had made and cut, and which LA II and I covered with fluorescent paint and drew on. I also showed a batch of plaster-cast Smurfs, which were also covered with fluorescent paint and drawn on. I did the Smurfs because they were cartoon characters on television, and also because break dancing was just coming up big, and there was this whole thing called "The Smurf" and "Smurfing."

Juan Dubose flanked by Smurfs tagged by Keith and LA II. Fun Gallery. New York. 1983.

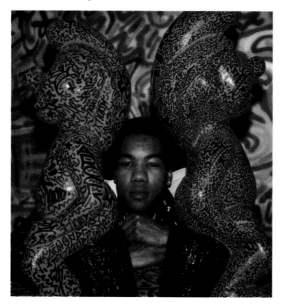

See, there was this incredibly raw energy in the air—and it lasted for a good two or three years—and the energy was called Hip-Hop. This Hip-Hop scene included rap music and deejays, who would be "scratching," which meant moving the record back and forth so that it would be making a sort of electronic scratching noise. And it also included break dancing and spray graffiti, because the graffiti scene was really the visual equivalent to the music.

So, you had the music, which was scratching and rapping, and you had dance, which was not only break dancing, but also electric boogie, which was a form of break dancing, but not done so much on the floor. It was doing movements that had electric pulsation, which would be transferred from person to person—it was a fluid sort of movement. Michael Jackson was picking up on this and by doing so, electric boogie made the crossover into a bigger cultural phenomenon.

Well I began incorporating all of this into the images I was making. Break dancing was a real inspiration, seeing the kids spinning and twisting around on their heads. So my drawings began having figures spinning on their heads and twisting around. My exhibition at the Fun Gallery was really a reference to this whole Hip-Hop culture. And it was during the opening of *this* show that I finally met Andy Warhol.

I was so in awe of Andy that I didn't know what to say. Well, he made me feel comfortable very quickly and from that day on, we became really good friends.

Very soon, Andy invited me up to the Factory, and we talked about trading art works. He let me look through his prints,

and I saw a series of really erotic prints—guys fucking guys and closeups of dicks. I chose one print of a guy fucking another guy, and he said, "I'll make you a painting of it." So Andy took a white canvas and made the same drawing on it, only in real closeup so that it's a kind of abstraction, but you still can see what's going on. That was my first Warhol painting. For it, I had to trade him I don't know *how* many things, because the trade was sort of value for value—and his stuff was very expensive. So his manager, Fred Hughes, arranged all that, because Andy didn't want to be involved in this part of the trade.

Not only did I meet Andy during this period, but also Madonna. Now, in 1983, Madonna was very much around the East Village scene. It was sort of her turf. Her boyfriend at the time was "Jellybean" Benitez, and he was the deejay of The Fun House, which was a Spanish club in the West Twenties—and Madonna performed there. She had just come out with a couple of songs—they were pop-disco songs—that were beginning to be popular on the radio. She was very much revolving around the Hip-Hop scene—and also hung out at the Roxy, which was a mecca for break dancing. So we all circulated, went to the clubs, and I'd go hear her sing. She and "Jellybean" were real close—he wrote songs for her—and it was the beginning of her incredible success.

The parties I gave in the Broome Street apartment were a mixture of all these scenes—and people, and the apartment itself was a scene-and-a-half, because it was totally covered with art. By this time, Andy had done a double portrait of me and Juan. The kitchen was completely covered with graffiti by LA II and this kid, CRANE—and my private art collection was growing—more Kenny Scharfs, more Basquiats, more graffiti paintings by Futura and Fab Five Fred. My refrigerator and the doors to my apartment were completely covered with signatures of graffiti artists.

The people who came, like Madonna and Andy, represented the downtown cultural elite. It was my "in" scene. It wasn't the Schnabel-and-Salle painters set. And it wasn't the Mudd Club scene, but more an extension of Club 57, which by now was defunct. Anyway, from that time on Andy Warhol and I spent more and more time together, because Andy became more and more energized by the scene that was evolving—that whole young thing that ultimately gave him a new creative kick and got him to collaborate with Jean-Michel. Madonna was around and we all kind of grew up together in this crazy swirl of activity.

MADONNA Keith's work started in the street, and the first people who were interested in his art were the people who were interested in me. That is, the black and Hispanic community—I'd say people from lower income and background. His art appealed to the same people who liked my music. We were two odd birds in the same environment, and we were drawn to the same world—and inspired by it.

I watched Keith come up from that street base, which is where I came up from, and he managed to take something from

what I call Street Art, which was an underground counterculture, and raise it to a Pop culture for mass consumption. And I did that too. The point is, we have an awful lot in common.

Another thing we have in common—and this happened quite early—was the envy and hostility coming from a lot of people who wanted us to stay small. Because we both became very commercial and started making a lot of money, people eliminated us from the realm of being artists. They said, "OK, if you're going to be a mass-consumption commodity and a lot of people are going to buy your work—or buy into what you are—then you're no good." I know people thought that about Keith, and they obviously felt that about me too.

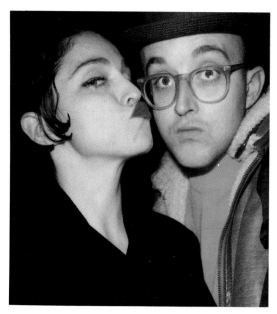

Madonna and Keith backstage following her performance in David Mamet's *Speed the Plow*. Vivian Beaumont Theater. New York. November 1989.

So Keith and I are sort of two sides of the same coin. And we were very supportive of each other in those early days. I remember Keith coming to watch my first shows. That was down at the Fun House, where "Jellybean," with whom I was involved, was the disc jockey. I'd sing and dance—and I'd choreograph these scenarios—and we had taped music and it was great, because this was a Hispanic club—and the atmosphere was just charged!

I don't know *what* drew us to these exotic clubs—like the Fun House or Paradise Garage. Obviously, it was the sexuality and the animal-like magnetism of those people getting up and dancing with such abandon! They were all so beautiful! I've always been drawn to Hispanic culture—and so has Keith. It's another thing we have in common.

So these were the people who bought my records in the first place—and they're a great audience to perform for. Keith keyed into that too. He'd give these great parties, and I'd go to them and I'd give parties and he'd come to them. And we had such fun!

Another thing we have in common . . . we have the same taste in men! I remember a funny story about people saying that I stole one of Keith's friends. What happened was that I had a New Year's Eve party, and Keith arrived with this incredibly gorgeous guy. I remember Keith saying, "He's yours, Madonna. He's your New Year's Eve present!" I said, "Oh, thank you!" And there was this really stunning guy—a great dancer—completely happy and a great positive spirit. And so he became my friend, too.

Anyway, I've always responded to Keith's art. From the very beginning, there was a lot of innocence and a joy that was coupled with a brutal awareness of the world. But it was all presented in a child-like way. The fact is, there's a lot of irony in Keith's work, just as there's a lot of irony in my work. And that's what attracts me to his stuff. I mean, you have these bold colors and those childlike figures and a lot of babies, but if you really look at those works closely, they're really very powerful and really scary. And so often, his art deals with sexuality—and it's a way to point up people's sexual prejudices, their sexual phobias. In that way, Keith's art is also very political.

What stays with me is that very early on, when Keith and I were just beginning to soar, our contemporaries and peers showed all this hostility. Well, the revenge was that, yes, there's this small, elite group of artists who think we're selling out. Meanwhile, the rest of the world is digging us! Of course, it's what *they* want too! It's so transparent! They're just filled with jealousy and envy. And it certainly didn't stop us, because Keith didn't want to do his work just for the people of New York City—he wanted to do it for everybody, everywhere. I mean, an artist wants world recognition! He wants to make an impression on the world. He doesn't just want a small, sophisticated, elitist group of people appreciating his work. The point of it all is that everybody is out there reaching for the stars, but only some of us get there!

When I think of Keith, I don't feel alone. I don't feel alone in my endeavors. I don't feel alone in my celebration of what I've achieved. I don't feel alone in the odds I've been up against. I feel so akin to Keith in so many ways! I really can't compare myself to many people . . . and I don't feel that many people can relate to where I've come from and to where I've landed. So when I think of Keith and his life and what he's achieved . . . well, I feel that I'm not alone.

KEITH HARING I had never been to Europe, and now I'm invited to have shows there.

Even before my big Shafrazi show, I'm offered a drawing show in Holland—in Rotterdam—by the Rotterdam Arts Council. It's where Francesco Clemente and George Condo have had some of their earliest shows. So I go, and I'm completely blown away by being in Europe.

After Rotterdam, I go to Amsterdam and visit the Stedelijk Museum, which has this really fine modern art collection—and I'm impressed. Then, on my last day, I remember being driven past fields and fields of tulips—it was my twenty-fourth birthday, May 4th!

The next trip to Europe is very shortly *after* my Shafrazi show, and I go to Kassel, Germany, to be part of *Documenta 7*, which will show two of my biggest tarpaulin paintings. This time, I take Juan Dubose with me.

Before my next shows in Europe—all of them in 1983—at galleries in Italy, Belgium, and England, I grab this great opportunity of going to Japan. Japan has always meant a lot to me—the whole Eastern philosophy thing and, of course, the

calligraphy. Also, when I was a little kid, my father, who was in the Marines, was stationed in Okinawa. There are snapshots of my father standing in front of Buddhas—so the whole Japanese idea has always fascinated me.

Because of my anxiousness to go to Japan, I agree to a one-year exclusive contract with the Watari Gallery in Tokyo. I decide to take Juan as well as LA II. Now, at this time, because of the demand for my work—it was still very inexpensive and collectible—I approach almost all my shows by doing the work on the site—painting the whole show in whatever gallery, right then and there. So, when we get to Tokyo, I buy all my materials. I set myself up in the gallery, and begin to work.

In Tokyo, we're this strange little group. LA II is like my little brother—he's fifteen by now—and he's totally cool about Juan and me being lovers. It doesn't intimidate him at all. The first night in Tokyo, we stay in this very traditional hotel—sleeping on floor mats, bathing in stone bathtubs. But it's a little too weird for us. The next day, we move to the downtown district and check into the Tokyo Hilton, where LA II, who doesn't take to Japanese food at all, can get a cheeseburger.

In the meantime, I spend almost all my time working on my show at the gallery. The people of Tokyo already know who I am, because the graffiti scene was just beginning and they're just finding out about the Pop and Hip-Hop scenes. Almost immediately, the three of us—this Puerto Rican kid, this black kid, and this white kid—become media stars.

We become even bigger stars when the gallery owners, who also own the three-story building opposite the Watari Gallery, ask if I'd like to paint the facade of that building. So I agree, and they put up scaffolding and LA II and I proceed to cover the entire facade of this building with Japanese spray paint. All this is covered on national Japanese television, there are photographers everywhere, and later there are tons of interviews in magazines and papers.

I then prepared my show—doing lots of drawings with sumi ink, paintings on tarpaulins, and also on some small canvases. I order Japanese screens, fans, and kites, because I want to draw on them—and they go into the show. LA II and I find these plaster-cast objects and he and I cover them with fluorescent paint—and this whole thing builds up and up to the crescendo for the grand opening. Tony Shafrazi flies in to be present and, finally, the opening day arrives.

People begin lining up to get into the gallery, and they line up to get my autograph, and to bring me gifts, which is a great tradition. It all takes hours, and everyone is very polite and really shy and timid. The opening is this wild success, and people loosen up.

Later there's a huge party at a club. At one point, the owner comes to our table with a silver platter on which stand rows of spray cans. And we're asked to paint one of the walls in the club, which, of course, we do. And, again, there's a sea of photographers—the flashbulbs are going off like mad. It gets a bit out of hand, because the press just follows us everywhere—we're even photographed at the club's urinals!

When we leave, we have media all the way to the airport and we are still being photographed while making this grand exit.

LA II I give credit to my parents, especially my mother, because I was fourteen years old when she said, "Yes, you can go with a stranger to Tokyo." Imagine your parents telling you that at such an early age. She hardly knew Keith, except for that one night that he came to my house and ate dinner. She trusted Keith—and she gave her son away to go to another place, in another part of the world—thirteen hours on the plane! I was so excited. When your parents are on welfare, it's something you would never expect to happen.

KEITH HARING After Japan, I have a show in Naples, Italy. It's another on-site show, where I do all the work right in the gallery—but it's also where I do my first body painting. A teenage magazine called *Frigidaire* wants to do a story on me, and for photographs, I decide I want to paint somebody's body. A young architectural student volunteers to disrobe and be painted. The only stipulation is that I remove the paint once I'm finished. I was to shower him. So he stands there completely naked even though I'm only painting him from the waist up. I use acrylic paint, which works fine—the experiment is a success. The pictures get printed, and I'm thinking I want to do more paintings on bodies.

This is still 1983 and I get the chance to do more body painting when I have my first show in London at the Robert Fraser Gallery. As it turns out, two friends of mine, Arnie Zane and Bill T. Jones, the dancers/choreographers, are also performing in London and I'm really glad to see them. Juan is with me, and Arnie, who is white, and Bill, who is black, are also lovers. I had collaborated with them in the past. So I want to paint Bill T. Jones. I want to use white acrylic paint on Bill's beautiful black body . . . and this time, I want to paint every inch of his body, from head to toe to the tip of his foreskin!

BILL T. JONES I first collaborated with Keith in early 1983, when I did a solo at The Kitchen in New York, and Keith came on stage and did drawings behind me as I performed. The music was the sound of his brush against the paper and my feet on the floor, my breathing. It was a collaborative thing and it was very physical and sexy. So this piece, which was called *Long Distance*, produced an intimacy between us that I prized. And it felt sexual.

And it still felt sexual when he painted me later that year in London. Keith was showing at the Fraser Gallery, and for this painting session of ours he rents a special studio. Tony Shafrazi is there, and Kwong Chi is there, photographing the whole thing, and Arnie Zane is there, videotaping it. And the music is going and the hip hangers-on are there hanging on.

It took so long! Over four hours! And the white acrylic paint was so cold! I sud-

denly felt what it must be to be a bushman! I was transformed, because as Keith was painting me, I moved almost constantly—and I followed Kwong Chi's instructions, because he was photographing me from every possible angle.

Of course, I'm totally naked, and Keith started at the top of me and gradually moved down with the brush, making these incredible patterns. Finally he reaches my penis, and he does these last three stripes on it. He goes, "One, two, three!" And he looks up at me in that kind of way he has, with that little smile of his—and it was total communion at that moment.

It was a very special moment, and I felt Keith was being absolutely honorable, and he made it very clear to the press that came around, that he truly did not want to exploit anybody. But I said to him, "Keith, these pictures will probably appear everywhere, and your name will always jump out. I want to make sure that every time these pictures are reproduced that my name is there as a choreographer, not just some black dude who you painted." And he got the message, and to this day, my name appears with those pictures. I've never seen money from it, and I don't know if he has either, but they're a great record of a great moment!

I'd like to say something about my friendship with Keith Haring, because it's very complicated. We've known each other since 1980, when we met in Kutztown, where Arnie and I were invited to be a part of the university's Visiting Artist program. First, we met this amazing young guy called Kermit Oswald, and it was Kermit who told us we must meet Keith Haring—and Ker-

mit showed us Keith's drawings—a lot of them erotic and some of Mickey Mouse with no ears—it was wild stuff. And we met him and right off sensed this was someone special.

The next time we met was through Bill Katz, who suggested that Keith do the poster for one of our concerts —which he did. Then, in 1983, Keith and I did this collaboration at The Kitchen. In 1984, we would collaborate again on a major scale, when Keith did the sets for *Secret Pastures*, a work commissioned by the Brooklyn Academy of Music.

By this time, we had become pretty good friends. Keith is a country boy, like I am. There's a part of him that's very down-to-earth-Pennsylvania-farm-country. When we first met, he didn't know about champagne or about entertaining or about the pretentions of the Sunday *New York Times*. Also, we were both struggling to have relationships—and interracial relationships at that. And I've always pushed Keith on that.

Look, I was with a white man—a middle-class, Jewish-Italian white man—for seventeen years. It was practically half my life—and then, in 1988, Arnie Zane died of AIDS. What I want to say is that at the beginning, I felt my inadequacies. I mean, I couldn't balance a checkbook. And people wouldn't even talk to me, because they assumed Arnie had the brains. But he was the one who encouraged and promoted me, saying, "Get your worth! Don't let people take advantage of you." Yes, we fought

Dancer/choreographer Bill T. Jones body-painted by Keith. London. 1983.

96

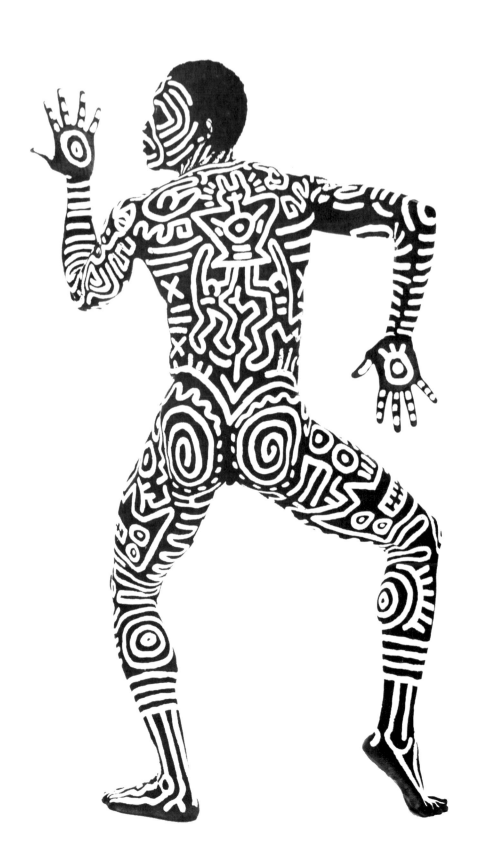

like hell at times, but the important thing is, we respected each other.

I've always told Keith, "You can't be with a person who you don't respect. You can't be with a person who you can't talk to." You see, I think gay men have some sort of moral high ground in the area of oppression, and they usually don't team up with just cute little things who you pat on the ass—who just keeps the house. I mean, if you're an artist, you need a real collaborator, somebody you're going to bring up with you. The fact is, Arnie Zane, who was the first man I had sex with, took me from age nineteen to the day he breathed his last breath. I was thirty-five, and he delivered me into the real world.

What I'm trying to say is that Keith loves people from a class lower than his own. Well, there's a responsibility that goes with that. And that responsibility is not just how generous you are, but how you can bring that person up through his emotional perils and feelings of inadequacy. Does Keith really know what it means to set up house with someone who is not as educated as he and is more emotionally and financially handicapped? So I talked to Keith about these things. But you can only push Keith so far until he's finally not there. Look, I think Keith is a great man, and I say this because I think the art scene is racist and extremely classist.

I once read an article in *Rolling Stone* magazine that listed the most overrated people in the art world. Well, they listed Keith Haring as a person who rips off third-world artists—meaning, the graffiti artists. But I defend him on that, because he showed great love for these artists. So I'm not calling Keith a racist. I'm saying he doesn't understand that he is a product of a racist environment.

Anyway, I remember visiting Keith and Juan Dubose in their funky little apartment on Broome Street—they looked so much like little boys. There was beauty in that. And there was tenderness between them. In a way, they started out as emotional equals. I always felt that Juan had even a little more maturity than Keith—and he was a perfect foil for Keith—and he sort of understood what was happening to Keith and his career.

I tried to tell Keith that because both of us had stepped out of our territories to bond with people of another race, we had to be extremely vigilant and courageous and look honestly at what we were doing. Now Keith has always taken very good care of his lovers, but he never quite looked at what he was doing. I mean, Keith does outrageous art, but he's not extremely warm nor is he an extroverted person. It's all in what he does—it's all in his art. So I called him "The Iceman," and because he's an iceman, he loves hot and passionate people.

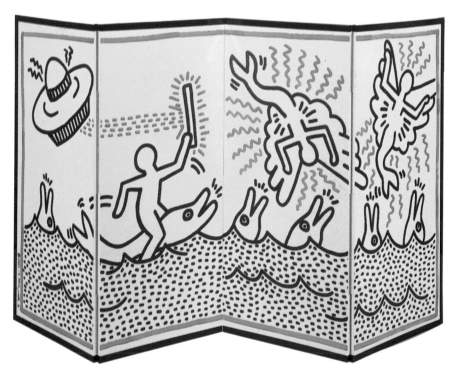

Folding Screen. 1983. Gouache and ink on paper. 36″ × 65″.

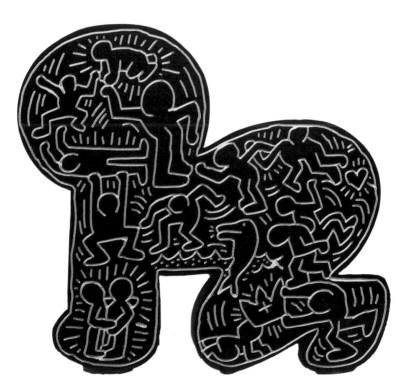

Untitled. 1981. Baked enamel on metal. 4′ × 4′.

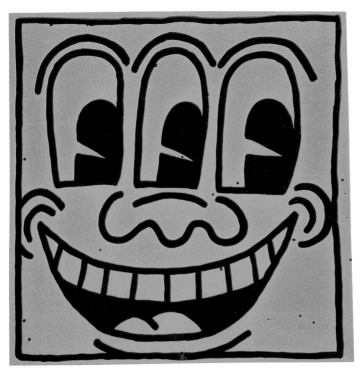

Untitled. 1983. Enamel on incised wood. 35″ × 36″ × 2½″.

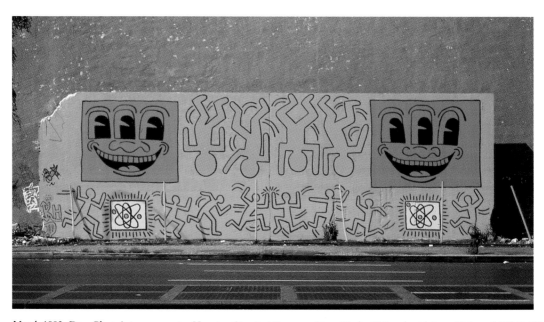

Mural. 1982. Day-Glo paint on concrete. Houston Street at Bowery. New York. (Painted with Juan Dubose.) 15′ × 50′.

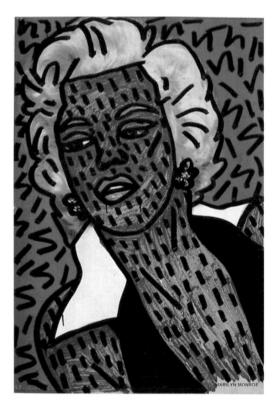

Marilyn Monroe. 1981. Marker ink on poster. 39″ × 29″.

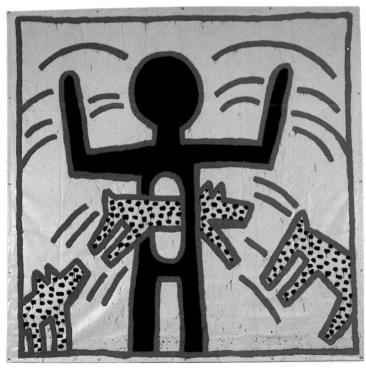

Untitled. 1982. Vinyl ink on vinyl tarpaulin. 12′ × 12′.

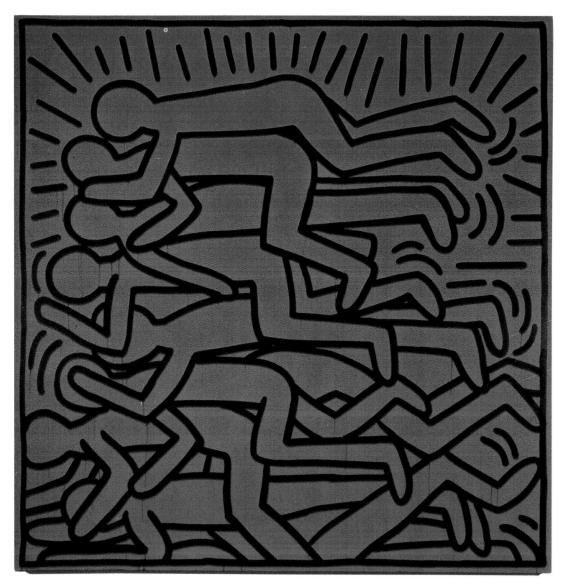

Untitled. 1982. Marker ink on found canvas. 86″ × 86″.

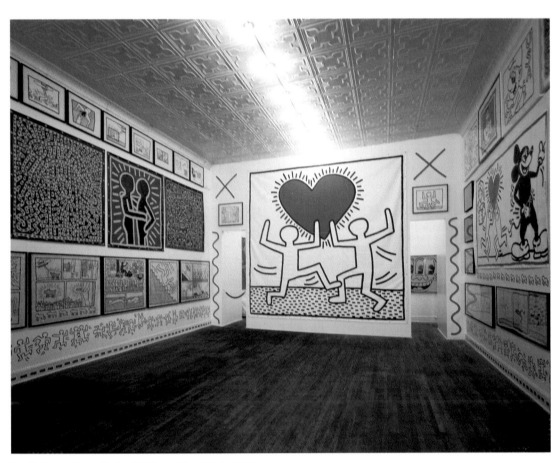

Installation at Tony Shafrazi Gallery. New York. 1982.

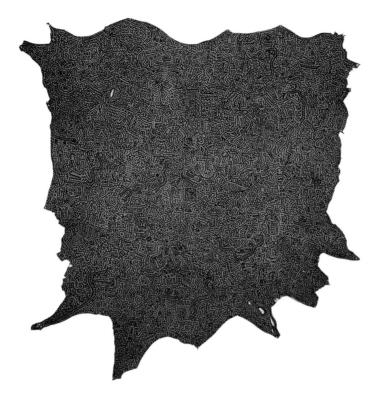

Untitled. 1983. Marker ink on leather hide. 94″ × 84″ (approximately).

Radiator cover, a collaboration between Keith and LA II. 1982. Acrylic, ink, and marker. 25″ × 41½″ × 5″.

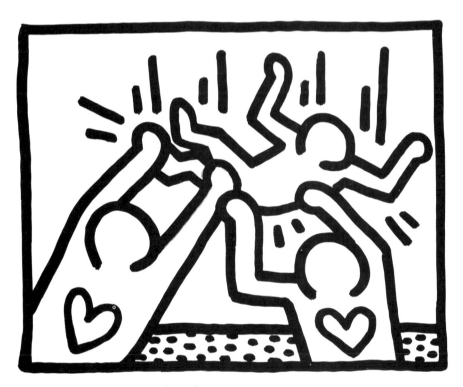

Untitled. 1983. Ink on vellum. 11″ × 14″.

Untitled. 1983. Ink on vellum. 23⁵⁄₁₆″ × 30¹⁵⁄₁₆″

Untitled. 1984. Oil and acrylic on canvas. 5′ × 5′.

Untitled. 1983. Silkscreen, edition of 100. 42″ × 50″.

Untitled. 1983. Day-Glo enamel and marker ink on fiberglass. 34″ × 16½″ × 13″.

Untitled. 1984. Day-Glo enamel and marker ink on fiberglass. 60″ × 25″.

III
1984–1986

KEITH HARING The time is now approaching for my second show at the Tony Shafrazi Gallery, and I'm asking myself, "How can I top the first one!?" So I begin with a title: *Into 1984*, because the show starts in late December 1983 and goes to January 1984. Again, I work very fast and decide I want larger-than-life blowups of Kwong Chi's photographs of the painted Bill T. Jones. These I mount on and cover in Plexiglas, and they're part of the show. Instead of a catalog, I design a huge poster of Bill T. Jones.

I next decide to work with my friend, Kermit Oswald, on a project involving drawings on wood. Kermit, who is now married and living in Brooklyn and making a living building frames, introduces me to a carpentry tool called a router, which is like a drill. You can push it around and glide it through pieces of wood. You can use it like a pencil or a pen, but it's really a modern way of carving, because there's a metal bit spinning around.

I practice with this tool until I'm comfortable with it, and I then proceed to make drawings on these pieces of raw wood, which Kermit has prepared. Then we paint the inside of the grooves, usually with fluorescent Day-Glo paints, and these new wood drawings practically make up the whole show. Some of them are three-dimensional—sort of totemic things—and I place these in the middle of the gallery. The rest, I hang around the walls.

Before installing these new pieces, I paint the whole gallery with a huge brush, making enormous gestural red shapes on the walls. The floor is done with large checkerboard squares, and inside the squares I paint

red lines and dotted white lines and the whole place sort of reels. On top and against these patterns, we install the wood pieces and the blowups of Bill T. Jones—and it all creates this incredibly active floor-to-ceiling totality.

Tony Shafrazi now rents an extra space right around the corner of the gallery, on Houston Street, because he wants to make the show bigger. The space is huge. There's an upstairs and a basement. As in my first show, I use the basement as a black light installation, and LA II and I paint the walls with fluorescent paints. Because it's the height of break dancing, I decide that the basement should become a kind of break-dance disco. I ask Juan Dubose to move his deejay equipment into the basement and there's great music. The break dancers come, and there's a party every night. In the upstairs space, I make new tarpaulin paintings, one of which measures sixteen by twenty-two feet. We also install more wood pieces.

Again, the opening is a wild success, thousands of people show up, and the Houston Street annex becomes a disco space for an entire month.

One night, Andy Warhol shows up and goes to the basement and the minute the ultraviolet light hits him, his wig starts to glow like crazy! I mean, it's really hysterical, because the wig looks like it's on fire. Well, none of us say anything, no one laughs, until René Ricard saunters up to him and just totally freaks him out by saying, "Andy! Your hair! It's glowing! It's incredible!" Andy feels terrible and leaves in a snit.

Anyway, this is another leap forward for me, my name continues to spread and

1984 becomes one of my most active, craziest years!

KERMIT OSWALD Keith and I went to a high-school reunion in Kutztown, and there were people we hadn't seen in ten years. Some came up to me and said, "I can't believe that Keith is the one who made it. We all thought it would be you!"

Well, it didn't really upset me, because I tried New York, and it just didn't happen for me. I became disillusioned by the politics and unfairness of the art world. It just seemed that whoever pushed the hardest, won. It didn't have to do with the work being done, but of who had the biggest mouth. I became cynical. I said, "This isn't a profession. It's a racket!"

Mural painted in Melbourne, Australia, at the Collingwood Technical School. 1984.

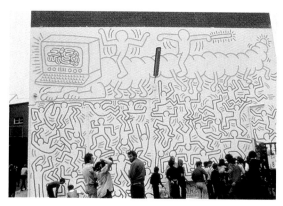

KEITH HARING Right after my 1984 show at Shafrazi, I'm invited by the National Gallery of Victoria in Melbourne, and by the Gallery of New South Wales, in Sydney, to go to Australia. Each wants me to do an on-site project.

The Melbourne gallery wants me to paint a huge glass wall, which has a cascade of water running down the front of it. This was the facade of the gallery, which is considered an equivalent to the Metropolitan Museum of Art in New York. So, they turn off the waterfall and supply me with a sort of scissor lift, which moves me back and forth or up and down.

I buy paints that work on glass, and proceed to do this mural with red and black paint. It takes about two days, and the whole thing is documented on film by pupils of the Australian Film School. When the mural is finished, front-page stories begin to appear in the Melbourne press, stating how insulting it was that I, an American artist, had been hired to come to Australia to make Aboriginal art. I didn't even know what Aboriginal art was! But the Australians took real offense at what they considered to be an invasion of their artistic heritage. They got real paranoid about the whole thing.

Well, what I had painted on the glass wall was exactly what I was painting all over the world. I mean, the imagery contained all kinds of concentric circles and snakes and little figures and patterns. I had no idea they strongly resembled Aboriginal art. Two months later, I learned that someone had taken a gun and shot through the central panel of the painting—and the whole thing had to be removed.

While I was in Melbourne, somebody called from the Collingwood Technical School, which is an all-boys elementary to junior high school. This person said that they had no funds, but that there was a great wall just outside the school, and would I be interested in painting it? I went to look at it, and agreed to do it—and it's become a permanent site!

For the Gallery of New South Wales of Sydney, I did an enormous indoor mural, which was temporary and was painted over a few months later.

On the whole, the Australian experience wasn't all that hot. What finally happened was that the guy who sponsored the whole trip—someone who seemed like a really great guy—just ripped me off. I mean, he got me to do all these paintings and drawings, which I left there because he was going to organize this big exhibition. Instead, he flaked on the whole thing. When I got back to New York, we never heard from him again. We tried to track him down, because he never paid for the art works, and there was never an exhibition. So I have all these lost works in Australia!

When I get back to the states, I do other murals in fairly quick succession. One is at the Walker Art Center in Minneapolis. One is on Avenue D in New York. One is in an orphanage called Children's Village in Dobbs Ferry, New York. I also have a brief stint as artist-in-residence at the Ernest Horn Elementary School in Iowa City, Iowa, because a teacher there, Colleen Ernst, wrote to say she was teaching a class about me. So I do these drawing workshops with kids from kindergarten to sixth grade!

Working with kids is something that I get into more and more—it's one of the most satisfying things I do. I think the rapport I have with children may have started when I was twelve years old and my little sister, Kristen, was born. I became very close to her and grew up with her as her friend. It had a lot to do with that. I was totally in love with this little girl! And I loved teaching her things, and being with her, and being sensitive to her.

But it wasn't just that. It's the way our parents brought us up too. My father, even now, is great with kids. If you see him with the grandchildren or no matter whose kids they are, he's exactly the way he always was—very loving, very funny, very good. So it has to do with the whole family atmosphere I grew up in, and with the father that I had, and the father *he* had.

I always pursued my interest in kids. Even while I was in Pittsburgh, working at the arts and crafts center, I'd spend time in this little nursery-school class. I met a wonderful woman there named Dorothy Kaplan, who had this amazing philosophy about teaching art to children in a way that would stay with them for the rest of their lives!

I remember, one summer in New York, working in a day-care center in Brooklyn as an arts and crafts instructor, and being completely comfortable working with kids— it was one of the best jobs I ever had.

What I like about children is their imagination. It's a combination of honesty and freedom they seem to have in expressing whatever is on their minds—and the fact that they have a really sophisticated sense of humor. Also, children have incredible instincts which get them through the world—

they can sense the energy or karma that comes from another person.

I found out that I can make any kid smile. It's probably from having a funny face to begin with—and looking and acting like a kid. And kids can relate to my drawings, because of the simple lines.

So, whenever I can, I do projects with kids. There's one I do as often as possible: I roll out this big roll of paper. All the children sit around it. I do some drawings on the paper. Then they start making drawings with markers or pens. I have music going and, as in "musical chairs," when the music stops, everyone moves to another part of the paper. When the music starts, everyone continues to draw. It's a way of filling the paper in an interesting way. I've done this project in Japan, all over Europe, and America—and it works every time. It never gets boring.

Anyway, I do this children's workshop in Iowa City, come back to New York and start hanging out more with Andy Warhol.

I'm at the Factory a lot and, through Andy, I'm meeting more and more people. The place is always exciting to me, because Andy is like a magnet—people just want to be around him. And there are these fabulous lunches, mostly arranged by Paige Powell, who is the advertising person for Andy's magazine, *Interview*. Paige hangs out a lot with Andy, and she was always taking Polaroids of everybody. Also, she was involved with Jean-Michel Basquiat. So, at this point Andy and I are very tight.

PAIGE POWELL I'm from Portland, Oregon, and I moved to New York in 1980, because I wanted to work for either Andy Warhol or Woody Allen. Frankly, I only had a vague idea of who Andy Warhol was. Well, I was offered the job I wanted from Woody Allen— he was working on his play, *The Floating Light Bulb*—but the job was going to start much later than I expected. I was offered a job at *Interview* magazine, and it started immediately. I really wanted to write for the magazine, and they were quite amused. Finally, they said they were thinking of hiring someone for advertising. I said, "Consider me for that." They said, "Have you ever sold anything?" I said, "Sure! I used to sell elephant manure at the zoo in Portland. And I was successful at it too. We had a three-month backlog!" So, after a series of interviews, they hired me as their advertising person. While I was being interviewed, Andy kept walking back and forth, eavesdropping.

There were several obstacles when I began. One was not spilling coffee on Andy's paintings, which were laid out all over the floor. The other was answering the phone. People called with very fancy names, and I was used to ordinary names from out West. Beyond that, it was a really fine environment. At the time, I had very little contact with Andy. Then, the first big account I got was from Hasselblad, this big Swedish photographic firm. I organized a lunch— it was my first—and Andy sat next to me. I happened to have been really thin then, and Andy kept staring at my elbows, which made me feel very self-conscious. It really started to annoy me. He just kept looking at my elbows and my arms.

Well, I started talking about the Hasselblad camera and how great it was. Andy started saying, "Gee, anyone can take a great photograph." I said, "Andy, that's not true!" And he said, "Yes, it is. Even *you* could take a great photograph." It was so embarrassing.

Anyway, I worked very hard at my job, because I knew how difficult it was to live in New York. At work, I was *so* disinterested in all the celebrities that came to the Factory—I mean, they came from all over the world. It was *such* a mix! From art collectors to artists to media celebrities to scientists—old and young! And that's how I met Keith Haring.

Keith came up to trade some art works with Andy. Then, we'd be at concerts or at dinners—usually, at Mr. Chow's on East Fifty-seventh Street—or there would be lunches at our office. Andy would say, "Come on, Paige, let's have lunch!" And there'd be Keith and Pee-Wee Herman and John Sex. It would be a different combination of people stopping by for lunch. Andy liked being with these young people. He derived a lot of energy and ideas from them.

I'd get into arguments with Andy over Keith's work, because at that point—around 1983 or 1984—I didn't think it was all that special. One time Andy and I were having dinner at this Japanese restaurant, and I told him that I thought Keith's work was more in the Peter Max vein. I said, "It's artistic, but it's more graphic design." Andy didn't agree at all. He said, "Absolutely not! Keith is a fine art painter!"

Well, I had a problem with Keith. See, he idolized Andy, and because Andy and I were together so much of the time, Keith

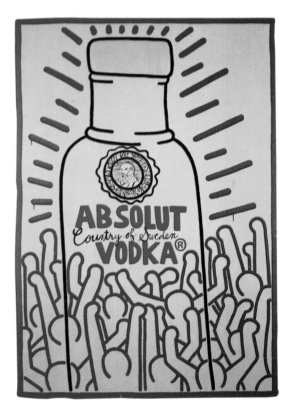

Absolut Vodka commission. Acrylic on canvas. 1986. 7' × 5'.

resented the attention Andy gave me. Also, Keith was really into stardom at that time—much more so than Andy. I mean, we'd walk past Radio City Music Hall, and Keith would see that some rock stars were performing there, and he'd say, "Let's go backstage and meet them!"

The other thing that bothered me about Keith was that I was always taking Polaroid photographs, and Keith would just grab some and ask Andy to sign them. Since they were *my* pictures, it really hurt my feelings and it happened *so* many times! I'd take a picture of Keith, and he'd say, "Oh, I like that picture!—Andy, will you sign it for me?" You can imagine that this didn't sit too well with me."

Anyway, Andy and I would go to Keith's parties down on Broome Street. Juan Dubose would be there with his huge tape deck and the music was really fabulous. The whole downtown crowd would be there—Kenny Scharf with his wife, Tereza, and John Sex with his boa constrictor and Jean-Michel—and Andy had a good time.

A few years later, there was this business of the Absolut Vodka ad. Since I was the advertising person for *Interview*, I received a call from Michel Roux, the president of Absolut. He said, "Do you think Andy would ever be interested in doing something for us?" I said, "Let me find out." Well, Andy thought it was a good idea, and he did this famous ABSOLUT WARHOL ad. Then, Andy said to Michel Roux that he ought to get some of the young artists to do some too. I said, "Yes—like Kenny Scharf!" But Andy said, "You should have Keith Haring." Well, I didn't push that, because Keith was treating me so badly. I didn't want to help him. I kept suggesting Kenny. Andy kept suggesting Keith. It was back and forth, back and forth. Of course, I thought a Keith Haring ad would look just great, but I was determined not to help him. Finally, I let the intelligence cells of my brain go to work. And Keith did this really terrific ABSOLUT HARING ad—it was marvelous! Subsequently, Kenny Scharf did one too, as well as other younger artists.

In defense of Keith, I should say that whenever Keith was mean to me, it was never done with malice. He just wasn't that kind of a person.

KEITH HARING It is Andy who introduces me to Grace Jones. When I look at her, I feel her body to be the ultimate body to paint!

First, Andy takes pictures of Grace and me together. Then he tells her that he wants to interview her for the cover of *Interview*. Of course, I had seen Grace Jones before, because she was the diva and disco queen of the whole Paradise Garage scene. But I really, really want to paint her body, because she's the embodiment of everything that's both primitive and pop.

Being primitive and pop is something I'm into, because my style of drawing is very similar to Eskimo art and African art and Mayan art, and, yes, Aboriginal art. And to me, Grace is all of that put together.

Well, Andy persuades Grace to let me paint her by telling her that I had painted Bill T. Jones and how great he looked. Next, Andy asks Robert Mapplethorpe to do the photography. A few days later, we all meet at Mapplethorpe's studio, and I'm a nervous wreck because Grace is late, as always, and Andy is sitting there—waiting.

Two hours later, Grace arrives by motorcycle. She's in a rush, because now she's late for her next appointment. But she disrobes down to her bikini underwear and I begin to paint her. In the meantime, my friend, David Spada, the jewelry designer, has created this huge crown as well as a lot of rubber jewelry for her to wear. As I paint her, Grace is very calm and the session goes very smoothly. Robert Mapplethorpe shoots her in all these different

116

Grace Jones as painted by Keith and photographed by Robert Mapplethorpe. New York. 1985.

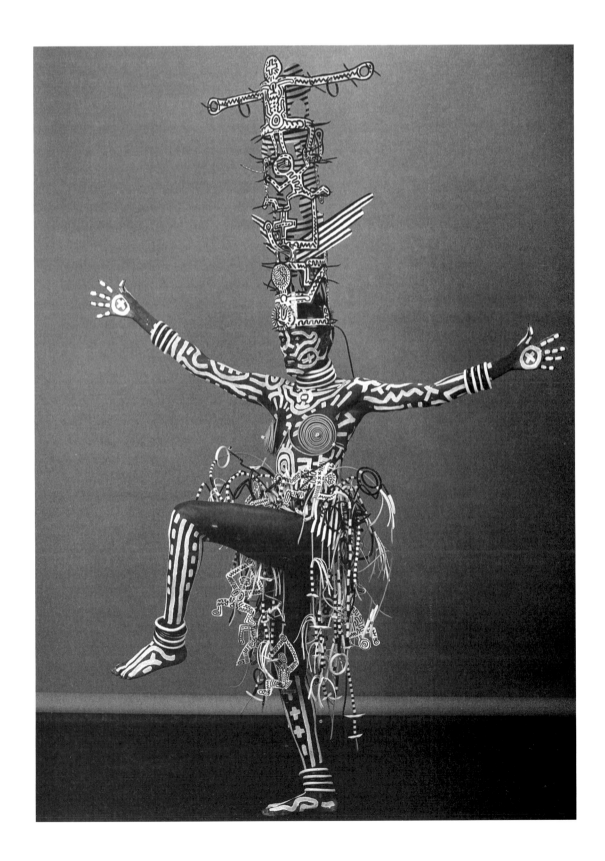

poses—and the pictures come out magnificently.

After the session, it's time for Grace to dash off to what turns out to be a birthday dinner to which I had also been invited. Well, Grace decides to make her entrance with the paint still on her body—that is, her back, her legs, and arms still have paint on them. It's one of the wildest sights to behold, but Grace carries if off just beautifully!

In the spring of 1984, it's time for my birthday, and I stage what I call my *Party*

Madonna wearing leather jacket painted by Keith in his studio. New York. 1985.

of Life event. I want to make this into quite a grand affair. The fact is, I'm now making a certain amount of money and I feel a certain guilt about it, and I want to share it with my friends . . . you know, sharing the wealth! So I plan this big party, which is for my birthday but not *on* my birthday.

I ask Madonna if she'd sing at the party and she agrees. As a matter of fact, she had been to my studio just days earlier to play me some cuts from her new album, *Like a Virgin*, which at the time hadn't come out yet. I immediately like "Dress You Up" and "Like a Virgin," and we decide she'll sing these two songs at the party. While we're hearing these cuts, I do a painting on Madonna's leather jacket, which she wears to the party. Madonna decides that she wants to sing the two songs on a brass bed covered with frilly material and strewn with white roses.

This is the time I hire Julia Gruen to be my assistant, and her very first assignment is to find all this paraphernalia for Madonna to use at the party.

I decide to hold the party at Paradise Garage, because it continues to be my clubhouse and the coolest club in New York. Although it's open only on weekends, I persuade the owner to let me hire the club on Wednesday night. I now ask LA II to help me decorate the place. We make these huge cotton banners, which we spray-paint in fluorescent colors. We hang these around the club. We also hang fluorescent streamers everywhere, and in another room we erect these huge fluorescent pillars and vases with flowers in them. We also hang some of my huge vinyl tarps so that the event also turns into a big exhibition.

We decide to make the invitations on handkerchiefs. In fluorescent colors and a little bit of black, I design the handkerchiefs, and on them is printed *The First Annual Party of Life*—and there's the date and the place—and that's the invitation. Of course, Bobby Breslau is around putting his two cents in, and seeing that everything goes smoothly. I also design a T-shirt—sort of a fluorescent tank top—which we plan to give out at the door. Also, David Spada makes all these Day-Glo necklaces, and everyone gets a necklace as they come in. The Garage's godlike deejay, Larry Le Van,

Julia Gruen. New York. 1990.

Juan Dubose, Keith, David Spada, and Bobby Breslau at *The First Annual Party of Life*. Paradise Garage. New York. May 16, 1984. David is wearing the T-shirt Keith designed and which was given to all guests.

agrees to work along with Juan Dubose, who will also be a deejay.

Now this is the height of Stephen Sprouse and the fluorescent Day-Glo scene, and he makes these clothes that I find really offensive. He once asked me to collaborate with him, but I refused. Well, he goes right ahead and does these little squiggles that really resemble my stuff and LA II's stuff. I get good and mad, but Bobby Breslau talks me out of being really angry. And anyway, his clothes are beginning to be very chic. I mean, Mick Jagger is wearing them! So I sort of make up with Sprouse, and he invites us to come to his showroom on Fifty-seventh Street to get suits made for my party. He makes these suits in fluorescent colors for Larry Le Van, Juan, Bobby, and LA II. For me, he makes a yellow velvet Day-Glo tuxedo, and that's what I wear at the party.

Around 3,000 people show up! Paradise Garage comfortably holds 2,000. It's *the* party to be invited to. It doesn't matter that there isn't any alcohol being served, because the energy level is unbelievable. People come dressed to kill—or to die! A lot of them start wearing my fluorescent tank tops and David Spada's necklaces. Again, all my various worlds collide: the club scene, the art scene, the graffiti scene, the music scene, and the hottest Paradise Garage regulars I could find. Also, through Andy, hundreds of celebrities show up, including Halston and Steve Rubell, Calvin Klein, Matt Dillon, and, best of all, Diana Ross—which for the Paradise Garage is the highlight of the gods!

John Sex does his act. Madonna sings. But her reception isn't exactly ecstatic, because her album hadn't come out yet and people are hearing these two songs for the first time. Six months later, they would hear those same songs six times a day on the radio! But it doesn't matter—nothing matters—because the atmosphere is just *so* incredibly charged. There is so much energy—it's electric! It just seems as though the whole world has turned up, and that I've become the ultimate host!

KEITH HARING At this time, there's a hustler bar I start going to called the Phoenix on West Fourteenth Street, which features nude break dancing. By nude, I mean the dancers just wear jockstraps. The scene is very sexually charged, because break dancing is already very sexy. For example, when they were done with their spinning, the kids would grab their crotches. And of course, all those young guys spinning around with their butts up in the air! And it's a male thing—a lot of males doing this together. So there's this edge of perversion.

At this hustler bar there are dance contests, and most of the dancers and hustlers are young Spanish and black street kids. One night, I meet this adorable Spanish kid. I watch him dance and . . . well, he just turns me on completely!

Now Juan Dubose is my lover throughout this whole time, but I'm becoming less

Keith tweaks art dealer Salvatore Ala, with whom he showed in Milan. 1983.

120

and less faithful to him. The point is, I'm now having all these boys around me what with more travel, more notoriety, I'm constantly surrounded by temptation and it's hard to pass that up.

So I begin hanging out with this new cute Spanish kid. I invite him to my *Party of Life*, and after a while, we get to be very close. He's a really tough-looking kid—the perfect image of the kind of street kid I want to be with. So not only do we start hanging out together, we're inseparable. Of course, this presents a major threat to Juan, because it's cutting into the time that's been exclusively his. Well, he now gets the message that I only want to share my time with my new guy.

And it's this new guy I bring to Madonna's New Year's Eve party, and *jokingly* tell her that he's her New Year's Eve present. Madonna immediately takes him into her group of friends. So now there's this weird competition going on. But what competition could there be between me and Madonna for this new kid of mine? Obviously, he's going to choose to hang out with this beautiful, gorgeous, talented girl, who is becoming more and more famous by the minute. I mean, by 1984, Madonna's fame is going way beyond anything I could ever imagine!

Still, the kid continues to hang out with me, and Andy Warhol starts writing about him in his diaries. Even though we all go places and do things together, none of this becomes a source of anxiety between Madonna and me, because we just go on being the best of friends!

My work, in the meantime, is going strong. I travel to Milan, Italy, for my first show at the Salvatore Ala Gallery, and I have a show in Basel, Switzerland. Back in New York, the Department of Sanitation asks me to design a logo for an antilitter campaign. Their campaign is called *Don't Be a Litter Pig*, and I design a cartoon pig which then appears on buses and in TV commercials—and I'm invited to the campaign's opening ceremony and am thanked by Mayor Ed Koch.

This is hysterical, because Mayor Koch is an avowed enemy of graffiti art, but I go to the ceremony and present him with my just-published book, *Art in Transit*, which contains the photographs Kwong Chi took of my subway drawings! So Kwong Chi comes to snap an incredible picture of the mayor looking completely horrified at this book of my graffiti art!

I then fly to Zurich to create a sixty-second animated television commercial for a department store called Big. And, when I return to New York, I design the set for Bill T. Jones and Arnie Zane's new ballet, *Secret Pastures*, which is premiered at the Brooklyn Academy of Music. The design is a movable tent on giant rollers, which moves across the stage with dancers weaving in and out of the tent. The set turns out to have worked better in theory than in practice—so it wasn't a big success. Still I hire three limousines to take us to Brooklyn for the opening, and it's Madonna and "Jellybean," Ann Magnuson, Kenny Scharf and his wife, Tereza, Carmel and Bruno Schmidt, Andy Warhol and Martin Burgoyne, Juan Dubose and me. Later we have a fabulous dinner at Mr. Chow's.

So 1984 is wildly active for me, but as it comes to an end, I realize more and more

that New York's art establishment puts me down a lot—the critics seem to resent me, museums pay no attention to me, and the art world in general kind of looks askance at what I'm doing.

As I see it, the problem is that I took all these shortcuts. Instead of having been cleared and verified by the art world—instead of having been explained by high culture, I jumped over the whole thing. See, art is supposedly first appreciated and digested by a small group of people—an intellectual and supposedly elitist group of people—and it finally sort of trickles down to the rest of the people—to the masses.

When a Mondrian painting first appeared, it was considered completely outrageous and shocking. But within thirty years, it was digested and entered the popular culture, and then appeared in things like shoe design or on bathing suits or on shower curtains. So the time span between something being recognized as serious, legitimate art, and then becoming popular,

Keith presenting his book *Art in Transit* to a disgruntled New York mayor, Edward I. Koch, on the occasion celebrating Keith's work for the New York City Department of Sanitation's "Anti-Litterpig" campaign. The mayor was an outspoken opponent of graffiti art. City Hall. New York. 1984.

123

was becoming smaller and smaller. I mean, there were Roy Lichtenstein bathing suits within a few years of the introduction of his work. So there was always this time lag.

With me, the time lag didn't exist. The popular acceptance of my work happened *before* the art world ever had a chance to make it known—to explain it—first to the intelligentsia and then to the world at large. What happened was, that the so-called legitimate art world couldn't take the credit for its popular acceptance. And there was no time to have my work filter *through* anything. The reason was that I went to the public first—and only later did the art world pay attention. Actually, I feel I'm *still* outside that art world—and I still wonder why.

ROY LICHTENSTEIN I once met Keith at the Milan, Italy, airport. He was in Milan for his show at the Salvatore Ala Gallery. I stopped by the gallery a couple of days before the opening, and there was Keith creating his show right there, on the spot! I mean, the gallery had stretched all these canvases for him, and he was painting a show that would open in two days! It was extraordinary!

Keith composes in an amazing way. I mean, it's as if he dashes the painting off—which in a way he does—but it takes enormous control, ability, talent, and skill to make works that become *whole* paintings. They're not just arbitrary writings. He really has a terrific eye! And he doesn't go back and correct—this is in itself amazing—and his compositions are of a very high level.

And he has such wit! His figures are just wonderful—the baby, the dog. I suppose Keith looked at our Pop Art—our cartoon figures—and realized they could be a part of art. Of course, he and I come out of very different backgrounds. I mean, Keith comes out of that whole graffiti school, while I was heavily into Abstract Expressionism. But then, I made a break, and Andy Warhol did too. Of course, the idea of doing cartoons is still something I feel isn't completely accepted. Critical opinion still goes that way. I mean, it doesn't seem intellectual enough, it doesn't seem anguished enough. Criticism of Haring is very much the same.

Keith is a great showman. He likes being on the street and attracting attention—he attracts and likes the media. It's a certain part of what he's about. But he's really not trying to make himself famous through advertising. He might like that, but it's not the primary motive. It's that he really wants people to love what he does. Also, Keith has a very interesting sense of humor. For example, those vases—those pseudo-Greek things, with Magic Marker on them. They're quite convincing and charming and funny. And much of the stuff is quite sexy, yet it's hardly pornographic. It's quite happy sex!

What I like best about Haring's work is that when he's finished a piece, there's nothing you could think of that you'd want to change. Even if he did something all at once—without standing back and changing anything—there just isn't a false move. It's all so beautifully drawn—and there's such a sense of relatedness. The stuff is beautiful! He's really done some gorgeous things!

JEFFREY DEITCH The reason Keith Haring is such a great artist is that his art does not rely on the whole art-historical tradition and issues that art critics toss about as a framework. It's an art that's free and direct. A lot of artists today are steeped in all this heavy criticism and philosophy—and they're looking to the luminaries of a previous generation, trying to come up with a formula that has all the intellectual support that's needed. The point is that most of what you see downtown is hopelessly constrained by academicism.

Keith just broke right through all that. Whereas other artists follow a formula—they take a little bit of Pop Art and combine it with a little bit of Minimalism—and there it is. In the eighties, a lot of art is about appropriation—of taking one from this style and two from this style and joining them. Keith isn't about that at all! Although you could write a complete book about all the art-historical references you can see in his work, it's really about somebody grasping what's important to *him* in the tradition of twentieth-century art—getting inside himself and then, feeling the tension in the society at large, using *that* to make his art.

The reason children like Keith's art is because it's direct communication. I find he's taken something on a very high intellectual level, like the automatic writing of the Surrealists and the all-over painting of Jackson Pollock, and he's using these means to communicate very basic emotions and he builds images that are very direct. In all great artists, the visual expression contains many aspects of all that came before in art—and it's not just the history of Western art, but it's Islamic art and Japanese art and all manner of primitive art. And there are visual sources that lie outside of art, such as from the commercial culture of signs. So Keith has all this in his work, and his is a very big message. I have no doubt that in the future, he will enter our great visual arts pantheon, and the work will speak for itself.

JULIA GRUEN I became Keith Haring's assistant and general factotum in June of 1984. The Tony Shafrazi Gallery hired me on behalf of Keith. At the time, Keith was out of the country, so they hired someone without consulting *him*. It was like an arranged marriage. Before actually meeting Keith, I worked for the gallery itself, in the fabulous capacity of receptionist. Beside Keith, Tony's roster of artists included Kenny Scharf, James Brown, Donald Baechler, and Ronnie Cutrone.

All I knew about Keith was that there were a lot of people around in New York wearing his baby buttons. It seemed this was the sign of the elite—that whoever was wearing one of those buttons knew something I didn't know. And I wanted to know! Also, I had seen the subway drawings —and that was my only connection with Keith. So, when Keith came back from Europe, I was taken to meet him at his studio, which was then located at 611 Broadway. Immediately upon meeting him, I liked him— just this guy in a studio. I really liked him a lot. Now, Keith never had a personal assistant before. He said, "Am I supposed to ask you questions? Am I supposed to tell

you what to do?'' What really amused me no end was that his gallery dealer, Tony Shafrazi, felt that I would be a maturing influence on this artist! Well, we were both exactly the same age—twenty-four—and quite apart from my feelings about being completely immature, I just couldn't see *how* I could be a maturing influence on him.

And so, I began working for Keith, doing everything from answering the phones to keeping the books to negotiating his contracts—I did it all, and I apparently did it well. Somehow, I always knew that the most important thing I needed to do was to gain Keith's confidence. So, I was always very honest and up front with him. I also made it very clear to him that I had my own life—that I wasn't going to be just a little Haring-ette or a groupie. If he wants to invite me to a party, that's fabulous, but I'm not going to hang around smoking pot with him after work. And that was part of his trusting me. Because I was not after his fame—he understood that the glamour aspect of his life didn't interest me.

Yet a lot of people would concur that, once having met Keith—male or female, young or old—there always comes a point where you *do* almost fall in love with him. It's crazy. I myself have fallen in love with plenty of gay men, and have suffered for it. But it wasn't like that with Keith—it wasn't about that. I mean, I wasn't attracted to him. It's just that there was this inexplicable *something* in him—an essence of goodness or trust or the essence in believing in someone, and an innocence and generosity that just absolutely made you fall in love with him. In those early years, meeting Keith was meeting a person you would never meet again in your life—there would only be one!

GEORGE CONDO When I was still living in New York—I now live in Paris—I saw Keith maybe one day a week and that day was the most important day of the week for me. I'm so fascinated by what he does. That one-take idea of his art! The investigation of this automatic kind of art is so totally pure! It's a universal meaning that Keith seems to have invented.

What an artist is working toward comes out of what he already knows. The point of understanding twentieth-century art by artists like myself, Keith Haring, and Jean-Michel Basquiat, was to know at what point the conservative and formal aspects of the paintings were broken up—and that the freedom and space were there for something else. So Keith was able to plug into a free-spirited kind of *out*. And it came from Calder and Miró and was even more direct than Jackson Pollock.

So he expressed that freedom in his paintings . . . just the way the paint itself sat on the canvas! It was fresh and untouched in the way we admired it with Andy Warhol. Keith is the machine that Andy said *he* wanted to become.

Keith Haring is the new Ben Franklin. His work somehow relates cosmologically at different moments into different kinds of meaning. It envelops itself in different regions—it can be graffiti, fine art, commercial, expensive, cheap, free, priceless. And always, Keith is in control of the scale of the work—like Alfred Hitchcock, who

leads you to a point of suspense. You hang on to your seats and that's what is inside a Keith Haring painting—that suspense!

RODNEY GREENBLAT

I met Keith at the School of Visual Arts in 1979, which was his last year, and my first year. And right away, I felt we were kindred spirits. He came over to my apartment once, because he had seen some of my work, and he wanted to see more of it. It was so exciting because I felt so disconnected with what other people were doing. So Keith came over, and I showed him my stuff, and at the time, I was making these little relief faces—they were like icons—and they had these cut-paper decorations around them—they were pretty solid. Keith really, really liked them and he put some of them in a show he curated at Club 57.

He was so nice, because he seemed very protective of me. I mean, I'm very shy, and I wasn't into the kind of scenes Keith was into. So he didn't want me to do all the stuff he was doing . . . you know, take drugs and go crazy. He wanted me to retain my purity, and to go on with what I was doing, because it was so different.

The important thing about Keith is that he made imagery okay—he made it real and acceptable. I mean, I didn't know if I should be doing pictures of Smurfs and little fish and things. But Keith made me feel it's fine to do that. I didn't want to think about line and color and surface—the way you're taught. I wanted to make Smurfs! And Keith gave me that permission, in a way. The fact is, Keith opened people's

Keith with Anna and George Condo. Paris. August 1988.

127

eyes to what young artists could do. You didn't have to be a fifty-year-old SoHo insider. You could be nineteen and twenty and still be doing something interesting. I really got out there—and Keith showed me the way!

KEITH HARING Around 1983, I became aware that imitations of my work were springing up all over the world. In Australia, I saw Keith Haring T-shirts. In Japan I saw Keith Haring T-shirts and posters. In Europe I saw Keith Haring graffiti of the baby and of the dog. My things had entered into the popular culture whether I wanted it or not.

Because these works registered as public gifts to the world, people felt they were

Madonna: "I'm Not Ashamed." Synthetic polymer, Day-Glo, and acrylic on canvas, by Andy Warhol and Keith Haring. New York. 1985.

allowed to copy them—to make them their own. The stuff had become a kind of international vocabulary to be used by everyone. Well, it gave me pause. In my studies of semiotics, I understood that the more exclusive something is, the greater value it has. The more people want it, the more they alone can understand and have the power to disseminate it, the more special it is. And that's the game you're supposed to play.

From the beginning I was against this game. Although I had a foot in the art world, I wasn't going to compromise and let the art world manipulate the work and make it become something it wasn't. My work had to go its own course, and I had to go with it—and let it become what it was going to become.

So I endorsed the fact that my work had entered the popular culture. Instead of suing people, and saying, "This is mine! You can't do this!" I decided to participate in this flow of fakes—and the way I did this was to show people the difference between the real thing and the imitation. Because you *can* tell the difference between a fake Keith Haring and a real Keith Haring. You don't need an artistic eye to tell you the difference, because twenty different people can draw the same Japanese character, but each one will be endowed with its own power and spirit.

At any rate, what I'm leading up to is the Pop Shop. It's now 1985, and I begin thinking about the Pop Shop, which doesn't actually open until 1986. Of course, I knew I'd get a lot of criticism for it, but I also knew that it was what some of the work called for—and *had* to become. Still, it meant I'd be walking an incredibly fine line. It was a real tightrope, and dangerous on either side. You had to avoid crass commercialism and also keep some hold on the art world—and I wanted to do that, because I wanted to keep the respect of artists who meant something to me.

In the meantime, the work had its own momentum. It was out in the world, and I had to kind of restrain it, and keep it from getting out of hand. I mean, if I had accepted all the licensing offers that I had from big firms, like those that licensed Snoopy and Garfield, I could have made just pots and pots of money immediately. Really, there were endless proposals from television and manufacturers which *had* to be turned down, because there was a specific vision for the work which *had* to be followed. The fact

is, I wanted to keep the work on an artistic level while still allowing it to communicate on a popular level.

I discussed the Pop Shop many times with Andy Warhol, and he was totally supportive of my taking the plunge, and not caring what people thought, because as long as I knew *why* I was doing it, then that was what was most important. So I went ahead and found this space near my studio on Lafayette Street. I looked for the capital and I started investigating how I was going to create this business and what kind of products I was going to make. However, it took me another year to think it through.

In the meantime, I use this acquired space to stage benefits. The first is for African Emergency Relief Fund, to help curb the famine in Ethiopia. I organize an exhibition, and I create a poster in collaboration with Roy Lichtenstein, Yoko Ono, Jean-Michel Basquiat, and Andy Warhol. We also host a one-night benefit at Paradise Garage, but it bombs because my celebrity guests don't show up.

At this time, I also create my *Free South Africa* poster, which had first been a painting, but the image was strong enough to also make a good poster. It was conceived to make people aware of the problems of apartheid. I had already done an antinuclear poster in 1982, 20,000 of which I handed out free in Central Park during an antinuclear demonstration.

In addition to all of this, I now venture into some small commercial projects, designing four watches for Swatch and doing a label design for a heart pill which is being released by a German pharmaceutical firm. Also at this time, I do a cover and a centerfold for *Scholastic News*, which is a newsletter for children in schools all over America. I next fly to Marseilles, France, where I paint a huge front curtain for the Ballet National de Marseilles for a new ballet by Roland Petit called *The Marriage of Heaven and Hell.*

When I get back to New York, I receive a call from Richard Avedon, who asked if I would be interested in collaborating with him on a poster of Brooke Shields. He had a very big success with a photographic poster of Nastassia Kinski with a snake, and wanted to do more. Well, he said he had seen Mapplethorpe's photograph of my body painting of Grace Jones in *Interview* magazine, and he wanted to do something similar with Brooke.

I immediately said it would not be appropriate to do this with Brooke Shields. Somehow it didn't make sense to impose a sort of African look on her. It didn't go with her particular American glamour. But I said I would be interested in doing *something*.

Avedon and I met and we talked. He wanted an image that was sexy yet sweet, and it couldn't be too revealing. So I decided to do this big cartoon heart that Brooke would hold, and she would appear to be naked behind it. It was sort of cute, but it just never really worked. It wasn't successful as an instant image. It was disappointing. And the deal I had with Avedon was totally ridiculous. I mean, I got only a few cents per poster! I remember getting royalty checks for, like, $7.22! It was a source of great amusement at our office. The best thing about the project was that I got to be better friends with Brooke Shields.

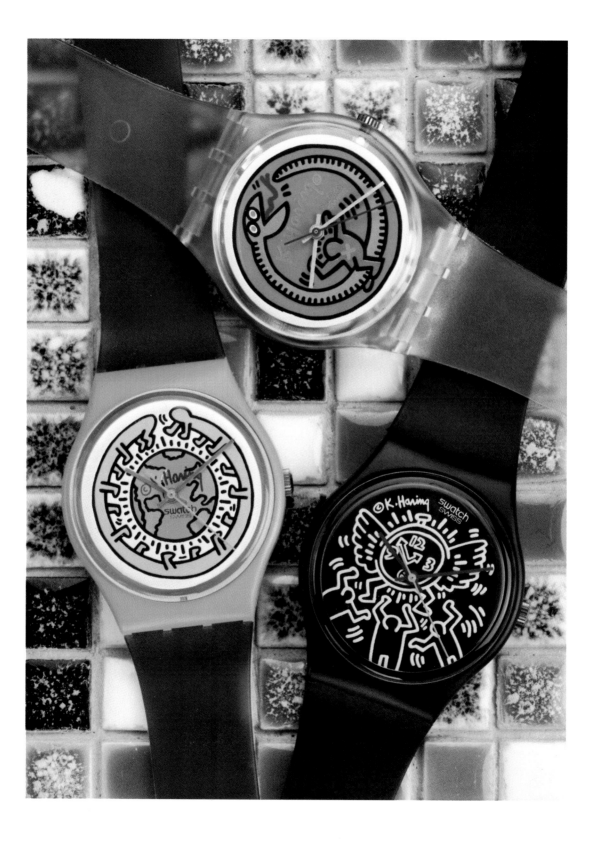

BROOKE SHIELDS I wasn't happy with the poster Avedon and Keith did of me. Frankly, I felt it wasn't very respectful toward Keith—it was handled poorly, the point being that Keith's art wasn't properly understood. I thought it was unfair to Keith. But it was such fun working with Keith.

We had met some years earlier—in 1982, I think—and I was with a lot of people, including Andy Warhol. Andy kept taking a lot of Polaroids of me . . . and he made me feel as though I were a part of this whole underground culture. I didn't know what to think . . . I was just seventeen.

At that point, my life was pretty hectic. I mean, I'd be at home sort of fighting with my half-sister one day, going to high school and doing a *Vogue* cover the next day, and going to the White House the day after! It was mad and hectic and wonderful. Well, soon after that, I went to Princeton University, where I graduated with a degree in French literature—I even received honors. That was in 1987. Anyway, before I went to college, Keith and I had dinner. He said, "I want to tell you something, and I hope you won't be upset . . ." Well, he told me that when he first came to New York, he saw my Calvin Klein jeans billboard in Times Square, and he realized how fully I was a part of the culture of the time—of the eighties.

Then he sort of sheepishly said he had done these collages of me in Calvin Klein jeans which he combined with this nude

man, and he made a kind of sexy double image. He said he hoped I wouldn't be insulted at the thought of his having done this. Well, of course, I told him I didn't mind. I completely understood his fascination with those ads. I mean, they did combine this incredible innocence with this unbelievable sexiness!

From the day Keith and I met, it was as though we'd always known each other. He wasn't much of a talker—nor was I, but a lot was said without too many words being spoken. Keith is like an angel. His eyes are so innocent! He is that beautiful mixture of strength, which you can see in his work, and of childlike innocence, which you can see in his person. He's very *Through the Looking Glass*!

Keith gave me a beautiful, beautiful drawing. It's of a strange diaphanous creature blowing bubbles. On the back of it he wrote, "For Brooke, One of the sweetest (honestly) people, with lots of love and respect. I learned a lot about humility, honesty, generosity and sincerity from you. Love you always . . . Keith."

As I said, I wasn't very verbal when I was young. Now, I'm twenty-four and I've learned to express my feelings more. Well, I recently met Keith again, and I said to him, "You know, I never said this before, but I really care for you. I just like being with you!" And he smiled and smiled!

131

Swatches. Three of the four Keith Haring designs commissioned by Swatch, U.S.A. 1985.

KEITH HARING By this time— 1985—things have seriously changed in New York, and in my life, because the horror of AIDS had come to light. It totally changed

people's lives. As early as 1982, we were starting to hear rumors of these mysterious deaths of gay men, primarily in New York City and in San Francisco. People called it "gay cancer." The first person I knew who died of AIDS was Klaus Nomi, who was this Viennese New Wave opera singer and who was around during the Club 57 days.

As soon as people found out this thing existed and heard how it was transmitted, they stopped going to the baths. The patterns of anonymous sex and the back-room anonymous sex became impossible to do. You had to start being selective and much more aware of what you were doing, and who you were doing it with. As this thing escalated and hit a lot of people around me, I completely changed my pattern of doing that kind of thing.

I didn't stop having sex, but had safe sex or what was considered and under-

stood to be safe sex at that point. I became more conscious of being self-protective. Still, there were all kinds of things you could do, and I kept being more or less active. But by 1985, AIDS had changed New York.

Of course, nothing changed as far as the creation of my work was concerned. At the prodding of Tony Shafrazi, I now become interested in the challenge of producing large outdoor sculptures—public sculptures. I begin by making models out of aluminum in my studio, and then I start working with a foundry called Lippincott, in Connecticut. The sculptures being made look almost as if they could be climbed on, and I paint the pieces in these sculptures really bright colors so that they resemble toys.

The idea is to have a double show in 1985. There'd be a show of paintings at the Tony Shafrazi Gallery, and a show of my new sculptures at the Leo Castelli Gallery on Greene Street.

For the painting show, I decide to stop making tarpaulins. I no longer feel inhibited about using canvas, because I now have the money to buy it as though it were paper. The paintings are large and center on subjects like AIDS and the slaying of Michael Stewart and other social-consciousness themes. Some are quite grotesque looking, because I want to show the despair and hopelessness of those situations. The paintings are very, very colorful—and they're painted in acrylics with the black outlines in oil.

Having my sculptures shown at the Castelli Gallery really blows me away, because . . . well, it's like this holy space! I mean, Johns had done a show there, Lichten-

Safe Sex. 1988. Acrylic on canvas. 10′ × 10′.

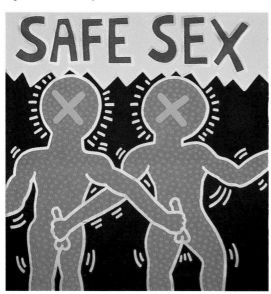

stein had done a big mural there, Rosenquist had worked within the space. For me, it was the perfect time to do something totally irreverent. So, along with exhibiting the sculptures, I decide to paint cartoon characters all around the walls of the gallery. It was the first time I had introduced cartoon characters into a "serious" art context. The figures are based on cartoons I made from the ages of ten to sixteen. But now, because my drawing ability is more advanced and sophisticated, I introduce these characters as art.

The Castelli show has the atmosphere of a wild playground. I arrange for entire classrooms of kids to come and see the show, and I insist that the kids be allowed to climb all over the sculptures.

One exciting thing that happens, is that three of the sculptures get placed at the United Nations—on Dag Hammarskjöld Plaza. I go help with the installation, and the next day, there's a picture of me and one of the sculptures on the front page of the Sunday *New York Times!*

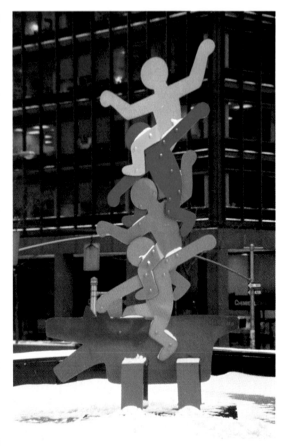

Sculpture installation. Dag Hammarskjold Plaza. Sculpture Garden. New York. 1985.

LEO CASTELLI I held the show of Keith's sculptures at my gallery on Greene Street, with enormous pleasure. The sculptures were quite marvelous, but the great surprise was when Keith said, "I want to paint a frieze all around the gallery." The way he did it was fantastic—I should have filmed it. I mean, he painted these cartoon characters all along the walls, which measure over 100 feet, and he did this in one day! Incredible. I saw him at work, just inventing as he went along.

Someone once asked me, "If Keith Haring had appeared at your doorstep in 1960 or 1961, when Lichtenstein, Johns, Rauschenberg, and Warhol came to you, would you have accepted him into your gallery?" I answered that I would have found him entirely acceptable and interesting. In a way, I would have found him easier to take on than Roy Lichtenstein.

You see, Roy had taken things from the printed page—from the funnies—and made them his model. This is not the case with

Keith with gallery dealer Leo Castelli at the opening of Keith's sculpture exhibition at Castelli's Greene Street gallery. New York. 1985.

Keith, because he has a direct approach to what he's doing. In the case of Lichtenstein, it was something really new—he appropriated something. But Keith is not at all an appropriator.

You can, of course, think of Keith Haring as somebody who is connected with comic strips—cartoons. But he made his own cartoons. Actually, I had a hesitation about taking on Lichtenstein. It lasted perhaps one or two days. Then I caught on to what he was up to. But in the case of Keith, there would have been no hesitation at all!

In thinking about Keith's position in the art world . . . let's recall the 1970s. It was a rather quiet period in the art world. It was quiet compared to the incredible flowering we had in the 1960s. But in the 1970s, we asked ourselves, "Who will emerge now?" Well, what we got at the end of the seventies was German and Italian neo-expressionism. These new young artists came full force and we almost thought that our primacy was over. At the same time, we had people like Schnabel and Salle and Robert Longo—so America was tagging along too.

And then came Keith Haring. It was the early eighties and I certainly saw him as someone who was playing an important role.

He came along with a group that included Kenny Scharf and Jean-Michel Basquiat and George Condo. Almost immediately, we had another group, the so-called Neo-Geo artists, and it was very interesting, because the group consisting of Haring, Scharf, and Condo, didn't really have time to develop. In a way, they were pushed to the side by this new movement. Anyway, the art-loving public wasn't really in favor of the neo-expressionists. You see, we Americans are more influenced by a cartoon culture. That's why Keith Haring is so important.

KEITH HARING At the end of 1985, I have an incredible show at the Bordeaux Museum in France. Earlier that year, Jean-Louis Froment, the director, comes to New York, and begins planning and curating the show. He is giving me the entire museum! Soon after, I go to Bordeaux to look at the space. Froment and I decide that the entire first floor will be devoted to a huge exhibition of my drawings, which we pick from my private collection. The drawings go back to 1980. The upstairs of the museum will have a selection of paintings up to the present time. There will also be sculptures and a few of the wood totems from previous shows.

In the museum's lower level, there's a huge space with five enormous arches. I ask the museum to build and stretch arch-shaped canvases that would be fitted into the arches. The plan is for me to paint on both sides of these arched canvases. I have no idea *what* I'll paint there. In fact, I decide to paint the arches at the last moment—right there on the site. So, the museum prepares this enormous show and I return to New York until just before the actual installation.

In the meantime, a beautiful catalog for the show is being prepared, with Brion Gysin writing the introduction. By this time, I had developed friendships with Brion Gysin and William Burroughs. But it's Brion who I see frequently. He lives in Paris, and every trip to Paris includes time spent with him. From the beginning, he takes on the role of a kind of teacher for me—this incredible genius, who is a member of the underground brotherhood of gay artists. And, we have this ongoing thing between us which is unspoken but deeply rooted, because it's about the shared suffering of past writers and poets and painters who were gay—and it's something that's been passed on from teacher to student for centuries.

It's now time to return to Bordeaux—and I'm in a dilemma, because I still don't know what I'm going to paint on these giant arched empty canvases! I only have a few more days before I leave on Sunday. Now, all my trips to Europe are coordinated with my Saturday nights being spent at the Paradise Garage. I don't want to miss any of my Paradise Garage time. So, I'm at the Garage dancing, when an idea jumps into my head about what to paint on the arches. It's so obvious! Since it's five arches to be painted on both sides, that comes to ten paintings—so why not the Ten Commandments! So, while I'm dancing, I try to think of as many commandments as I can but I can only think of a few. So the minute I get to Bordeaux, I ask for a Bible!

I now supervise and help hang the entire exhibition. The museum has supplied me with an assistant, but I can't work that way . . . with white gloves! In the meantime, Kwong Chi has come to Bordeaux to photograph the whole event. I ask Kwong Chi to help me hang the show. Between the two of us, we get it done in record time.

Finally, I concentrate on the ten panels. It's three days to the opening. The museum personnel get nervous. I begin on my *Ten Commandments*—and I work like crazy, longer than I ever worked before. I knew I could do it physically. The problem was staying awake! At the end, I was taking amphetamines—it was the only thing that kept me going. Well, by the third day, the ten paintings were done. It was a major accomplishment but I was a wreck!

The opening is sensational. Julia Gruen and Bobby Breslau come from New York to join me. There's a large Paris contingent: Patrick Kelly, Andrée Putman, George Condo and his girlfriend, and Brion Gysin. Some people come from Switzerland, some from Germany. Tony Shafrazi arrives as does Jeffrey Deitch. Helmut Newton is doing a portrait of me for *Vanity Fair*. I wear a gold lamé tuxedo made for me by my friend, Hector Torres. The whole thing is an incredible extravaganza!

136 *The Ten Commandments.* Installation at Contemporary Art Museum, Bordeaux. Acrylic and oil on canvas. 1985.

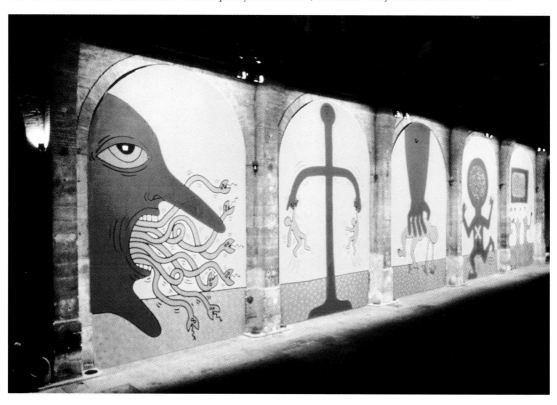

JEFFREY DEITCH I'll never forget the opening of Keith's museum show in Bordeaux! There stood Jacques Chaban-Delmas, who is one of France's major political leaders *and* the mayor of Bordeaux, being this total Keith Haring fan. I remember Chaban-Delmas taking out his pocket handkerchief and Keith drawing a design on it. It was quite wonderful seeing this high-level bourgeois French politician putting the handkerchief back into his pocket.

Bordeaux is not on the main path—it's not Paris—but the city really knows how to put on a show. I mean, everyone was housed in a very good hotel and there was an incredible reception in the mayor's man-sion. On the following day, Philippine de Rothschild gave a fabulous luncheon at her family's château. It was really very grand. And Keith, being the most unpretentious person, never let any of that go to his head. I've seen other artists becoming real snobs. They get recognition and suddenly they don't know you. All they want is to have dinner with celebrities and rich collectors at Le Cirque!

The fact is, artists are often seduced by their recognition and all that goes with it. Keith is not. I mean, he knows how to deal with it. He's great with the media—he really has an instinct for it, and can give them the action they want. But he's not seduced

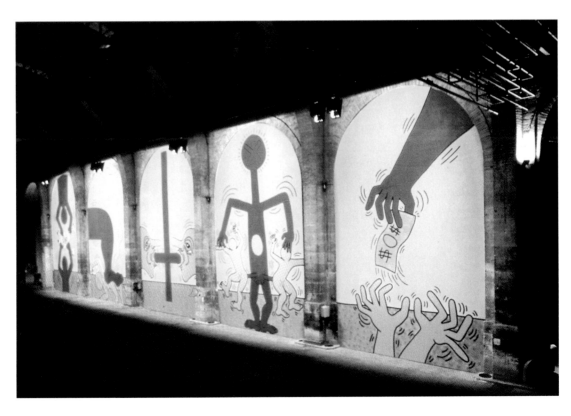

by it. It's just part of his orientation. That's how he knows he's communicating.

CARMEL SCHMIDT Early on, we were all such good friends! But when Keith got really famous, things got difficult. Suddenly, most of us old friends were relegated to second place. That's because he was swept up in the American pop scene. I mean, there was Keith with Brooke Shields and Michael Jackson—and he fell for it. It was inevitable. It was a point of weakness with him, but it's understandable. If you've been a busboy at Danceteria, how can you resist?

BRUNO SCHMIDT And then there came the inevitable breakup with Juan Dubose. Obviously, Juan wasn't a sophisticated person. He didn't know about wines and such. It was very hard for Juan to manage himself in Keith's new glamorous world. This was embarrassing to watch.

DAN FRIEDMAN Juan was never exposed to all the things that Keith was becoming exposed to. Because Keith was emerging into an established white culture, but still identified a great deal with black culture, he brought Juan Dubose along for the ride. Well, Juan didn't really know how to deal with that.

CARMEL SCHMIDT What happened to Juan is very interesting. Juan was a very simple person. He had dignity and within his little world, which was installing radios in cars, he felt good about himself. And then, he was swept up into a world that was *so* over his head that he lost all footing. He developed the worst symptoms of the nagging wife. He argued. He made scenes. He wanted more and more money. He and Keith used to fight horribly. Juan simply lost himself. He got heavily into drugs—and it was his undoing. It was Keith's fame, and also the times, that undid Juan Dubose.

KEITH HARING My relationship with Juan Dubose reached its climax in 1985. I began being less and less content just staying at home. I was traveling a lot. I was seeing all kinds of new and interesting people. I was certainly unfaithful to Juan. I just lost interest in the whole thing. The fact is, I was bored with Juan's inability to do anything with himself. And I didn't like Juan's involvement with drugs, which was partly spurred by my rejection of him. It all became a vicious cycle. The more I didn't want to be with him, the more unpleasant he became. Well, it got worse and worse. Finally, I had to move out—I just left him.

I was now determined that I would start spending time on my own. I wanted to be a bachelor. I wanted to play the field. I didn't want to fall back on another hopeless love affair.

Fate had other plans! One night, at the beginning of 1986, I go to the Paradise Ga-

rage, and I see this incredibly beautiful boy. I look at him and see that he's the man of my dreams. I convince myself that should he look at me and come over and talk to me, then *that's* going to be *it*! I will have found my new love. Well, he does look at me, and he does come over and talk to me—and I take him home with me. Within two weeks, I invite him to come with me to Brazil!

By a terrible coincidence, my new lover is also named Juan! Juan Rivera! I became completely obsessed with him—and he quickly replaced all the feelings I had for the other Juan with no time in between.

Juan Rivera really did nothing. He was beautiful, and he had some talent at constructing things—doing some carpentry—and he could drive a limousine. When we met, he didn't have a job, and he was eager to fall into the position of being . . . well, Mrs. Haring. There were no aspirations for independence or for a life of his own.

I could see from the beginning that it was a mistake. It's probably one of my major faults that I pursue physical love with such obsession. It was always the first and foremost aspect that I took care of. I always felt that intellectual stimulation and companionship could be supplied by other people. But from the beginning, this arrangement . . . this pattern, was a source of trouble and frustration. For me, the physical part was so overpowering that I just let it lead me around in this really obsessive way. And a lot of it I enjoyed. Look, both Juans were not terribly well educated, but they were good companions—you could travel with them, and they could be fun to be with. It's just that there was nothing

particularly challenging about them, which, in the end, may have been a cheap and easy way out.

KENNY SCHARF In 1983, I married a Brazilian girl, Tereza, and we have two little girls, Zena, who is six, and Malia, who is two. We often go to Brazil, where we have a country place, and Keith would come and visit us. One time, Keith arrived with his new lover, Juan Rivera . . . and, well, I wanted to spend time with Keith, but not with Juan. I found being with Juan was a big strain—he really had nothing to contribute. Frankly, I thought he was dragging Keith down. I thought Keith was surrounding himself with unintelligent people—it was freaking me out. He was surrounding himself with people that

Keith and Juan Rivera in Antwerp. 1987.

were using him—for his money, for his fame, and in return were letting him look at them or play with them. Mostly, I felt Keith was shutting out his friends—including me, who really, truly cared about him from the beginning. I wasn't the only one who felt that. But by 1985 and 1986, we all felt we lost Keith to fame, to his pursuit of famous people and fabulous celebrities, and by surrounding himself with these gay Puerto Rican hustlers.

JUAN RIVERA I was born in New Haven, Connecticut. My parents came from Puerto Rico. They were middle class, but loving for days! When it came to love, they were filthy rich! I have five sisters and two brothers. I'm the oldest boy. My parents are still together, and they seem to be the happiest people in the world. My mother is already a great-grandmother. My oldest sister is only thirty-four, but she's already a grandmother—twice over! Yes, my family loves children. My mother has fourteen grandchildren!

We were not brought up in an educational environment. I ended up graduating from high school with learning disabilities. This has been a tremendous setback in my life. When I graduated from high school, I just couldn't read. There just wasn't anything the school could do about it, although they knew I was giving it some effort. I can now read somewhat better. But I'm still trying to figure out what to be when I grow up—and I'm already in my thirties.

I met Keith at the Paradise Garage when he was moving into a new apartment on Sixth Avenue and Third Street. I helped put that apartment together, because I could do carpentry and some design. The colors were wild. There was the red kitchen, the yellow living room, and the blue bedroom. Keith's friends were thrilled that he lived in this type of environment. It was as crazy as his art! And he had art works by Jean-Michel Basquiat and Kenny Scharf—and that was great.

I cooked and kept the house clean. Keith seldom spoke about what he was doing. He came home to have peace of mind and some home-cooked meals. He liked to watch cartoons, and he loved to watch "Mr. Ed" and "The Honeymooners." At times, Keith let me stretch canvases for him. I felt honored, because I felt I was stretching canvases for Picasso! Keith is a perfectionist and I came pretty close to being one also. At the beginning, he explained to me how perfect he wanted it. I said, "Well, let me do it, and I'll show you what *my* perfection is." So, with my first few canvases he was totally thrilled at how perfect they were!

Keith was very affectionate. I think he was happy with me. We were together for about three years and, yes, we were lovers. He told me about being with Juan Dubose—and how overwhelming that relationship was at the beginning. But Keith is someone who likes to keep moving—and he likes for other people to keep moving or he just gets bored with them.

Well, all I wanted to do was cater to Keith, because I'm a very domestic person. Keith wanted me to do other things. But all I could really do was maybe paint apartments and do small things.

But living with Keith . . . I learned so much about art. It was an honor hanging out with him. I will say that at the beginning, I didn't think his work was all that great, but when I saw him *doing* it—Jesus Christ!—it was amazing! I mean, the energy just flowed through him. He'd start at point *A*, and when he was finished you didn't know *how* he started or *where* he started! He just had this big mental image of the whole thing there in his head!

KEITH HARING I stage my second *Party of Life* at Palladium. Steve Rubell and Ian Schrager asked a lot of artists to contribute to the decor of this new club, including Kenny, Jean-Michel, and Francesco Clemente. I painted a huge backdrop for the dance floor. I invite 5,000 people and give out 5,000 T-shirts. The invitation this year is a little picture puzzle of a black-and-white drawing, and it's sent out in a little square box. Also in the box are two little

Keith in front of backdrop painting at the Palladium nightclub. New York. 1985.

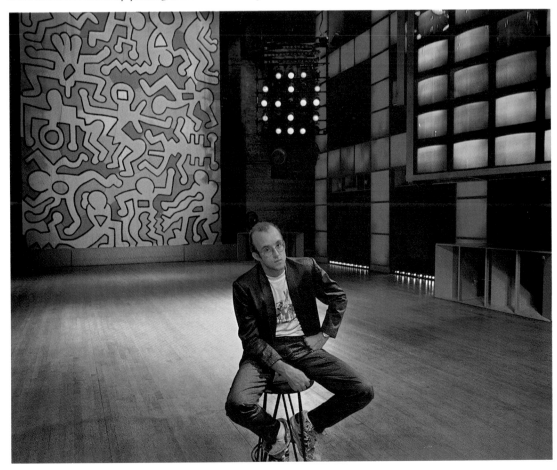

buttons I designed, and they had to be presented at the door to get in. Boy George comes and *sort* of sings "Happy Birthday" to me—he kind of speaks it. Afterwards, a huge drop of balloons is released onto the dance floor. The party lived up to the first one held at Paradise Garage the previous year—except this one closed traffic on West Fourteenth Street, and there was a mob scene outside and a lot of people couldn't get in—it was a nightmare! There were endless celebrities!

Both 1985 and 1986 are wildly active for me. At the close of 1985 I paint Grace Jones for the second and third times on the occasion of her live performances at the Paradise Garage. In early 1986, I again collaborate with Grace on a videotape called *I'm Not Perfect*, which we do in Paris. For this, I design and paint a huge skirt which is sixty feet in diameter. Grace has this idea that she's going to be like the Pied Piper, and she'd be singing and all these people are following her and they go underneath the skirt, and the skirt consumes them as Grace floats away into the sky.

While I'm working with Grace Jones in New York for her Paradise Garage performance, a wonderful thing happens. She introduces me to Timothy Leary, who is a friend of hers, and who had come to watch Grace rehearse. Well, to me, Leary was this

(Below) Keith working on Grace Jones's costume for her music video "I'm Not Perfect." Paris. *(Facing page)* Grace Jones wearing the costume. Paris. October 1986.

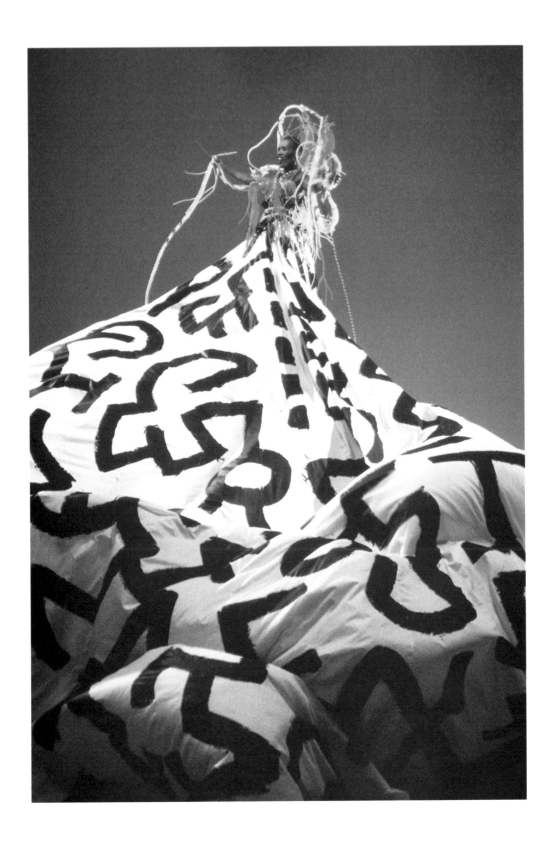

mythical figure—a kind of guru of the six-
ties, who completely fascinated me. When
we met, he gave me a copy of his autobi-
ography, *Flashback*, which I took with me
to Europe.

When I go to Europe in early 1986, I
find myself in a hotel room in Montreux,
Switzerland, and I start reading Leary's book.
I'm completely overwhelmed and practi-
cally freak out, because his explanation of
the phenomenon of hallucinogenics and the
whole LSD experience is so close to my own
experience with these drugs that, for the
first time, I find a real clue as to what the
so-called mind-expanding experience is all
about.

As I continue to read the book, I feel
completely at one with Leary's thoughts
and ideas, and I'm so indebted to him for
these ideas that I make several drawings
for him and immediately send them off to
him in California.

Some time later, when I'm in Califor-
nia, I call him up, and he invites me to
his house in Beverly Hills, where I meet his
wife, Barbara. At this point, Leary is re-
ally into computers, and we share many dis-
cussions about computers, and how I might
make use of them in my own work. So from
this time on, I become really, really good
friends with Timmy—and he becomes a
big fan of mine. Barbara Leary paints a big
table in her house in the manner of Keith
Haring, decorating the top of it with a lot
of little Haring figures—and I'm quite
flattered!

TIMOTHY LEARY I see Keith
Haring as the twenty-first-century archetypal
artist. What I mean by that, is that the
twenty-first century is going to be global—
it's going to break down all the national
and geographic borders. And it's going to
be timeless, in the sense of the enormous
spectrum of information that the world will
be sharing. We're also going to discover
our youth in the twenty-first century. When
I say it's going to be global and timeless,
I mean that it's going to be sending out sig-
nals that will be recognized by anyone on
the planet earth right now, and also for those
who think back to the beginning of cave
art when young Paleoliths were putting art
on walls. And here's Keith Haring being
arrested by the New York City police for
painting the wall! I must say that Keith
may be controversial, but nobody really dis-
likes him. He may be shocking, subver-
sive, offensive, but they all love him. They
all know he's the kid on the block who's
painting on walls.

And how mythic that he's painting on
walls for Afro-American young people!
He's addressing the real problem of New
York City in the late eighties with this
most powerful and tribal art! However, some
people have asked whether Keith Haring
is really a *needed* artist.

Well, in 1946, you had to have some-
one to express the psychology of the next
forty years, and this happened to be a baby
doctor. A pediatrician named Spock said,
"Treat each child as an individual." Keith is
a child of Dr. Spock, and there are mil-
lions of Dr. Spock's children with the no-
tion of "express your individuality." Keith
is also a child of Marshall McLuhan, who

said, "The medium is the message." For Keith, *his* medium is his message. He's there painting on walls and running around the world, and kids flock to watch him do it. Keith could jump into one of his wall paintings and we'd never miss him, because the spirit of the artist is just merging with the magic that's suddenly appearing on the wall. It's metaphysical! I mean, when you need someone like Dr. Spock, he comes along. When you need an artist like Keith Haring, he comes along.

I'm a linguist. I'm interested in language. I see everything in signs. And the messages coming from Keith . . . well, it's difficult to separate Keith from his art—they're really one. It's hard to tease out the artist part of Keith. The way he looks. The way he moves. The intensity—the way he approaches a wall—with total openness, is the way he approaches *you!* He is, in the best sense of the word, childlike—open. Of course, like any young person he has tantrums, and he has low moments. He's not Mother Teresa.

Some people have said that Keith Haring is a flash-in-the-pan. Well, it's a good place to start. Because, first there's the pan. Then there's the flash. And the flash expands into an explosion and that gets space-velocity. What more do you want? People have criticized me. They said, "He was a brilliant professor at Harvard, but then he went off the deep end!" But what end *should* one go off? The shallow end? These metaphors! Of *course* Keith is a flash-in-the-pan. If you're not a flash-in-the-pan you're not going to get out of high school. You're going to still be living back on the farm. I think Keith has made all the best enemies!

Keith and I . . . we're mutants. We've been swept by the waves of the twentieth century into the twenty-first century. So we're climbing on the shoreline. There are a few of us up there who are moving in the direction that our species will take in the next century. And there are poets and writers and painters, and millions of people who understand what we're doing. But what *are* we doing?

Well, if you're going to mutate and migrate into the future, you have to cut yourself loose from the schools, academies, institutions, and reputations of the past. Keith didn't really go to art school. He didn't get a Master of Fine Arts degree. He didn't play those games. He suddenly popped out like a flower, like a seed in that cauldron of energy: New York City. And he put all his remarkable energy together—the wall, the easel, the canvas, the pigment . . . it's a dance! No one has accused Keith of being serious. He's so beautifully playful! All that energy shimmering and jumping!

KEITH HARING In the spring of 1986, the 1985 show that I had at the Bordeaux Museum is taken by the Stedelijk Museum in Amsterdam. There are some additions and changes. For example, the huge *Ten Commandments* are too large, and can't be moved. They're in storage in the basement of the Bordeaux Museum.

But there are two new installations at the Stedelijk. One is a vast painting I make on the giant cloth that acts as a light filter of the museum's central skylight and it protects the art from the sun. The material is wonderful—almost like cheesecloth, and very

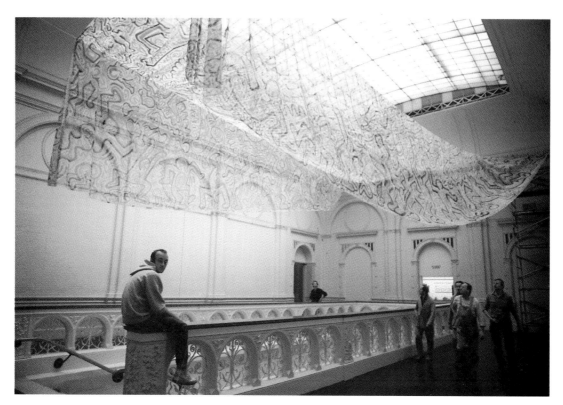

Installation of spray-painted vellum scrim in the central atrium of the Stedelijk Museum. Amsterdam. 1986.

loosely woven. It's impossible to paint it with a brush, so I resort to spray paint. I paint the entire thing in a few hours. The next day it's hung up and it now reflects different kinds of lights. The museum acquires this for their permanent collection.

The other installation is one of my very long drawings that covers the entire length of a continuous sort of circular room. I do the drawing right there, and call it *Amsterdam Notes*.

So these are the new things. Everything else is from the Bordeaux Museum show, including many rooms full of drawings, one of which gets stolen during the opening.

This causes a big scandal, because it was a drawing that was part of a series, and it shows a white guy fucking a black guy. Well, the Stedelijk circulates a reproduction of this drawing to the entire press, including TV. The subject matter doesn't phase Amsterdam at all. To them, it's no big deal. I mean, there's hardly anything that could shock Amsterdam! So the whole country sees this stolen drawing, which is eventually returned.

The Stedelijk opening is even more exhilarating than the Bordeaux opening and, of course, because it's a major museum in Amsterdam, the show has phenomenal at-

tendance. For me, it's an overwhelming experience, showing at the Stedelijk Museum. I felt I really had accomplished something.

DORINE MIGNOT As the curator of contemporary art at the Stedelijk Museum, I was very much a part of Keith Haring's show here in 1986. Of course, Wim Beeren, the director of our museum, made the show possible, and although we took almost everything from Keith's show in Bordeaux, ours turned out to be quite different.

There was the excitement of Keith painting on our huge protective screen, which filters the sunlight. We made an event out of it, and as the entire city of Amsterdam knew about this his fans all came and stood around Keith as he painted on the cloth.

One of the most exciting things was that Keith asked to do an outdoor wall piece where we thought it could be done. Well, we all got together, and decided that Keith could paint the side of our huge storage building, which is a building that stands together with a lot of factories. We rent this place from the city of Amsterdam.

We raised the scaffolding, and Keith started painting the wall at eleven in the morning, and at six in the evening he was finished. It was amazing how he handled

Keith Haring's largest mural on exterior of the Stedelijk Museum's warehouse building. Amsterdam. 90' × 90'. 1986. **147**

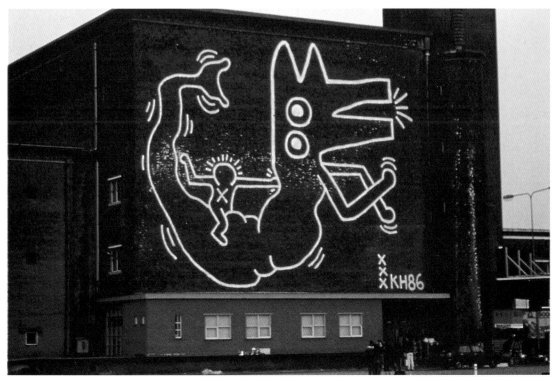

the scale of such a huge building—how he could start and not make a single wrong stroke—and he never came down to appraise or look at how he was progressing. Now thousands of people can see this Keith Haring work from far, far away.

Our show caused quite a bit of controversy. There were a few people here at the museum who weren't too happy about exhibiting his work. But mostly the upset came from the established art world in Holland. A lot of people felt that Keith was a graffiti artist, and the graffiti belonged in the street. They felt it shouldn't be shown indoors. As the Stedelijk is certainly used to controversy, our argument was that our goal was to show what's happening in the art world no matter where people thought it belonged.

One of the best things that happened while Keith was here was that hundreds of children came to the museum, and Keith held workshops with them. Now Keith is a big hero to them. Keith's capacity of communicating with children is extraordinary. I've never seen such a thing!

Most certainly, Keith Haring will be part of art history.

KEITH HARING Crazy things happen in 1986. By now, I've stopped drawing in the subways completely. These drawings had run their course, because they had achieved what I wanted them to achieve and that was getting the work out to the public at large. I also stopped because the subway drawings were disappearing. Word had gotten out that my prices were rising

more and more and people just cut the drawings out of their panels and sold them.

Two things then happen in quick succession: I move to a new studio at 676 Broadway, and I hire an architectural firm to design the Pop Shop. The new studio is huge, and I decide to add an office, which would be elegant, beautifully lit, and totally decorated by me. Julia Gruen, my assistant, now has this gorgeous new space to work in.

Here's the philosophy behind the Pop Shop: I wanted to continue this same sort of communication as with the subway drawings. I wanted to attract the same wide range of people, and I wanted it to be a place where, yes, not only collectors could come, but also kids from the Bronx. Bobby Breslau was put in charge of managing the shop and supervising the whole merchandising aspect of it. The main point was that we didn't want to produce things that would cheapen the art. In other words, this was still an art statement. I mean, we could have put my designs on *anything*. In fact, *Newsweek* came out with a story on the Pop Shop that said we were selling sheets and pillowcases, which we *never* did! And we didn't sell coffee mugs or ballpoint pens or shower curtains. We sold the inflatable baby and the toy radio and, mostly, a wide variety of T-shirts, because they're like a wearable print—they're art objects.

Of course, the Pop Shop was an easy target, and it was attacked from all sides. People could now say, "What do you mean Haring isn't commercial? He's opened a store!" But I didn't care, because it's still going strong—and it's an art experiment that works.

Another project of 1986 was my mural called *Crack Is Wack,* which is located on the East Harlem Drive at 128th Street. When I discovered this wall, it was a handball court that was more or less abandoned and which didn't have a fence around it. And because the wall looks like a big billboard on the highway, it's perfect for a painting. As usual, I didn't ask permission, and I just brought my ladders and paints and, within a day, I had painted this mural, *Crack Is Wack.*

Now, there's a very personal reason why I wanted to do this particular mural. Back in 1984, I hired a young studio assistant. He was a Puerto Rican kid—very in-

telligent, top star of his school, and ready to go to medical school. He did volunteer work for a Catholic community center and he was just an all-around good and wonderful person.

But, little by little, he became a crack addict. At that time, people didn't understand the complexity and danger of the drug. You see, crack is a derivative of cocaine. It's made and prepared in a way that can be smoked and, from the first puff, you have this incredible exhilaration, which is immediately followed by anxiety which is immediately followed by a desire to achieve that same, first high. The problem is that the only time you get this kind of exhila-

Keith in his Manhattan Pop Shop retail store. 1986.

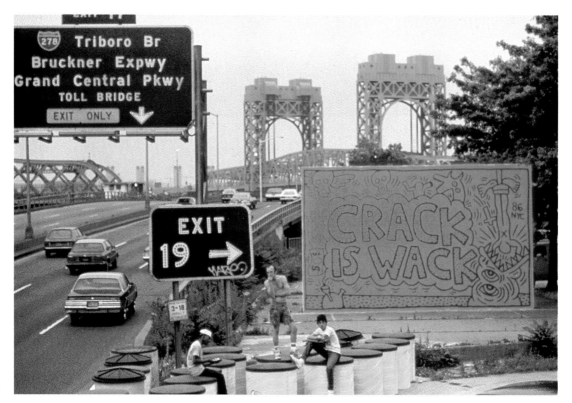

Crack Is Wack. Keith's anti-crack mural at 128th Street and Second Avenue. New York. June 1986.

ration is on that very first hit. Anything after that, is sort of chasing the high. You never, never, never get the same feeling you get that very first time. So you become obsessed with smoking it more and more. I mean, it's a businessman's drug!

Well, eventually this young assistant of mine found himself completely addicted and I got really distressed, because this was a brilliant kid and one of the best assistants I ever had. He got into more and more trouble, but because he was also intelligent, he wanted desperately to stop. Finally, he was put on a program and, thank God, he was cured. But going through this incredible turmoil with him made me really aware of the dangers of this killer drug, and it was

this assistant who inspired the *Crack Is Wack* mural.

During the summer of 1986 I was approached by a woman called Laurie Meadoff, who runs Citykids. It's an organization run by the kids themselves and is an alternative to high school. It gives kids more say in things that affect their lives, from city planning to school curriculums to drug and child abuse. Basically, it's a multicultural venture and Laurie Meadoff wanted me to become involved in some way that would draw attention to the group.

Liberty Banner painted by Keith and Citykids to celebrate the Statue of Liberty centennial. New York. July 1986.

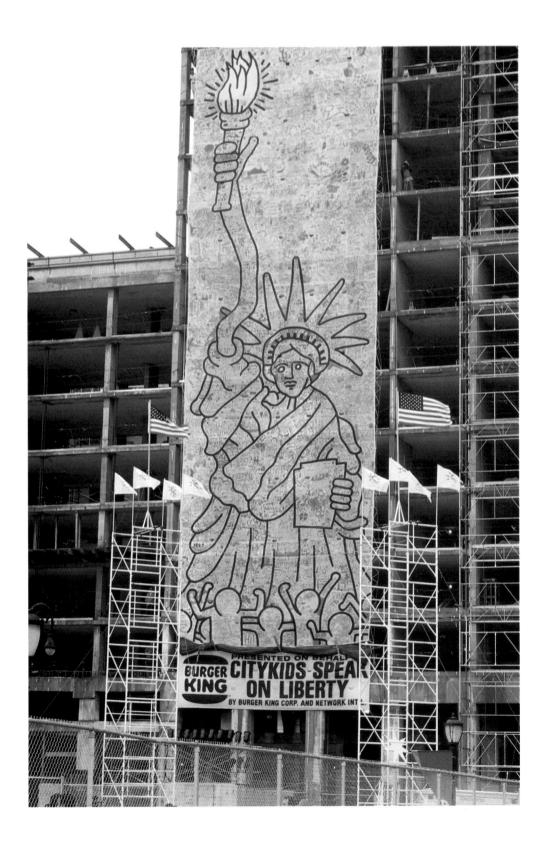

The World's Symbol of Freedom: Andy Warhol as Miss Liberty. Construction by Keith Haring. New York. 1986.

152

As it's the Statue of Liberty's centennial, and a huge event is planned around it, we come up with the idea of making a Statue of Liberty banner that would be ten stories tall and on which I would make black outlines, and the kids would then draw, paint, or write within the outlines. This project, which we call *Citykids Speak on Liberty,* turns into an incredible event involving 1,000 kids!

LAURIE MEADOFF Keith was an absolute natural for this project. He's just a great team player. When he accepted working with us, I went into high gear. Because the Statue of Liberty banner would be enormous, we needed an enormous space to work in. The Javits Center in New York donated its space for three days. The whole idea was to have kids get together for three days, hit a target of 1,000 kids, and mix them so that it would be a real Citykids concept. We contacted the Board of Education and we received approval. We reached out to all the schools. I was able to obtain a sponsor, Burger King, who in turn brought in Pepsi-Cola.

The kids came in droves. There were kids from the United Nations School, the School of the Deaf, and Phoenix House. There were white kids, black kids, Asian and Hispanic kids. Fifty kids at a time worked with Keith on a rotating basis with forty-five minute intervals. While that was going on, the rest of the kids had to be occupied. We had a program director who devised all kinds of games around the subject of liberty. We got performers to come and entertain. The New Kids on the Block came as did Philip Glass, Herbie Hancock, and Peter Yarrow.

When the banner was completed, it was transported to Battery Park City where it was hoisted and attached to a tall building still under construction. We covered the banner with a blue veil until the unveiling on the Fourth of July, which was incredible. Hundreds of kids came. Keith was there with Yoko Ono and other friends. Matilda Cuomo, the governor's wife, spoke. Then, as kids sang "America the Beautiful," the blue veil dropped away, and the Statue of Liberty banner was exposed. It was one of the most beautiful moments ever!

KEITH HARING One of the best things that happens in 1986 is being asked to paint a section of the Berlin Wall. The invitation comes from the Checkpoint Charlie Museum in West Berlin and, the minute I get there, it becomes a phenomenal media event. Every major publication is there—from the *New York Times* to the *Herald Tribune* to *Time* magazine to *People* magazine—and all the international television networks. It is one of the wildest publicity scenes I ever witnessed.

My goal is to paint about 350 feet of the wall. I decide on a subject, which is a continuous interlocking chain of human figures, who are connected at their hands and their feet—the chain obviously representing the unity of people as against the idea of the wall. I paint this in the colors of the German flag—black, red, and yellow.

On the day I start painting, it's drizzling, but it never rains enough to stop me from painting. It takes about a day to complete the section of the wall, and I finish in the late afternoon. A party is arranged for me that night, and on the next day there are more interviews by the wall. When we return, someone has already begun to paint

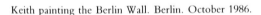

Keith painting the Berlin Wall. Berlin. October 1986.

153

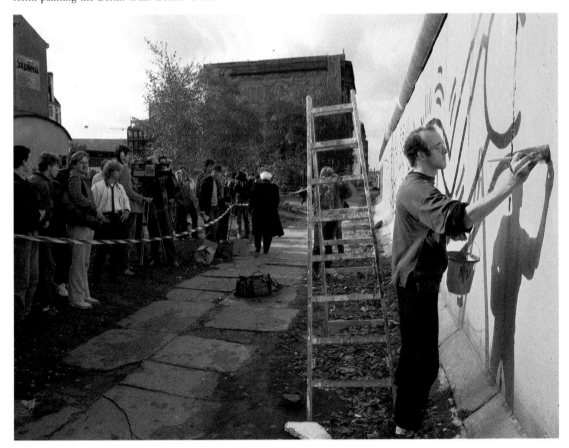

out part of what I'd done. The artist who did this is there, and he says that the wall should not be colorful or artistic. It should remain gray.

Of course, what happens next is that most of my painting gets covered over, because now it's become the most important painting to obliterate. I'm told there are only small fragments that remain as testimony of its former existence.

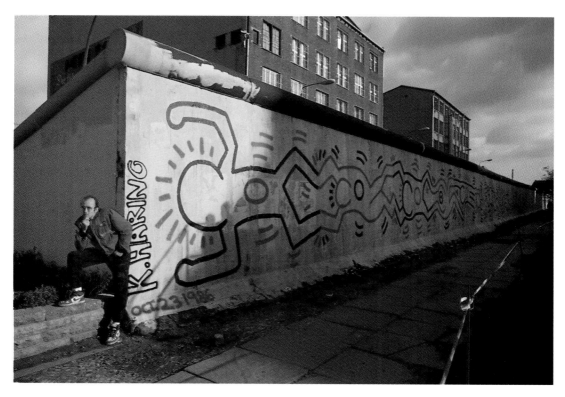

Keith and completed section of painted Berlin Wall. Berlin. October 1986.

154

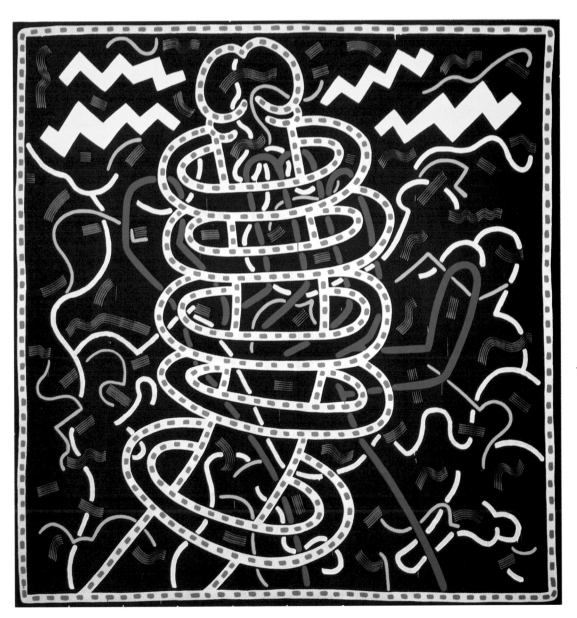

155

Untitled. 1985. Acrylic on canvas. 10′ × 10′.

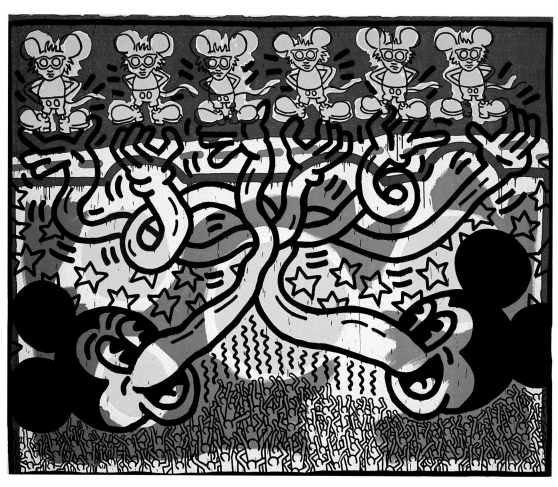

Untitled. 1985. Acrylic and oil on canvas. 10′ × 12′.

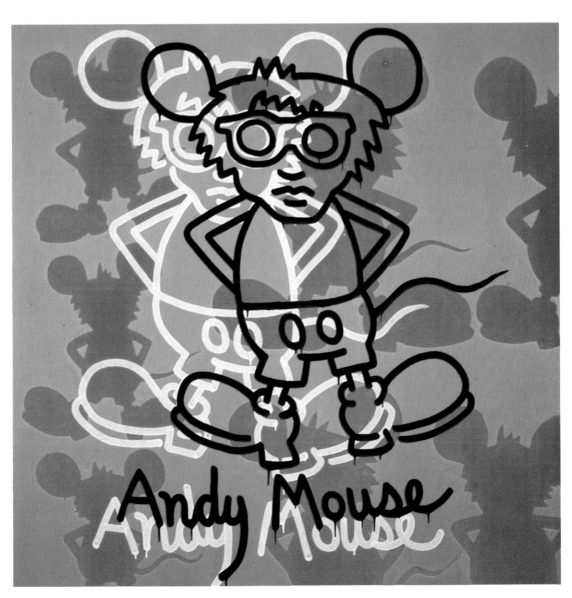

Andy Mouse. 1985. Acrylic on canvas. 5' × 5'.

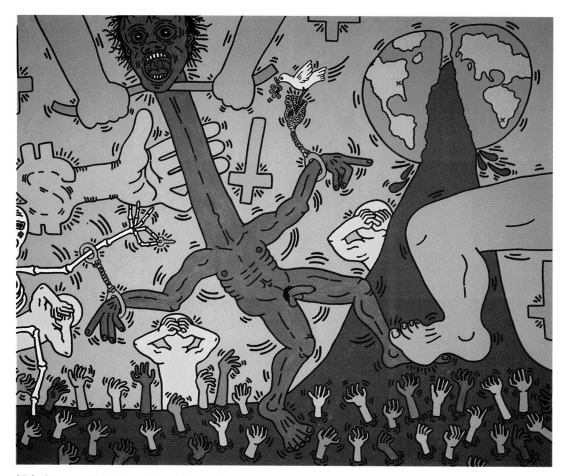

Michael Stewart: U.S.A. for Africa. 1985. Acrylic and oil on canvas. 10′ × 12′.

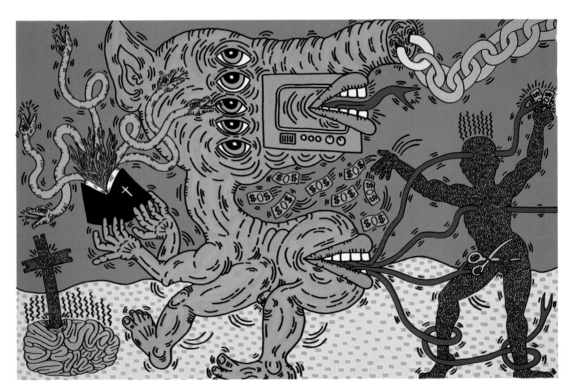

Untitled. 1985. Acrylic and oil on canvas. 10' × 15'.

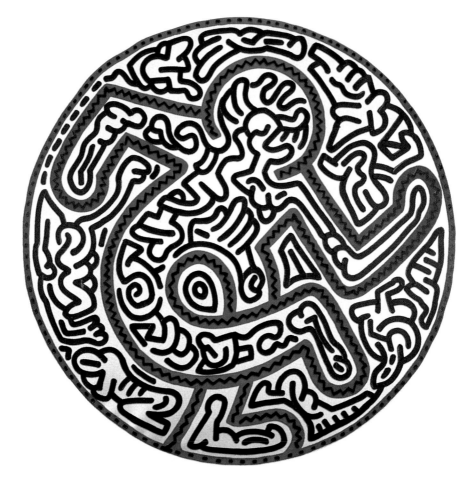

Untitled. 1985. Acrylic on canvas. 3′ diameter.

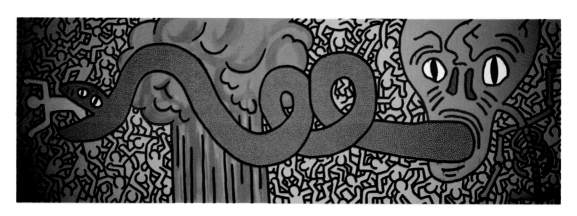

Untitled. 1984. Acrylic on canvas. 94″ × 282″.

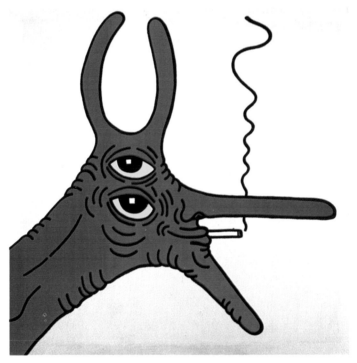

Untitled. 1985. Acrylic on canvas. 3′ × 3′.

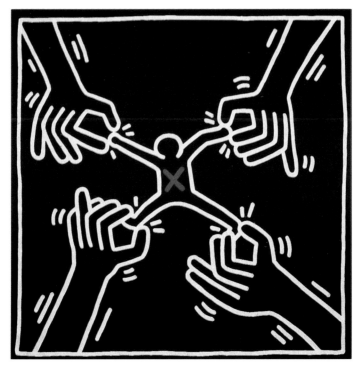

Untitled. 1985. Acrylic on Canvas. 5′ × 5′.

162

Self-Portrait. 1985. Acrylic on canvas. 5′ × 5′.

163

Cruella De Ville. 1985. Acrylic on canvas. 5′ × 5′.

Keith and Julia. 1986. Acrylic and oil on canvas. 36″ × 48″.

164

Grace Jones. 1986. Acrylic and oil on canvas. 8′ × 12′

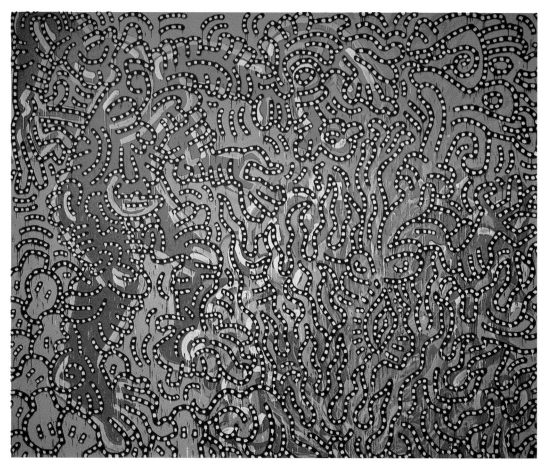

Untitled. 1985. Acrylic and oil on canvas. 10′ × 12′.

IV

1986–1990

KEITH HARING My least successful show at the Tony Shafrazi Gallery is the one in which I veer from the expected Keith Haring style. It opens in December 1986 and runs through January 1987. All the paintings are made a week before the show. I exhibit some sculptures as well as large painted masks, which turn out to be the best things in the show. Although almost everything sells, the show is uneven—and the critics agree.

Just after the exhibit is installed, Bobby Breslau, our good friend and general supervisor, gets sick. He develops a lung problem. Finally, he goes to the hospital and, within a week, he's dead.

Bobby had been our guiding conscience—like Jiminy Cricket—the kind of mature advice that would keep all of us doing the right things at the right time in the right manner and with the right taste. His death is an incredible blow and we feel as though we're being kicked out of the nest—that now we have to do things for ourselves. Losing Bobby is a great shock.

After my Shafrazi show, I take a vacation and again travel to Brazil to visit Kenny Scharf and his family. One day, we're sitting around looking at Andy Warhol's book, *America,* which has all these photographs of his friends. There's a picture of me skinny-dipping in his pool at his house in Montauk, Long Island, and there are pictures of Madonna—and it's like going down memory lane.

After looking at this book, I decide to go into town and call New York. The first thing I'm told is that Andy has died. I couldn't believe it! I go back and tell Kenny.

That night we make a big bonfire for Andy on the beach in Brazil.

I return to New York, and there's a memorial for Andy at St. Patrick's Cathedral on April Fool's Day—April 1, 1987. Thousands of people show up. Andy's loss really hits me. You see, whatever I've done would not have been possible without Andy. Had Andy not broken the concept of what art is supposed to be, I just wouldn't have been able to exist.

PAIGE POWELL Keith sent me a letter of condolence about Andy. I was so moved! I was especially moved, because Keith and I . . . well, there's always been a kind of barrier between us. But then, he sent this letter:

> Paige,
> I just wanted to express my sympathy for the loss of our friend. I know you loved Andy as much as I did. I returned from Brazil a few days ago. Somehow, the impact of New York City without Andy was quite different. It's difficult to imagine New York City without him.
>
> I was glad Andy was really at peace with himself though. I think of the times we spent with him, and his interest in health, vitamins, crystals, God, etc., were testament to his inner peace. Remember the prints he made for Christmas a few years ago? "The Only Way Out Is In"?

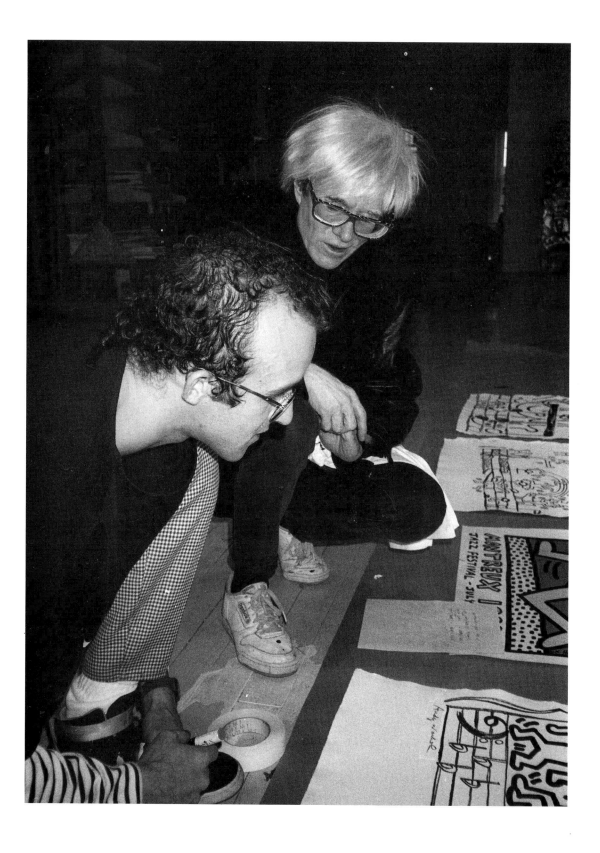

I will always remember him as you will as one of the kindest, sweetest, considerate and caring individuals I have ever met. I only met Andy five years ago, but the impact of his friendship and encouragement has changed my life. It was an honor to have known him.

I feel a particular sadness for you because I know you spent a lot of time with Andy and will miss him dearly. But, like we learned from Andy's matter-of-fact attitude toward death, Life Goes On! I hope his loss will bring people even closer together. Let's try to make it better.

With love and respect,

—Keith

KEITH HARING In the spring of 1987, I make a three-and-a-half month tour of Europe. It's the longest I've ever been away from New York. Just before I leave, I agree to do the set design and costume concept for a ballet called *Interrupted River,* choreographed by Jennifer Muller with music by Yoko Ono. This opens at the Joyce Theater in New York, and the ballet is really boring, although Yoko's stuff is pretty interesting. Of course, I had known Yoko through Andy, who once brought me to a birthday party Yoko gave for her son, Sean

Keith and Andy Warhol working on poster for the 1987 Montreux Jazz Festival in Keith's studio. New York. 1987.

Lennon. Sean and I hit it off right away—he's a brilliant kid!

YOKO ONO When Andy brought Keith to my son's birthday party, Keith came in with this large canvas—still wet! Sean was nine years old that day, and Keith had incorporated the number nine with Sean's face. I believe it's one of the best pieces he ever did—it gives off such energy!

I have always thought Keith and Andy Warhol, who were such good friends and had so much in common, were really very different artists. Andy made statements that had a terrific sense of humor, but he treated his statements very, very seriously. I mean, when he painted the can of Campbell's soup—that was a very humorous concept—but he treated the soup can in a very serious way. He had to do that to make his point.

With Keith, it's exactly the opposite. Keith deals with very, very serious subjects, such as AIDS, but graphically. He, in turn, approaches such subjects in a very humorous, even uplifting way. So it's the total reverse of Andy. That's what makes Keith so interesting. I don't think Andy would ever deal with material such as AIDS. He would deal with something very superficial—something that would reflect the superficialities of the world—and then treat it in a very serious way. So his direction was very different from Keith's.

Keith has always stood outside the art world, because his art is the people's art. In that way, he is like a record producer of pop music—of groups whose songs reach

172 Mural on exterior stairwell at the Necker Children's Hospital. Paris. 1987.

out to the people. John Lennon did that, and the Beatles did that back in the sixties. Keith is doing exactly the same thing, and that's why he communicates on such a big level. Keith is very accessible—and he's also very kind, especially to children. He just has an innate ease of communicating with people, and most artists don't have that ease. I don't have it. But he does—and it's amazing!

KEITH HARING My first stop on my long trip abroad is Paris. I'm in Paris because the Centre Georges Pompidou— the Beaubourg Museum—is celebrating its tenth anniversary, and they are putting to-

gether an exhibition of artists who have risen during the last ten years—and I'm nicely included. I want to do something outside of the museum as well, and through my French dealer, Daniel Templon, and the people at the Beaubourg, we find space available at France's oldest pediatric hospitals, the Hôpital Necker, in Paris.

It's sort of a compound of old and new buildings and, right in the center of it, stands this very modern building with a glass facade and an exposed stairwell running along the side of the building. It's the perfect place to paint! We immediately arrange for a crane which will hold a box with a railing in which I would be hoisted up and down, back and forth.

At this time, I have my new lover, Juan

Rivera, with me, and he becomes my assistant on this project. We decide on the colors, we order the paint, and I start working. The stairwell takes three days to paint—and it's a major and difficult task, because we were outdoors, and the weather was not good. Still, we get it accomplished and Juan and I are very pleased.

While I'm in Paris, I see all my friends—George Condo, Andrée Putman, Kate and Jean-Charles de Castelbajac, Claude and Sydney Picasso. I also run into Jim Rosenquist and James Brown and Donald Baechler—and Kwong Chi is there, and Julia Gruen comes from New York. So everybody is there for my twenty-ninth birthday—and it's May 4th! And there's a birthday party for me at Le Train Bleu. Everybody has a great time, and I'm feeling great!

At this time I also have my first exhibition at the Daniel Templon Gallery.

DANIEL TEMPLON I first saw Keith's work in 1982 at Documenta in Kassel, Germany. They were large tarpaulins—and I had never seen anything like that before.

Installation of Haring exhibition at Daniel Templon Gallery. Paris. 1986.

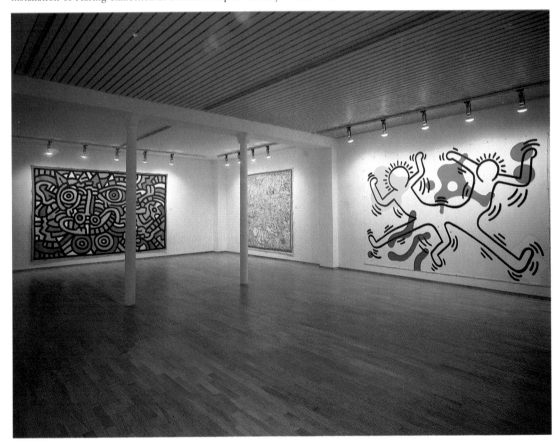

His first show with me was in 1987 and, critically, it was very well received. Though we did not sell everything— the market was not as strong then as it is now. Also, this was Keith's first major show in Paris, and the reaction was the same given to Roy Lichtenstein when he first started exhibiting. People thought what he was doing was just some silly cartoons. Now, of course, a cartoon image by Lichtenstein costs millions of dollars.

Well, we can objectively make a comparison between what Roy painted at that time, and what Keith paints now. What Keith paints now is something totally new— he has invented a new language, and that's the sign of a major artist. Yes, it comes from children's drawings, but you can also say that of Klee, Miró, and even Picasso. In fact, Keith is exactly as gifted as Picasso.

CLAUDE PICASSO I lived in New York from 1967 until 1975, and worked as a photojournalist. When my father died in 1973, I had to return to Paris, because the Picasso estate became more and more complicated. Eventually, I decided to stay in Paris and I became involved in working for artists' rights, which is a worldwide issue. In Paris I also met and married my American wife, Sydney.

We really got to know Keith well

174 Keith with Sydney and Claude Picasso, Yoko Ono, and Raymond Tseng. Paris. 1987.

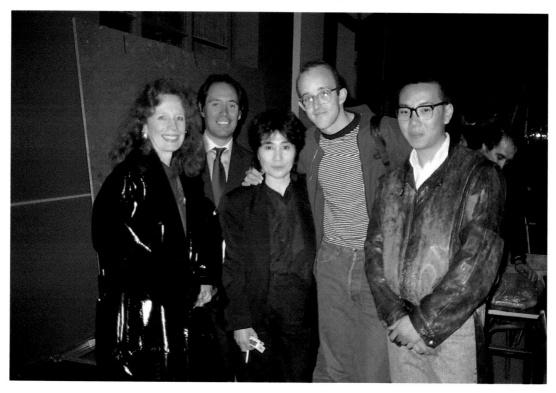

through our friend, George Condo, who is American but lives in Paris. While Keith was painting the stairwell of the Necker Hospital we saw him almost every night, because the hospital is very close to where we live. So Keith would come over and we'd share some spicy food out of the refrigerator or we'd all go out, and Keith immediately became part of the family. And Keith made an immediate friend of our little son, Jasmin—they played and made drawings together. What's beautiful is that Jasmin and Keith have their own friendship just as Sydney and I have our friendship with Keith.

Among the things I inherited from my father is a door that he had painted on. When we moved into this apartment, we had this door installed within a wall so that it actually functions like a door between two rooms. Well, this painted Picasso door inspired us to commission other artists to paint the other doors in our apartment. And, we asked Keith to paint the door to Jasmin's room. The way Keith painted that door reminded me very much of the way my father would work.

I must say, Picasso would have been absolutely thrilled to meet someone like Keith, because Keith is a real worker—he's constantly doing something—and in a way that my father would appreciate. They have similar energies. In painting Jasmin's door, Keith attacked the problem head on, just as my father would have done. I mean, my father would look at a blank canvas, go up to it, then start painting without stopping. When he stepped back, the painting would be finished. And that's just how Keith approached Jasmin's door. He just stayed close, close to the door, painting it from top to bottom—bending on his knees, and never once stepping back to see how it looked. Only after he had covered the entire door did he step back, and that's when the door was finished and became a marvelous painting. Well, my father would have approached something like this in exactly the same way.

KEITH HARING From Paris, I fly to Japan, because some people in Tokyo are interested in my opening a Pop Shop there. We investigate some possible locations and hold many discussions. I then return to Paris, and from there travel to Munich where I've agreed to participate in a project called *Luna Luna,* the brainchild of a Viennese artist named André Heller. His idea was to commission artists to create a traveling amusement park, with artists designing various rides and decorating everything from carousels to shooting galleries to funhouses. So all these artists participate— Lichtenstein, David Hockney, Basquiat, Kenny Scharf, Jean Tinguely, Joseph Beuys, and even Salvador Dalí!

I decide to do a carousel, with the seats in the shape of cartoon characters, and the whole thing filled with my icons and symbols—and it's a terrific project to work on. Well, the big opening for *Luna Luna* takes place in Hamburg, and it gets almost totally rained out. Still, it's a big event, and I'm glad I went. I'm told that the whole amusement park will ultimately be installed somewhere in the U.S. So far, this has not happened, but there's a really beautiful book out called *Luna Luna,* published by

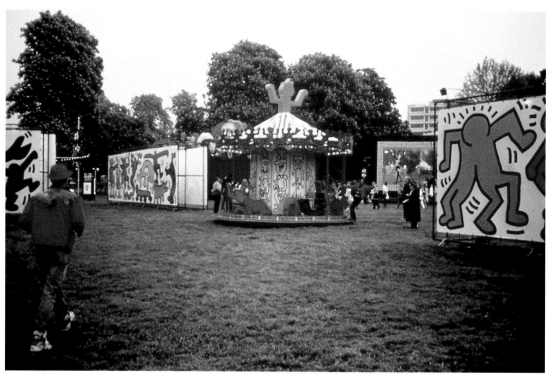

Luna-Luna Park with Keith's carousel and murals. Hamburg. 1987.

Wilhelm Heyne in Munich, which shows everyone's work on the project.

I next fly to Antwerp for an exhibition of collage-drawings being held at Gallery 121, which is one of my favorite galleries in Europe. The show is a sellout and the opening is a mob scene. I sense that Belgium is one of the most supportive countries for my work. This is confirmed when I'm invited to have an exhibition at the casino of Knokke-le-Zoute, on the coast of Belgium. The casino is owned by Roger and Jacques Nellens, who are brothers. Roger Nellens is not only a painter himself, but also a very important art collector, and he and his wife, Monique, own a beautiful house in Knokke, where I'm invited to stay while I prepare for my casino exhibition.

Now this casino is famous because one of its rooms, which is a huge circular room, contains a fantastic mural by René Magritte which was commissioned by Roger and Jacques Nellens' father, back in the 1940s. It's called *The Enchanted Domain,* and it goes all around the room—it's huge! Anyway, I become very good friends with Roger and Monique Nellens. While I stay with them, I live in the fantastical dragon house designed for them by Niki de Saint Phalle. Of course, I do a mural on one of the walls inside the dragon house.

ROGER NELLENS Our casino in Knokke-le-Zoute is quite famous for its art exhibitions. My father started this tradition with a big showing of Picasso. Then he showed Matisse, and for the next twenty-five years there were exhibitions of Max Ernst, Miró, Balthus, Dalí, Magritte, Delveaux, and Dufy. Of course, the Magritte mural is our special pride.

When my father died, in 1971, I was asked to take over the exhibitions at the casino. The first show I put together was works by Niki de Saint Phalle, who I've collected for a long time—I own fifty-seven important sculptures by Niki. That exhibition was in 1985. The next show came in 1986, and it consisted of works by Jean Tinguely. It was a fabulous success. Then I asked myself, "How can I top this?" I spoke to Tinguely, and he said, "Why don't you ask Keith Haring?"

I must confess that I didn't know Haring's name at the time. Then—and I'll never forget this—Jean went into a pantomime of Keith drawing on a wall—he scurried around doing his Keith imitation and

Keith with Jean Tinguely in Lausanne. 1988.

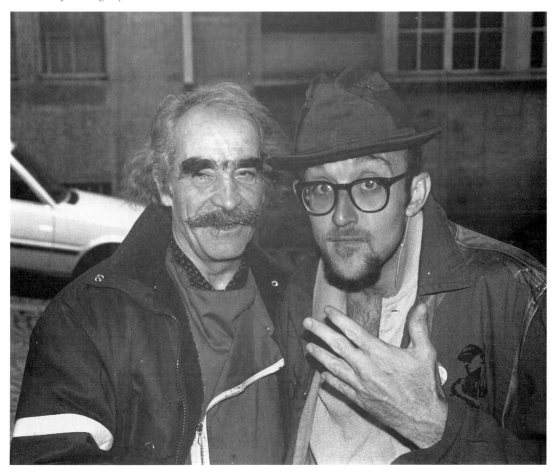

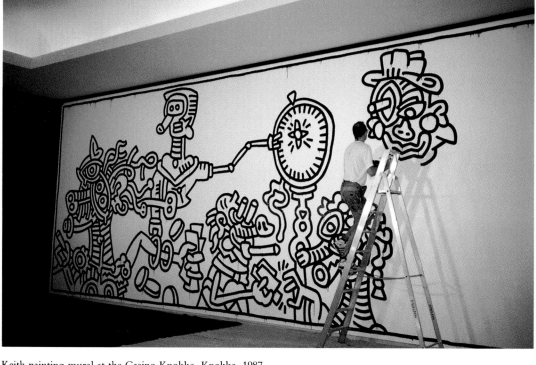

Keith painting mural at the Casino Knokke. Knokke. 1987.

he was saying, "Keith will make draw-
ings everywhere, everywhere—even on the
chandeliers!" Well, Jean wrote a letter to
Keith and Keith and I met some time later.
I discovered how very much in demand
his work is in Europe, and of course, we
hold a Haring exhibition in 1987. In addi-
tion to the show, which consisted of paint-
ings and drawings, I asked Keith to do a
permanent mural in the casino. To watch
him make this mural was a fabulous ad-
venture for me.

I ordered a very special canvas and it
was installed just on the wall which leads
into the Magritte room. Keith began to work.
First he put in the black outlines. He stood
on a ladder and did the whole thing, con-

tinually going up and down, and shifting the
ladder around. We pleaded with him to
take an assistant. He refused. We asked him
to at least let us help him with the ladder.
He said, "No." What I found so interesting
was that when he made the black out-
lines, the music he played was very heavy
rock music—pounding and very rhythmic.
Then, the next day, when he painted in the
colors, the music was much more lyrical—
violins and such.

People continually say to me that Keith
could not have done this mural without
first doing many sketches and drawings. But,
of course, he never does this. He is just
there, with his nose against the wall, and
whatever line or mark he puts down, is

correct. And he never steps back! When he is finished, it looks absolutely perfect—as though the whole thing had been thought out for weeks in advance.

Anyway, when it came time for the opening, my brother wanted it to be a formal affair, as it always was in the past. I said, "We cannot do this with Keith. In fact, we have to open the casino and let very young people in, and, instead of champagne, we have to serve Coca-Cola and orange juice and beer. And we have to have very loud rock music!" And this we did.

Endless people come. They come from far and wide. It was amazing! It was tribal!

KEITH HARING One evening, after finishing a day of painting for my Knokke show, I'm sitting down to dinner with the Nellenses, when I'm called to the phone. It's from New York, and it's a reporter from *Newsday* asking whether it's true that my prolonged stay in Europe is because I'm suffering from AIDS. Well, I'm completely taken aback, because I have never been in better mental or physical health in my life!

KEITH HARING The Tokyo Pop Pop Shop becomes a reality in January 1988. I fly to Japan to meet with Kaz and Fran Kuzui, who are the people working with me on the project. I meet different manufacturers and also travel to Kyoto, where I find kimono makers and fan makers, who supply me with kimonos and fans which are printed with my designs and which will be sold in the shop.

The Kuzuis have the idea that instead

Keith painting the exterior of the Tokyo Pop Shop. 1988.

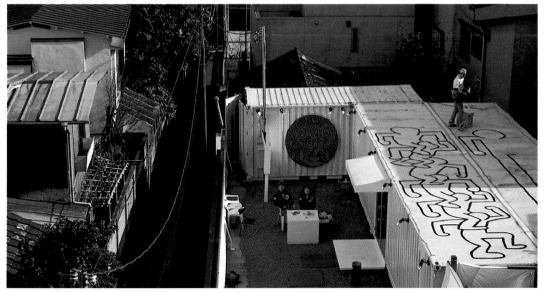

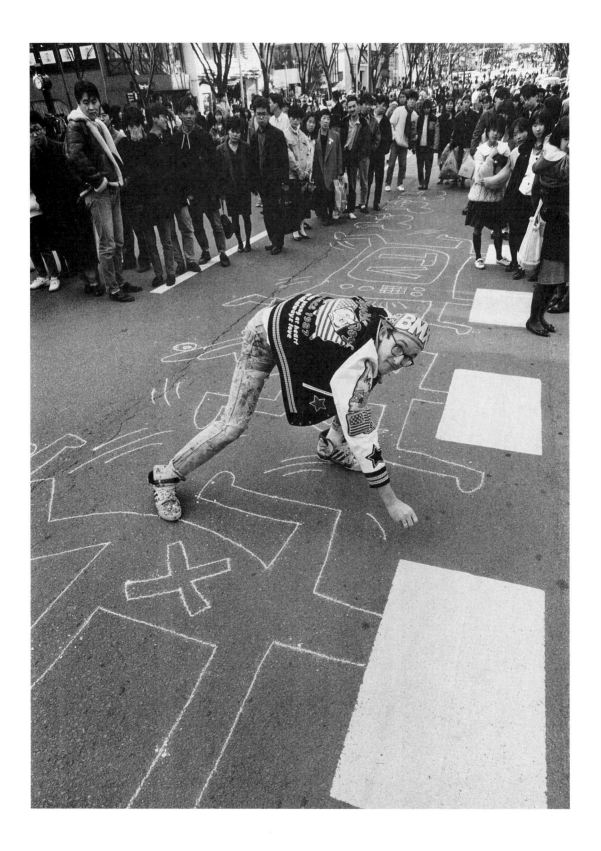

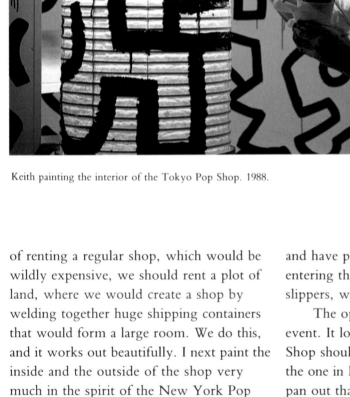

Keith painting the interior of the Tokyo Pop Shop. 1988.

of renting a regular shop, which would be wildly expensive, we should rent a plot of land, where we would create a shop by welding together huge shipping containers that would form a large room. We do this, and it works out beautifully. I next paint the inside and the outside of the shop very much in the spirit of the New York Pop Shop. We stock it with merchandise, all of which bear my designs and logos. We install video monitors, which have ongoing displays of my various projects from around the world. We decide to go with tradition

Keith executing sidewalk chalk drawing. Tokyo. 1988.

and have people remove their shoes before entering the shop. I design Keith Haring slippers, which they wear in the shop.

The opening is another crazed media event. It looks as though the Tokyo Pop Shop should be an even bigger success than the one in New York. However, it doesn't pan out that way. Within a year, the Tokyo Pop Shop falls apart. The reason is that there are just too many Haring fakes available all over Tokyo and, this time, they're really well done. They look like the real thing. Also, I played against the rules, they being that big department stores wanted us to incorporate the shop within their own operations and we refused. We wanted to re-

main independent. So the big stores worked against us, and allowed the proliferation of all the fake Harings to continue—and we were crushed.

GEORGE MULDER When the Pop Shop in Tokyo closed, the big containers that shaped the shop were given to me as a gift from Keith. He gave them to me with the proviso that I pay for the transportation and make something interesting of them in Europe. So these structures, which are all painted and decorated by Keith, are now in Holland, and I'm hoping to make a small Keith Haring museum out of them.

My connection with Keith is that I am one of the people who publishes his editions of prints. My company is called George Mulder Fine Arts in Amsterdam and New York, and Keith has done three major series with me. In 1986, we did our first print series together called *Andy Mouse*, which was a homage to Warhol, and is based on a painting of Keith's also called *Andy Mouse*—a painting I subsequently acquired. This series of prints was signed by both Keith and Andy, and it was a huge success.

In 1987, the year Andy Warhol died, Keith was in a kind of depressed mood, and I thought he should perhaps make use of this depression. I came up with the idea of doing a portfolio of prints entitled *Apocalypse*. It would be a collaboration with a writer—and the writer was William S. Burroughs, who Keith had admired for years. *Apocalypse*, which is a series of ten prints, was published in 1988. Then, Keith and William Burroughs collaborated again in 1989

on a work entitled *The Valley*, which is a chapter from Burroughs' book *The Western Lands*. It was a chapter Keith loved. The series consists of fifteen etchings, and, again, the portfolio was a phenomenal success.

What I love about Keith is that he is determined to produce a body of work in a career that would normally take eighty years, and do it in twenty years. He wants to do everything quickly, immediately, and very well! I find that both funny and admirable.

WILLIAM S. BURROUGHS I had heard that Keith was very much influenced by my writings and by my cut-up principle, and that he had also been at the Nova Convention when he was a student, back in 1978. But it wasn't until 1983 that I actually met Keith. At the time, he had befriended Brion Gysin and I remember he was illustrating "The Faultline" section of Brion's novel, *The Last Museum*.

Keith struck me as being rather spectral— as though he wasn't there. He was strange yet very positive. I remember seeing a very big show of his at the Tony Shafrazi Gallery, and I was absolutely knocked off my feet by the large works in the show. Those paintings had a tremendous electric vitality. It was a very powerful experience for me.

In 1987, we had a big get-together of poets, writers, and painters in Kansas called The River City Reunion, which was organized by James Grauerholz. Keith came for that, and I remember him making a beautiful drawing on the sidewalk in front of the gallery where we had all gathered. He seemed

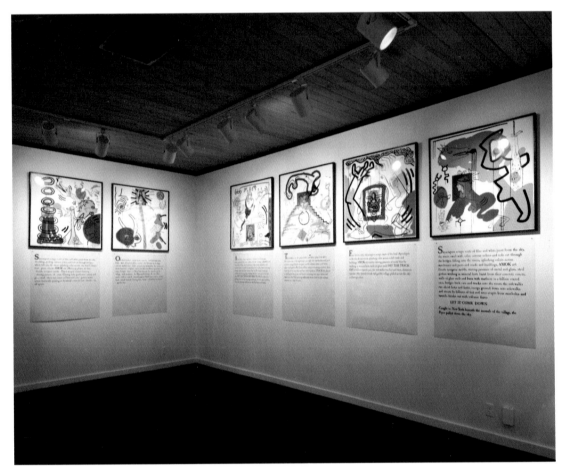

Installation of *Apocalypse,* a collaborative print project of Keith and William S. Burroughs. Hokin Gallery. Florida. 1988.

shy and withdrawn—and yet he was very popular. He was never bothered by the crowds.

When Keith and I collaborated on *Apocalypse,* it was never a master-and-disciple kind of undertaking. Although Keith was young, he was not immature when it came to art. Our work was of equal weight and purpose. I found Keith's art for *Apocalypse* completely astonishing. When I first saw his prints, it was a shock—but a good shock. My texts were perfectly understood and perfectly rendered. This was also the case when we collaborated on *The Valley.* For that, Keith made etchings, and they were exquisitely appropriate.

I think Keith is a prophet in his life, his person, and his work. In that way, he's like Paul Klee, who was probably the most influential artist of the twentieth century— certainly through his art, his writings, his teaching. Keith will influence other painters— probably profoundly.

By association, Keith is part of the whole

New York subway system. Just as no one can look at a sunflower without thinking of Van Gogh, so no one can be in the New York subway system without thinking of Keith Haring. And that's the truth.

JOHN GIORNO I met Keith when he was already famous. He came to dinner with William Burroughs and during dinner he invited me to come to his studio on the following day. I went to see him and

Portrait of William S. Burroughs, Keith, and Brion Gysin. New York. 1985.

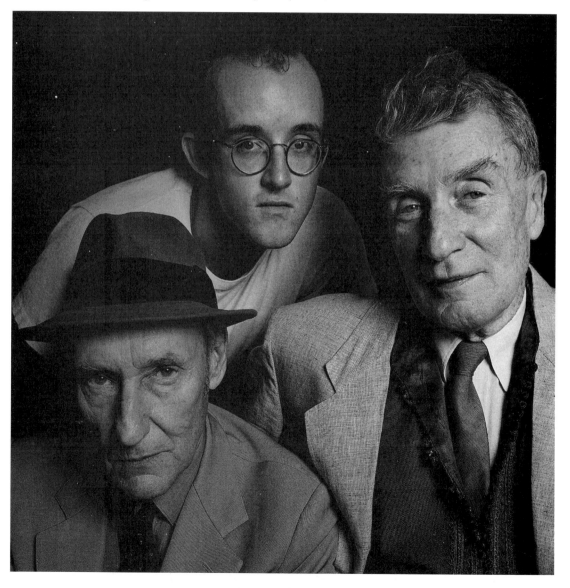

he immediately gave me a beautiful big drawing. I said, "But it's not necessary!" He said he wanted to give me the drawing, because the first thing he did when he came to New York was to go to the Nova Convention, which I had organized at the Entermedia Theater on Second Avenue in 1978. Keith said, "I owe this to you, because you and William Burroughs and Brion Gysin completely changed my life!"

In 1985, I asked Keith to do a record cover for one of my Dial-A-Poem albums. It was an album of readings and music called *A Diamond Hidden in the Mouth of a Corpse,* and, in typical Haring fashion, he produced something exciting. Then, about three years ago, I gave Keith a rather long poem of mine called *Sucking Mud,* for which he made a wonderful series of illustrations.

Although we didn't really see all that much of each other, Keith and I developed a brotherly relationship—an instant camaraderie. I found it rare and sweet.

Keith with Timothy Leary. Los Angeles. 1988.

TIMOTHY LEARY There's certainly a difference in age between Keith Haring and William Burroughs, but both have much in common. They've both avoided the mainstream and they've both broken through the conventions of the art of their time. Burroughs slashed the word line and cut up paragraphs, and it's so synchronistically perfect that it's almost metaphysical. For Burroughs and Haring to get together in 1988 to produce a work such as *Apocalypse* is like Dante and Titian getting together. You know, when all the reputations settle down, Burroughs and Haring will be beacons, because *Apocalypse* is one of the century's great works of art.

185

KEITH HARING Throughout the eighties, I always knew I could easily be a candidate for AIDS. I knew this because there was every kind of promiscuity in every corner of New York City—and I was very much a part of all that.

When early in 1988 my ex-lover, Juan Dubose, got sick with tuberculosis, which seemed to be related to AIDS, it became apparent to me that, of course, I'd eventually get sick too. Besides, there were people who had already died of AIDS with whom I had had sex. So I knew that my contracting the virus was a real possibility. However, up to this point I had no symptoms.

In July 1988, I notice trouble with my breathing. I develop shortness of breath. I

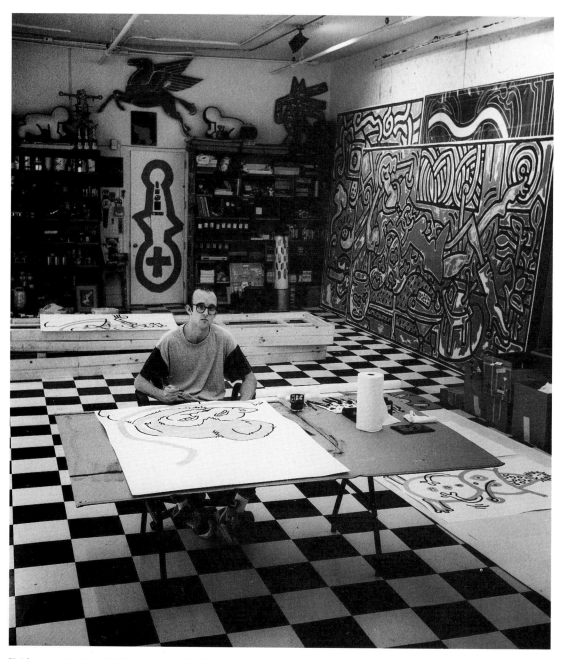

Keith at work at his 676 Broadway studio. New York. December 1988.

go get all sorts of chest examinations and I get my blood checked. Well, within a month or so, the lungs clear up and whatever infection I had heals by itself. The lungs are fine. The blood check is fine. Everything is O.K.

Then, a couple of months later, I again travel to Japan, because I want to visit Hiroshima and discuss with city officials the possibility of doing a Hiroshima mural. I subsequently make arrangements to paint a school wall.

One night, in my hotel room, I begin reading a book that Julia Gruen gave me for the trip. It's entitled *Cities on a Hill,* and deals with four different U.S. communities, one of which is the Castro district of San Francisco, which is a gay community. In this chapter, which deals with gay liberation and the effects of AIDS, there's a guy who inspects himself every day, looking for the purple splotch, which means KS or the AIDS-related cancer, Kaposi's sarcoma.

I suddenly decide to do the same. I look all over myself, and I find a spot on my leg which has a tiny, tiny mild little purple spot. I immediately get paranoid.

When I get back to New York, the spot has not gone away—and there's another one on my arm. I go to my doctor and get the spots biopsied, and within a week I find out that it is, in fact, KS. In the meantime, I go to my other doctor for a blood examination, and he finds that my T-cells have dropped dramatically. This means that I can now definitely be classified as having AIDS.

At first, you're completely wrecked. You go through a major, major upset. I mean, even though I sort of expected this to happen, when it actually *does* happen, you're not prepared. So the first thing you do, is break down. I went over to the East River on the Lower East Side and just cried and cried and cried.

But then you have to get yourself together and you have to go on. You realize it's not the end right then and there—that you've got to continue, and you've got to figure out how you're going to deal with it and confront it and face it.

I immediately start taking the drug AZT—and other drugs. I start seeing doctors. Basically, there's nothing you can do, except take care of your health, watch your diet, and avoid stress. There's no miracle drug. AZT inhibits the replication of the virus—it slows it down. There's a new drug, DDI, which I plan to take, but it's not a wonder drug either. It doesn't reverse things.

For now, the only visible evidence of my having AIDS are the purple splotches—the lesions that start appearing on my body. I get more lesions and more lesions and more lesions. I get one right in the middle of my forehead, which I have treated with radiation. It was much easier before I had the spots. Now, I look at myself in the mirror before I go to bed and when I wake up in the morning, there they are!

You can't despair, because if you do, you just give up and you stop. To live with a fatal disease gives you a whole new perspective on life. Not that I needed any threat of death to appreciate life, because I've always appreciated life. I've always believed that you live life as fully and as completely as you can—and you deal with the future

as it comes to you. Actually, I've always felt that if you have a long life, it's a gift—and you're lucky if that happens to you. But there's no reason to count on it.

Somehow losing more and more people who have been close to you, especially people younger than you are, makes life become more real and more special and more precious.

KENNY SCHARF Obviously, I've known everything about Keith from day one. When our friend Klaus Nomi first got AIDS—I think it was in 1981—Keith was having these enlarged lymph glands. We all thought, "Oh, my God, Keith has 'gay cancer' too!" But it seemed it was something called ARC, which is another type of virus. So, in the back of my mind, I always knew that Keith had the virus.

About two years ago, Keith came to visit me in Brazil for the second or third time, and he looked a little strange, and I had this feeling that Keith had AIDS. This notion freaked me out, because I was really worried about my little daughter Zena, as they really love each other a lot. I thought I had to protect Zena, and so decided to cool it with Keith.

I was getting more into my family—my wife, my children. And Keith had his boyfriend, Juan Rivera, who I didn't really like. So things cooled down between us. But last year, we got back together again and our relationship has come back to its original, true closeness.

CLAUDE PICASSO Keith never said anything to me about his illness—he never complained. Then I heard from George Condo that Keith was sick. I called my stepfather, Dr. Jonas Salk, who is working on the AIDS virus, and the first thing he said was that Keith should reduce his intake of the drug AZT—that strong doses of it are harmful. Of course, I called Keith immediately with this information, and I offered that he get in touch with Salk, who had by then been allowed to do much wider testing on a drug he'd been working on.

KEITH HARING Because of the crisis in my life, I start to need more intellectual companionship. Juan Rivera is fun to be with, but we really don't have much in common. So the more I'm struggling with the situation that starts to unfold, the more I need to talk to someone with whom I can really have an intellectual relationship.

I didn't want to have sex anymore. I didn't want an emotional relationship that was just based on sex, which is pretty much the sum of everything I had with Juan.

Well, shortly before I was diagnosed HIV positive, I met this young kid. He had an aura around him. He's incredibly beautiful, and he's straight—and I fall madly in love with him! It's funny, because we met on the street in front of my studio and we just looked at each other and instinctively said "Hello." Then I saw him again, and we began a friendship *not* based on sex.

His name is Gil Vazquez, and he's eighteen. He's smart, sympathetic, and clever.

He starts to be an intellectual companion for me. For the rest of 1988 and into 1989, more and more of my time is spent with Gil, and less and less with Juan Rivera. In fact, we eventually split up. Of course, when I find out about my AIDS, I tell Gil, and he turns out to be incredibly compassionate.

It now becomes a challenge to be with someone with whom I'm not having a sexual relationship. I discover how wonderful it is to have a sharing and caring relationship with someone. I never experienced that in my entire life. Very soon I take Gil with me to Europe, and he turns out to be a great traveling companion—curious about things . . . and we can talk about everything! Now, even though I have this sickness, all my feelings revolve around my love for Gil.

Gilbert Vazquez and Keith. New York. February 1989.

GIL VAZQUEZ The relationship between Keith and me is something we have yet to comprehend. We don't understand it ourselves. Do my friends understand it? Well, whoever *is* my friend knows enough about me not to misjudge or prejudge me. If they say, "Hey, Keith Haring is gay. What are you doing?" Then obviously they don't know very much about me as a person. The fact is, I feel a real love for Keith. It has nothing to do with whether or not we go to bed together.

The first time I met Keith was on the street. I was walking along lower Broadway with a friend of mine and I saw this guy, and I said, "Wait a minute! That's Keith Haring!" Like everybody else, I'd seen his stuff in the subway and on T-shirts—and

just everywhere! So I looked his way, and he acknowledged me with a "Hello." Later, we met again when I was working in a store on Astor Place—and we became friends.

I'm Puerto Rican, born on the Fourth of July, 1970. I went to Brooklyn Technical High School for three years, and then attended the Manhattan Center for Science and Mathematics, where I graduated in 1986 at the age of sixteen. I sort of hesitated going to college as I wanted to know what it was like to work. So I took a couple of years off. Then I went to La Guardia Community College in Queens, but only for a semester—it wasn't what I expected. So far, I've not gone back to school. At the moment, I'm a salesman and deejay director for Emporio Armani—it's a very good job.

Keith and I went to many places together—to Paris, Barcelona, Madrid, Morocco, and Monte Carlo. The first time I was kind of scared. It was a culture shock. But then I learned so much while I was there! We'd go to lots of museums, and we found we had very similar tastes. We went to lots of restaurants and lots of clubs.

About Keith: I think he's really, really brilliant. I think his art is not as simple as some perceive it to be. Keith and I have talked a lot about his work—how his drawings and paintings changed over time. People think he's stayed the same—that he hasn't grown. But if they really look at his art they would see how he's grown as a painter and as an artist.

We've talked about AIDS. I don't yet know how to deal with it. It's still really abstract to me. But it's not something I think about every time I'm with him. Yes, we do talk about it, and when we do, Keith talks about all the things he wants to get done. It's all about work—and what he can accomplish before he's no longer able to work.

I like being with Keith—I just like being around him. He has taught me so much. Everything I know now—the way I live and the way I think—has, in some way, to do with him. It's not that he's pumped me full of information but more that he has shown me things and he has let me analyze them. He encourages me to express my own ideas and opinions about everything. Keith has been a major influence on my life.

KEITH HARING Jean-Michel Basquiat dies in the summer of 1988. The last time I see Jean-Michel is about a month before he dies. My relationship with him is a funny one. We were always sort of checking up on each other. I always felt he was doing more than me, and he always felt I was doing more than him. In actuality, we were both in a very similar place. I was always jealous of the attention he would get in some circles—and he had similar feelings about me. It sort of balanced itself out.

Anyway, one day I was asked to do a photo-shoot for *Spin* magazine. They gave me a camera and said to just go out and take some pictures on Broadway of my idea of street fashions. It sounded like fun, and one afternoon I went out and shot some pictures. Well, I run into Jean-Michel. I told him what I was doing and, in his usual way, he said, "People never ask *me* to do things like that!" I knew that what I was doing was kind of stupid, but I asked him if I could take his picture. He said. "Sure! I'm dying to be in *Spin!*"

So he lays down on the street on top of some open gratings—sort of like a homeless person—and he closes his eyes. He looks completely peaceful and I snap his picture. Jean-Michel looks great that day. He tells me he was kicking again—that he'd just come back from Hawaii and that he had definitely kicked heroin this time. And we talk about the work he's going to do.

The last thing he asks me is whether it's true that I'm sick. I tell him that, yes, it's true, but it's only as true as I look. Then we parted.

Well, Jean-Michel had gone back to Hawaii and he had kicked again. But he still

couldn't stop. He wanted to do just a little bit more. He underestimated the power of what he had done, and did too much. Jean-Michel OD'd on heroin.

HANS MAYER I'm Keith's German dealer. The first time I heard the name Keith Haring was around 1979. He was a student of Bill Beckley at the School of Visual Arts, and Bill told me, "I have a wonderful young student. You should meet him." But I was too late. Unfortunately, I didn't pay attention at the time and several years later he went with Tony Shafrazi, with whom my relationship was not so wonderful. During a certain period, I was jealous of Tony as we were business rivals in Iran. I've since gotten to know him and I feel he's quite a marvelous person.

When I actively represented Andy Warhol in Germany, Andy always said, "Hans, you should meet Keith Haring—he's a wonderful artist." Well, by this time, I had already been a dealer for some twenty-five years, and my feeling was that if a painter is really very good, you can always catch him at a later time and work with him. I felt I didn't have to be the first on line.

In 1984, Keith Haring began working in Germany with Paul Maenz, who is a very distinguished dealer in Cologne. I became very jealous because I looked at Keith's work and was really excited. I realized that a new artist was creating a new art for a new generation. Well, Paul Maenz did great things for Keith, because after 1984, Keith was all over Europe. I was really off the mark. I was not on top of things. How-ever, in 1985, Keith started making marvelous sculptures and in 1986 I was able to sign a contract with Keith for thirty-six sculptures. And now, all the sculptures have been completed—except two pieces.

Keith is very powerful in Europe. He's big in Germany, Holland, Belgium, Italy, and France. These are the countries that first bought Pop Art in a very big way—even before America. There is no resistance in Europe or Japan to the work of Keith Haring. But, I'm sorry to say, there is in his own country. I think I know why.

You have to understand that Keith comes from the tradition of graffiti art—wall painting—and in 1982, he joined a gallery where the owner once painted on Picasso's *Guernica*. You know how narrow-minded certain art historians and museum people are in America. Imagine what they think of the dealer who smeared the *Guernica* taking on an artist who paints and defaces walls and subways!

I had a similar problem with Warhol. For years, German curators and art historians used to laugh, saying, "Look at Warhol! He has to exhibit in small villages in Europe, because in America he's nobody!" Now, of course, if you go to Cologne and talk to museum people about Andy Warhol, he's a god!

The point is, if Keith Haring were to be given a big museum show in America, every museum in Europe would be green with envy, because it would be the biggest success in America. Everybody would go and see it. And that's because Keith's art is the art of the coming generation.

KEITH HARING In September 1988, I go to Düsseldorf for a show of my paintings and sculptures at the Hans Mayer Gallery, which is one of the best galleries in Germany. I've become more and more interested in doing large outdoor sculptures. With my friend Kermit Oswald and his father, who is a great carpenter, I create models and maquettes, which we send to Germany. Hans Mayer, in association with Tony Shafrazi, begins production of these sculptures. This is a major, major project involving small-, medium- and giant-size pieces, and represents my largest sculpture output to date.

When I get back from Düsseldorf, I get ready for my 1988 show at the Tony Shafrazi Gallery. These new paintings are on raw canvas, with the color sort of soaking into the canvas, but letting some white spaces show through. It's a new direction.

These paintings are made after my having been diagnosed as having AIDS. It's a peculiar time for me and it's a peculiar time for the art world. What's happening now is the emergence of a new group of artists, who are suddenly receiving the attention that had been bestowed upon me and Jean-Michel and Julian Schnabel. I'm talking about these Neo-Geo artists—people like Jeff Koons, Ashley Bickerton, Peter Halley, and Meyer Vaisman, who hold long intellectual discourses about language and get really bogged down in themselves.

They become exactly what the elitist art world wants and needs to separate itself

from the masses and the rest of the culture—because it's so anal and self-referential. What's interesting is that this movement purports to be conscious and reflective of the whole consumer aspect of the art world, which, of course, I had been doing all along with ideas like the Pop Shop. But these people have the blessings of the museums and the critics because they played the game and went through conventional art channels as opposed to starting on the streets.

What I can't understand is that in 1989 and going into 1990, there's still resistance to my work from the American art establishment—from the American museum world. In a way, I'm glad there's resistance, because it gives me something to fight against. As always, my support network is not made up of museums and curators, but of real people. And that's good, because everything I've ever tried to do was to cut through all that bullshit anyway.

People might say, "If you're not interested in being a part of the system, then you shouldn't care that you're being ignored by the museums and the curators!" Well, I really do believe that it will all happen later—the acceptance. It's going to happen when I'm not here to appreciate it.

193

TONY SHAFRAZI Any work that addresses and reflects a more populist language will be disdained by the art establishment. It's for this reason alone that Warhol was shunned for so many years by museums in America. The same goes for Jean-Michel Basquiat even after his death. In terms of formalism he is being treated as

Monumental sculpture by Keith at foundry in Düsseldorf. 1988.

a sort of *enfant terrible* and put back into a niche of so-called primitive figuration.

Neither Keith nor Jean-Michel are being seriously considered by the institutions. This will continue for a while. The main point, though, is that museums resist artists who already have an audience as they would rather help create that audience. When, as with Keith Haring, they have a ready-made artist who is successful and has an established audience, there's no real challenge—and they resist.

KEITH HARING My show at Shafrazi in 1988 means a lot to me. It's the most important show to date. Because of my health situation and because of the death

of Andy and Jean-Michel, I felt it was time to prove something. As it was the kind of show that would either make me or break me, there were a lot of expectations, both on my part and on the part of others. If it failed like the last show, then I might simply be considered a failed artist. Luckily, this doesn't happen.

A lot of the canvases were shaped— triangles, circles, some squares and rectangles. I felt these works were almost a summation of what I had accomplished in painting so far. I tried to show my drawings and my use of color to the very best of my ability.

Well, the public loved the show and almost everything was sold. Still, the reviews were very shallow. There was no review in the *New York Times* nor in *Art Forum*. But the artists came and that always means something to me. When an artist comes to your show, it always means there's

something there to look at. And when he comes to your studio, that's even better.

FRANCESCO CLEMENTE I'm a painter, and I don't go around with a connoisseur's eye. That doesn't interest me. What I really want to know when I look at a painting is, "Who is speaking? Why? Where is he speaking from?" When I ask that of a painting by Keith Haring, "Who is speaking?" I find it's a graphic genius. When I ask, "Where is he speaking from?" it's from a very challenging and fertile spot, because it's located between social groups and races and between division of high art and low art—and between painting and non-painting.

When you first see Keith's work, you see how correct it is. And you see if it makes sense or not. Right away, I saw that it made sense. And I started wondering about his lineage. I went to his studio and looked around. On the walls were some reproductions of Dalí and some things of Tinguely and Niki de Saint Phalle—and I saw that this lineage had to do with connecting himself to free spirits. There's a beauty to this kind of position and it's needed.

With his art, Keith made a place—a place that has a soul and has light. I'm one of the last persons who can still read an image and believe what the image says . . . accepts what it tells and what it can teach. I believe that images can heal. Keith Haring definitely made healing images.

KEITH HARING I've always been respectful of Francesco Clemente. Along with Jean-Michel Basquiat, George Condo, and Kenny Scharf, he's been one of my favorite artists. I like looking at his stuff, and I'm inspired by it. But my real friendship is with his children, and with his wife, Alba.

KEITH HARING I'm definitely ready for a vacation. My show at the Shafrazi is coming down, and I decide to take Gil Vazquez to Europe. I need to be away with him. I need to take time off. But as bad luck would have it, I now hear that my first lover, Juan Dubose, isn't well.

I hadn't heard from Juan in a long time. Over the months, I've been hearing that he doesn't have a job and that he's doing drugs. Now I hear he's gone back to live with his mother in Harlem and that he's sick and deteriorating. Juan's mother finally calls me, saying she can't take it anymore, because she's watching her son getting sicker and sicker.

Somehow, Juan Dubose manages to check himself into a hospital. I visit him and he tells me he has AIDS, which I've already suspected. Juan says the hospital isn't treating him for AIDS. They haven't put him on AZT, and I can see he's just draining away to nothing. I talk to the doctors and they start running tests on him.

I make sure Juan is comfortable. I talk to him for a long time. When I leave, Juan reaches up to kiss me goodbye. At the door, I turn and wave goodbye to him. The next morning, Juan's mother calls to say Juan has died.

I now call our friends and it's very hard, because my telling them that Juan had died of AIDS is the same as telling them that I'm going to die of AIDS. I mean, Juan Dubose was my lover for four years.

The funeral is in Harlem. I get people to come to the wake. The coffin is open and I think I'm really going to be scared looking at Juan. But he looks so beautiful! He looks so peaceful!

After the funeral I'm more than ready for my vacation with Gil. I want it to be totally luxurious and I don't want to spare any expense. I just need to make this time with Gil very special.

We fly to Paris by Concorde, of course, and stay at the Plaza Athénée. We explore the city together. We go to museums, the best restaurants, the best clubs. After some days, we fly to Madrid where I decide to call one of my closest friends, Yves Arman, the son of the artist, Arman. Yves, his wife, Deborah, and their little girl, Madison, who is my godchild, live in Monte Carlo. So I talk to Yves, and tell him that Gil and I would like to visit them in Monte Carlo. Well, Yves says he was just getting ready to come to Madrid, because of the Art Fair that was in progress—Yves is a private art dealer and also a writer. So he says that he's going to be driving his father's Porsche from Monte Carlo to Madrid—and that he would be leaving that very evening, drive all night, and arrive in the morning. This kind of worries me, because Yves is a terrible driver. However, it's left that Gil and I will wait for Yves in Madrid. I'm really looking forward to seeing Yves, because every time we're together we have the greatest time.

DEBORAH ARMAN Yves and I met Keith in the South of France in 1986. We became instant friends. That summer, Keith was in great shape—just being all over the place and so full of fun! So we took Keith to fabulous parties, and we hired a yacht and went to Saint-Tropez. I remember one really hot night at someone's gorgeous home. We were sitting around the pool drinking champagne, when Keith says he's dying for a swim. I said, "Go ahead, Keith. Jump in!" He said, "No, I don't have a bathing suit." I said, "Keith, this is the South of France. You can take your clothes off, it's no big deal." He said, "Well, Deborah, I'll go in if you'll go in." I said, "OK. If you get in the pool, I'll get in too." He said, "You will?" I said, "Yeah! I promise!" So Keith strips and jumps in. But I didn't. He hollered, "You bitch!"

I'm from Fort Worth, Texas, and I moved to New York in 1982. I did some modeling in New York, Paris, and Milan. Then, one day, I met Yves Arman in New York. It was love at first sight. We started living together and, after a year, we decided to have a baby. But Yves said, "We will not raise our baby in New York. We will raise our baby in the South of France." So first we lived in Nice, then Cannes, and we finally settled in Monte Carlo, where our baby girl, Madison, was born in the Princess Grace Hospital.

When Madison was born, Yves said I could choose the godfather and he would choose the godmother. Well, I chose Keith as the godfather, and Yves chose Grace Jones as the godmother. So we went to our lawyer to make it all legal, but instead of being called godfather, Keith is called artfather, and Grace is called soulmother. So Grace is supposed to teach Madison about soul, and Keith is supposed to teach her about art.

A month after Madison was born, Keith flew over to see her. He cradled her, fed her, and played with her. Then, he painted her room. He decorated her little crib, and high chair, and he painted on the walls—cows, teddy bears, monkeys, chickens—all around the room. On Madison's door, in red, he wrote, "For Madison," and in blue, he wrote, "Love, Keith, 1987."

Also at that time, Yves was working on

Deborah Arman with Keith in front of mural commissioned by the city of Pisa. Pisa. June 1989.

a project to bring various artists to Monaco. While Keith was here, Yves introduced him to Princess Caroline, who is a friend of ours, and Caroline commissioned Keith to do a mural in the maternity ward of the Princess Grace Hospital.

Anyway, when Keith called from Madrid that February, 1989, Yves and I were thrilled. Of course, my heart sank when I heard Yves tell Keith that he would be driving from Monte Carlo to Madrid which meant Madison and I wouldn't get to see Keith—but there was nothing I could do.

KEITH HARING Gil and I are waiting for Yves Arman in Madrid. But there's no sign of him. Well, after hours of waiting, we get a call from Deborah Arman. Right away, I sense something is wrong. She tells me Yves is dead—killed in an automobile accident on the way to Madrid. Deborah's freaking out. She says I have to come to Monte Carlo immediately. This is terrible for Gil, because it's supposed to be our vacation, and he didn't really know Yves all that well. Now he has to be party to this whole tragedy. But, of course, we go.

DEBORAH ARMAN Yves was terrible about driving a car. Something awful got into him when he sat behind a wheel. Everyone knew this. People refused to drive with him. He drove too fast—too recklessly. He took stupid chances. You could have put a blindfold on him—that's how he drove.

Just a month before he died, Yves asked me, "Deborah, if I were to die, do you think anybody would really care?" I said, "Yves, of course people would care! You're loved! Besides, you always told me that you and I will live forever." Yves was only thirty-four when he died.

Yves's body was returned from Spain. I insisted the coffin remain closed. I didn't want to see Yves's face. His mother and father came as did my parents. Keith and Gil arrived. When we were all gathered together, Yves's mother turned to Keith and said, "I want you to paint Yves's coffin."

KEITH HARING Yves's mother tells me that Yves would have wanted me to paint his coffin. Reluctantly, I agree. On the night before the funeral, Deborah and I and a few friends enter the chapel where Yves's coffin has been placed. The chapel is beautiful—painted all in white. Outside, there's a big moon. We put on soft music. I begin to paint the coffin.

I decide to paint one of my angels, because Yves always wore my little angel logo on his lapel. So I paint the angel and also a mother and child. And all around that I paint the words, FOR EVER AND EVER AND EVER. . . . What I thought was going to be a really horrible task turns into an effortless outpouring. And for the first time, Deborah is calm.

The next day is the funeral. Everyone speaks. I don't want to speak, but finally I do. When it's over, the whole thing gets

to me. There have been too many deaths—Andy, Jean-Michel, Bobby Breslau, Juan Dubose—and now, Yves! I'm amazed I've managed to get through it all. But I learn that you have to stay strong for other people.

After the funeral, Gil Vazquez and I are determined to make the rest of our time in Europe totally great. We go to Barcelona, and there I meet some people, and through them I make my first AIDS mural. I do it in a section of the city called Barrio de Chino, which is populated by junkies and prostitutes, and where they have a very big AIDS problem.

Gil and I visit amazing churches and museums and go to the Miró Foundation, the Picasso Museum, and we look at endless Gaudís. From Barcelona we go to London, where my friend George Condo is having a show. We have a great time in London, and from there we fly to Morocco, which is fabulous, and from Morocco we go back to Paris and from Paris we fly back to New York. Now it's getting toward the end of February 1989, and Gil continues to be my beautiful friend.

JULIA GRUEN Andy Warhol's death certainly had a sobering influence on Keith. The death of Juan Dubose was very, very hard on him as were the deaths of Jean-

Keith in front of his mural on the White House lawn on the occasion of the annual Easter at the White House. Washington, DC. 1988.

Michel, Bobby Breslau, and Yves Arman. These finalities were facts Keith had to come to terms with. What finally plunged him into despair was that some of his closest friends began being tested HIV positive—John Sex, Kwong Chi, and Keith's last lover, Juan Rivera. With his own health problems looming, there wasn't much he could do except continue doing what he always did—work like a madman.

During 1987, 1988, and 1989, he had taken on endless projects, including an image for the Public Library's *Literacy Campaign,* a poster and a T-shirt for the New York City Ballet's 40th Anniversary *American Music Festival,* a huge mural that was erected on the White House lawn for President Reagan's *Easter at the White House* celebration, a mural for the Grady Hospital in Atlanta, Georgia, and the famous *Don't Believe the Hype* mural on the FDR Drive at Houston Street in New York City. Of course, he continued to make things for all these causes and others, for which he never charged a cent.

During those years there's an enormous amount of traveling. I'm asked to come along with regularity. I never had a stitch of work to do overseas, but Keith liked me to be at all the dinners and parties. In a way, I think he was glad there was someone along who wasn't as tongue-tied as some of his other traveling companions might have been.

Keith was an object of total adulation abroad. Especially in Japan. In Europe it wasn't so much a question of adulation as some kind of intuition as to who this guy was, and what he was doing—and an acceptance of his vision and his philosophy.

Coin Box. Created and painted by Keith for international airports throughout France. These coin boxes serve to collect foreign currencies to benefit France's underprivileged children. Paris. 1989.

He was much more accepted in Europe than he ever was here.

Anyway, when Keith wasn't traveling, he held to a rigorous schedule in his New York studio. As always, he surrounded himself with young Hispanics and black kids. I mean, the flow of these young people into the studio was constant—constant! I didn't analyze it, but I often wondered, "How can he work?" But he did. And with terrific concentration. These kids would either sit and watch him work or they'd hang out in a corner of the studio, smoking pot and listening to music. Obviously they inspired

Keith in some way. I once asked him about it. He said they helped him to keep up a certain rhythm, a certain beat, a certain closeness to the street life that he wanted to be part of.

Keith was totally at a loss as to what to do with a secretary or an office assistant when I first started working for him in 1984. However, as the years progressed, he came to be a very proficient boss. He liked being in total control. One could not, literally, go to the bathroom without his knowing about it. And if you did go to the bathroom, and the phone was ringing, he'd start screaming: "Why didn't you answer the phone!" Keith has a temper. He can get very, very angry. But his anger disappears in about three seconds flat and usually, he's very rueful about it afterwards.

In 1987, Keith's success demanded that we hire someone to be in charge of his finances. We found a terrific girl from South Africa by the name of Margaret Slabbert.

Margaret Slabbert, Keith's financial manager. 1990.

MARGARET SLABBERT

My work for Keith involves everything to do with money—from entry-level bookkeeping to financial statements to preparations of tax returns and submitting everything to the accountants for the final compilation of the numbers. I'm also involved with the Pop Shop, ordering the merchandise and dealing with the general day-to-day operations. Basically, Keith wants a certain atmosphere in the store, which is very street-kid oriented. He doesn't want it to be a formal boutique. And the people working there are more or less street-kid types.

I like working for Keith. He's extremely intelligent and he's very intense. He's also a terrific businessman. He's very fair, and not very high-tempered. He tends to be on the quiet side. The entire Keith Haring, Inc. enterprise is a large financial success. Just since I've been here, his overall income has quadrupled. And recently, with the news of Keith's illness, his prices have gone sky-high.

In the office, it's just Julia and me. Then, there's Keith's studio assistant, Adolfo Arena, who's been with him for about three years.

ADOLFO ARENA I met Keith at a club in downtown Brooklyn. It must have been 1984 or 1985. We passed each other on a dark stairway and I said, "How are you, Mr. Haring?" The minute I said it, I thought, "Give me a break! Why couldn't you just have said, 'Hi! How are you?' " But I respected him as an artist without having any real knowledge of the art world.

At the time, I was going to school at the Fashion Institute of Technology. I graduated from FIT with a degree in fashion merchandising and retailing. My first job was working in a posh tennis store on Park Avenue. Then I landed a job with Ralph Lauren—in the footwear division. This was in 1986. I then met the jewelry designer, David Spada, and became his assistant. As David and Keith were good friends, I found myself becoming closer to Keith. I was there when Keith and David worked with Grace Jones.

In the spring of 1986, Keith opened the Pop Shop on Lafayette Street and *everybody* wanted to work there. Bobby Breslau was the manager, and he talked to Keith about me, and I was hired. Then, in 1987, Keith's studio assistant was becoming heavily involved with drugs.

It was agreed that I should temporarily replace him. Well, it just blew me away! To be Keith's assistant, even temporarily, was just incredible! And I've been with him ever since.

The way I saw the job was, like, "Keith, you paint and let me do the rest." That meant I would even be willing to brawl with anyone who wasn't supposed to be in the studio, because Keith would have all these loonies around, taking advantage of him. Sometimes, I'd have to protect him physically. Also, I tried keeping myself in tune to what went down at the studio, being alert about things and intuiting what was needed before Keith asked for it. This showed him I was on my toes.

Yes, at one point, Keith and I were intimate. I love Keith so much! And I wanted it to be just about me and Keith Haring. But I had to outgrow that, because I would hate to be overly possessive of somebody. So at one point I said, "This must not be," and we stopped being intimate.

I try to be some of the things that Bobby Breslau was to Keith. I mean, Bobby was Keith's mentor. He pushed Keith to the limit. He was an incredible force behind Keith. If Keith would do a magnificent painting, Bobby would just throw flowers over Keith. He made Keith feel so confident and brilliant. I know Keith misses that. So when Keith is painting, I sometimes come out and say, "If you want me to tell you how beautiful your artwork is for half an hour, I'll do that!"

KEITH HARING In the spring of 1989, this really wild friend of mine, Princess Gloria Von Thurn und Taxis, asks me to design the invitations for her upcoming birthday party on April 15th, which is to be held in her castle in Regensburg, about an hour from Munich. Gloria is quite young, and she married this old prince—Johannes—and they have three little kids, who are completely adorable.

I met Princess Gloria through Andy. She was up at the Factory, and Andy called me and said he had someone there I just *had* to meet. So we met. When I was in Germany in 1987, I saw her again, and she invited me to her castle.

Tony Shafrazi is in Germany too, and Tony and I are picked up by her limousine and we have lunch with Gloria and Johannes, the prince. One of her children, Albert, is there—he's about five—and we do

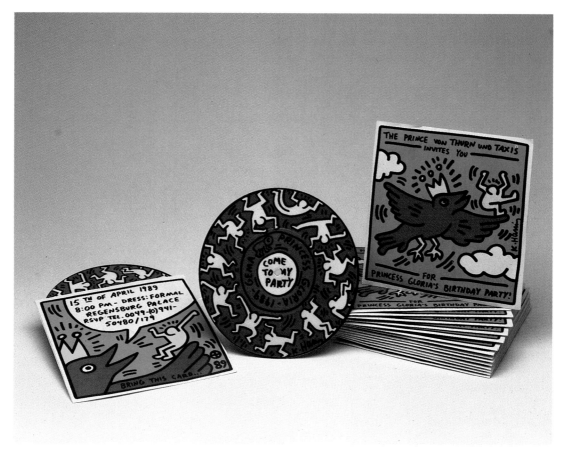

Record album and sleeve created as an invitation to the birthday party of the Princess Gloria von Thurn und Taxis, held at her Regensburg castle. Regensburg. April 1989.

all these drawings together—on paper, on the door of his room and on the walls. So we all become very good friends, and Gloria buys some of my stuff and also buys things by Jean-Michel. When she asks me to do something for her birthday party in 1989, I say, "No problem!"

Gloria wants me to design an invitation that would be in the form of a little 45 rpm record. It's a *sung* invitation, with her doing the singing, because she's also something of a rock singer. So I design the record sleeve, and it turns out really neat.

The princess next decides she wants Keith Haring dinnerware at her party. So she commissions me to design these place settings and arranges for Villeroy & Boch to manufacture the settings. They look fabulous!

When the time comes, I prepare to go to Germany, and Julia Gruen is my date. In the meantime, the lovely Julia has fallen in love with a young German actor who lives in Munich, and so naturally she's thrilled to be coming along.

The party is an unbelievable event. When we get there, I notice that the castle is dec-

orated with banners which echo the designs I made on the invitation and on the dishes. They did this without consulting me—but the banners look OK so I don't say anything. Deborah Arman comes from Monte Carlo—she needs some cheering up—and there is a huge amount of people—artists, art dealers, tennis champions, rock stars, actors—and it's just great.

I hang out with the people who're doing this drug, Ecstasy, and we're all playing silly games around the castle . . . you know, doing things in the bedrooms and in the bathrooms. Deborah Arman gets drunk out of her mind, and I have to take her back to her hotel. Julia Gruen disappears and goes back to her hot love in Munich by taxi as quickly as she can. As parties go, this one is among the best I ever attended.

We fly back to New York, and I embark on this workaholic routine, doing mural projects that were in the works for about a year.

One of them is in Chicago. I had been approached by a man named Irving Zucker, who had followed my work with children for years. The project turns out to be a huge mural sponsored by the Chicago Public Schools and backed by the Museum of Contemporary Art of Chicago. There's also a land developer who is willing to donate tons of money so that we can have the best supplies and materials and also have T-shirts for each of the kids involved.

So Irving Zucker proceeds to organize all this, and it's the most carefully orchestrated project I ever worked on. The mural is the longest space I ever dealt with. It's set up in the heart of Chicago and consists of four-by-eight-foot panels—122 of them—

stretching to 520 feet! I begin making loose interlocking shapes on the panels with black ink. It takes me one whole day. Then, for the next three days, 300 kids from every high school in Chicago come and fill in my shapes with color and they do this with every kind of painting technique imaginable. All these kids are a wonderful mixture of every possible ethnic and cultural background.

So this becomes a major Chicago event and the newly installed mayor—Richard M. Daley—proclaims my stay in Chicago as *Keith Haring Week*. There's very big media coverage. Martin Blinder, who is a friend from California and also one of my print dealers, gets his company, Martin Lawrence Limited Editions, to partially sponsor a documentary about this event. The documentary, *Off the Wall with Keith and the Kids* is made by WTTW-TV and is narrated by another friend, Dennis Hopper!

As I wanted to do more in Chicago, I offer to do a mural in a local hospital called the Rush Presbyterian-St. Luke's Medical Center. When I get there, I see two appropriate walls, one in the pediatrics ward, and one in the main entrance lobby. I paint them both.

The next morning, I fly to Iowa City, Iowa, where I hadn't been in five years. Again, I go at the invitation of Colleen Ernst, who is the same teacher who wanted me to come and conduct drawing workshops at the Ernest Horn Elementary School. This time, I'm there to do a mural in the school library. At one point, the whole school is assembled and I give a talk. Later, all the teachers invite me to lunch, which consists of covered dishes that each of them had brought from home. That evening, I walk

down by the Iowa River and sit by the water and watch some ducks going back and forth . . . back and forth.

KEITH HARING In June 1989, I accept an invitation to go to Paris and paint the side of the blimp that will fly over Paris as part of the big bicentennial celebration of the French Revolution. I work on this project with the Russian Painter, Eric Bulatov. The idea is that I'd do one side of the blimp, and he'd do the other.

Now, we didn't actually paint on the blimp itself—the blimp was parked in London, waiting for the flight to Paris. So each of us makes this huge banner, which will eventually be attached to the sides of the blimp. Well, I make this really elegant work—one of my best—and it gets placed on the blimp. A couple of weeks pass, and I hear that because of incredible red tape and bureaucratic shenanigans, the blimp will *not* be flying over Paris for the celebration. The closest it comes to making the flight is from London to the French port city of Calais.

Luckily, Kwong Chi is with me on this trip. He was to have photographed the whole thing in Paris. When we hear it's not going to happen, we drive to Calais, hire a small plane, and take photographs of the blimp as it's flying into Calais. The pic-

204 Haring's banner mounted on blimp celebrating the bicentennial of the French Revolution. Calais. June 1989.

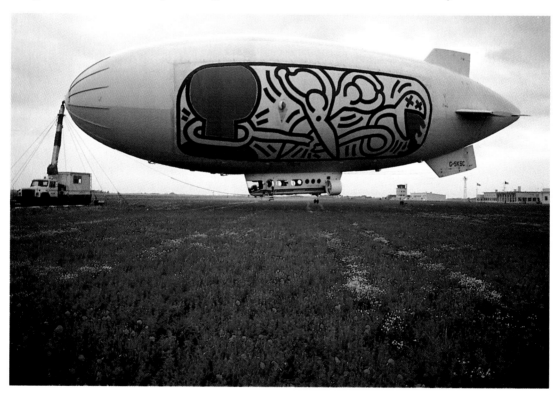

tures are really beautiful and at least we have a record of a project that, through no fault of ours, ended up being a major disappointment.

My next project—in Pisa, Italy—is anything *but* a disappointment! It's a project that began totally by chance. I was in New York, having a night of drugs. When I woke up the next day, I was in a state of semioblivion and I decided to go out for a walk. As I walk out of my building, I see a van parked across the street with a group of Hare Krishnas in it. They're playing their sitars, and the sounds are soothing to my head. I stand there, listening, watching.

Almost immediately, I notice a beautiful young boy also standing there listening to the music. He had black curly hair and must have been about twenty. He kept looking at me, obviously trying to get my attention. Well, I made myself available for the entire situation. I lingered a little longer, until he finally got up the nerve to come over and speak to me.

He asked if I was Keith Haring. I told him I was. Then he introduced me to this older man, who did not have curly hair but was rather bald. This was his father. Well, it turned out they were Italians, and the father owned an enormous vineyard outside of Florence. They were in New York on wine business. As it happened both father and son, Roberto and Piergiorgio Castellani, knew my work. In fact, Piergiorgio had been doing Keith Haring–type drawings for about two years—and he's an incredible fan. He keeps gushing to his father about me and though my head is full of mush, it begins to swell ever so slightly, and I'm enjoying the attention.

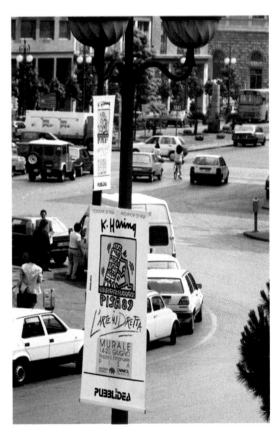

Posters announcing Keith Haring's mural project on the Church of Sant'Antonio. Pisa. June 1989.

I invite this pair to my studio and after a while, the father asks if I'd be interested in doing something in their hometown, which is Pisa. I tell him I've always been open to ideas and to exciting projects.

Well, months later, I hear they've organized a thoroughly wonderful package for me in Pisa. They've worked out a two-part program, sponsored by the city, which involves first, a huge permanent mural, and second, a major museum exhibition of paintings and drawings. In the meantime, the city of Vienna has also approached me about a painting exhibition, and I'm think-

ing of combining both events. I'm also thinking how a big exhibition of my work *isn't* getting off the ground in America—that it's only in Europe people are requesting exhibitions. So I say, "Fuck everyone in America! I'll do my stuff in Europe!"

I now decide to take Gil Vazquez—my lovely Gil—to Pisa to look at possible sites for the mural. I meet the mayor and the head of the cultural commission, who will be organizing the museum show, and we have preliminary talks. Then, in late June 1989, I return to Pisa—and everything has been totally arranged. The mural is to be painted on the wall of a church no less! It's the church of Sant'Antonio in the old center of the city. I'm amazed that the city

is sponsoring this radical American artist to do a painting on a church wall.

I begin to paint the mural, and after the first day, I'm invited to have dinner inside the monastery with the friars of the church. It turns out that the friars are pretty radical themselves. Some spent time in the Brazilian rain forests with Chico Mendez, before he was killed. Others are on their way to Cape Town to fight against apartheid. So the friars welcome and love me.

As I continue painting the mural, I'm surrounded by the most beautiful Italian males I've ever seen in my entire life. And, every day they're waiting to get their T-shirts signed or their blue jeans or anything else they can thrust in front of me. I also meet

206

The completed mural on Church of Sant'Antonio. Pisa. June 1989.

an entire troupe of paramilitary parachutists, who stand watching me paint for hours and hours!

As the mural nears completion, the hysteria starts to mount. Every day there would be more and more people. I'd be on my scaffolding with my tape deck, and I'd be painting and listening to the music Gil had put together for me, and every night, when I was finished for the day, there would be a party in front of the mural.

Now, as the day of the mural's inauguration draws near, friends come from all over America and Europe. Kids hitchhike from across Italy, and from Belgium and Germany, because they hear Keith Haring is in Pisa, and they want to be with him. Some end up sleeping on the floor of the church because they don't have a place to stay—and they all want to watch me work and be around me.

When I put my last stroke on the wall, it all seems incredibly Felliniesque. It all seems utterly unreal—beyond anything I had ever experienced before. The next day is the inauguration. The city puts up huge floodlights to illuminate the wall. There's a huge party, with break dancers and skate boarders and hundreds of people dancing. It's a huge media event, with press and television from many countries.

Afterwards, there's a big dinner, and there are toasts—but I must catch a train for Paris, where other projects await me. Without question, Pisa is one of the highlights of my entire career!

In Paris, I give myself over to a certain social madness. I immediately check into the Ritz. Of course, the Ritz won't allow me into their restaurants nor into their bar, be-

cause I don't have a proper pair of shoes, and only wear high-top sneakers. And they're constantly reprimanding me for wearing shorts in the hotel lobby. But they certainly take notice when *Paris Match* comes to do a big photographic spread on me—right there at the Ritz—and that I have messages from Yoko Ono and Grace Jones and the Princess Gloria von Thurn und Taxis! In the meantime, the busboys and the bellboys—some of whom are extremely adorable—keep coming to my room to get autographs and suddenly even the *concierge* wants an autograph for his child.

In Paris I paint two vases for Jean-Charles de Castelbajac, the clothing designer and art collector. I do some stone lithography at the Franck Bordas Litho Studio. I go to see wonderful art exhibits like the Matisse show at the Beaubourg. I have dinner with my friends, the Picassos, and with George Condo and his new bride. Gil Vazquez rejoins me in Paris, and he's incredibly chic, because he's gotten a good job at Emporio Armani in New York. Gil doesn't want to be supported. He wants to be a success in his own right.

Gil and I drive to Belgium to see the George Segal exhibition at the casino in Knokke, where I had shown two years earlier. There's a wonderful party, and Jean Tinguely is there. Kwong Chi has come to join me, and after a weekend in Knokke, Gil, Kwong Chi, and I proceed to Rome, where we have a great encounter with Stevie Wonder, who is performing there. I'm in Rome, because I want to work on computer graphics—and it's all set up for me in a big television studio. I work on the graphics for several days. One night, at a restaurant,

Keith in the home of Jean Charles and Kate de Castelbajac painting on a terra cotta urn. Paris. 1989.

I run into Francis Ford Coppola, and I thank him for using some of my items from the Pop Shop in his movie, *New York Stories*. He's working in Rome at Cinecittà and he invites me to come visit the studio, but I decline, because Gil and Kwong Chi and I must get back to Paris the next day.

Again, we immediately check into the Ritz, and there are invitations waiting for us—one of them is to a party for Malcolm McLaren at a club called Le Palace. We go and hang out with Willy Ninja, who is the toast of the party and the representative of a whole new dance craze called "Vogueing." This kind of dancing used to be done by silly queens and drag queens, who started it all years ago in Harlem at these events

called *Balls*. And, of course, I knew all those queens, being the queen that I am, and going to New York clubs such as Tracks.

We stay in Paris for another few days, then take the Concorde back to New York. The following morning, Gil and I change clothes and take the MGM Grand Airlines to Los Angeles. We're going to spend Gil's birthday—July Fourth—in L.A., because Gil has never been there.

We rent a bright red Jaguar convertible, which Gil wants to learn to drive—and we have some near accidents—but I patiently put up with his driving. The week in Los Angeles is wonderful. We hang out a lot with Pee-Wee Herman. We have dinner with Madonna, Sandra Bernhardt, and

Warren Beatty at Sandra's house. Sandra and Madonna are being very ambiguous as to what kind of relationship they're having but Madonna is definitely having an affair with Warren Beatty.

The next day is Gil's birthday. Warren Beatty is having a barbecue to which we're invited but we've already said yes to Dennis Hopper, who's having a dinner for us. He's a real friend and I adore him. So we go to Dennis's dinner and Tony Shafrazi is there and Ed Ruscha and Marty Blinder and, of course, Dennis's beautiful Catherine, who he recently married—and we proceed to have a great time. After dinner, we all watch a movie called *Do the Right Thing* directed by Spike Lee—and it's terrific.

Afterward, Gil and I decide to look in on Warren Beatty's barbecue. When we get there, the only people left are Madonna and Warren. We get to take Polaroid pictures of Gil and Madonna—because it's Gil's birthday.

One of the last things we do in L.A. is to watch the installation of a huge sculpture of mine—one of my big dogs—at the home of Marty Blinder, who is a publisher of graphics, a collector, and a major supporter of my work. Marty bought two sculptures out of my Leo Castelli show, and commissioned this third one, which is now being installed on his lawn.

The piece is supposed to be lifted and put in place by a helicopter, which has been hired for the occasion. It's nine o'clock in the morning. Thirty guests are invited to watch the event. As the helicopter lifts the sculpture, it becomes clear that the weight of the sculpture is too heavy for the chopper. Suddenly, the sculpture falls to the

Keith with George Segal. Belgium. 1989.

ground. People are screaming. As it falls, it hits and breaks off a huge chunk of concrete on the front of the house, and the sculpture gets totally scratched.

It's an incredible scene, with the wind of the helicopter blades uprooting the neighbor's rose bushes and making lawn furniture fly in every direction. Luckily, no one is hurt. Finally, Marty gets the piece installed with the use of a crane, which is what he should have done in the first place.

MARTIN BLINDER My company, Martin Lawrence Limited Editions, has thirty-eight retail galleries on both coasts. We deal in upscale limited editions graphics, our theory being that good art belongs to the people. I was very proud when Keith once told me that his aesthetic and my aesthetic are basically the same. Like Keith, I've long been rejected by the so-called high-art world, because there's an elitist attitude which says that fine art shouldn't be sold in shopping malls.

Of course, that same high-art world accepts me for my personal collection of con-

temporary art. I've been collecting for some twenty years, and I'll say this: There's been at least one major movement for every year I've been collecting. It's been very, very confusing. As time goes on, I'm sure that many of these movements and many of these artists will become a blur—and out of that blur will emerge Keith Haring.

Keith's work will survive and last because his work can be easy, tough, gritty, fun, and almost anything you want it to be. I've never met a more confident artist! I've never met anyone more self-assured and directed in my life. I feel fortunate to have met Keith early enough in his career to have watched him become a genuine phenomenon!

KEITH HARING It's now August 1989 and *Rolling Stone* magazine has come out with my interview with David Sheff, in which I have bared my entire life story, and have told of my involvement with drugs and of my current struggle with AIDS. It's a totally revealing interview, and I'm getting hundreds of calls and letters from all kinds of people. Lots of people were shocked and dismayed. Others thought I had a lot of nerve for spilling my guts.

KRISTEN HARING Kermit Oswald brought us an advance copy of the *Rolling Stone* interview and, for some reason, I was the first one to read it. I remember sitting in my room, and my mom came upstairs and she asked what I thought of the article—she hadn't read it yet. I said

it was really honest and that it shows Keith has it together. He's got everything straightened out in his head. He knows what's happening, and he knows how he feels about it. And I was really proud.

Then, a couple of days later, my mom read the article and I asked her what she thought, and she said, "Yes, you're right. It was really honest, really open." I only learned about Keith having AIDS two weeks before the article came out. I don't know whether or not it was being kept from me because I was his youngest sister. Keith said that he thought I knew, but I didn't. So this horrible piece of information was suddenly thrown at me, and then, two weeks later *Rolling Stone* comes out and the whole world knows about it!

Of course, we all knew Keith was gay. Although we didn't discuss it much, things were really mellow in our house about it. It was something that made me really appreciate our parents, because they were accepting of who Keith was. They would say, "That's how it is. It's his life and we respect what he's doing."

KERMIT OSWALD Keith's mother told me that Keith never used the word AIDS when at home with the family. When the *Rolling Stone* article came out, everybody in Kutztown knew about it— and it was hard on Keith's parents. Actually, Keith's having AIDS had been kept a secret from everyone for a long time. If I feel guilt over anything it's that I kept his secret for some two-and-a-half years. I'm extremely proud of how he's handled the

coming forth of that information. It wasn't easy for him to say, "Now that I've gotten to be known, and gotten your attention, I'm dying of AIDS." He's essentially willing to stand up and say, "The party's over." Nobody wants to hear that, and nobody wants to say it. But let's face it, Keith has an illness that will claim his soul and his talent.

JULIA GRUEN In November 1989, Keith took his parents to Europe for the very first time. Joan and Allen Haring were totally thrilled, not only at the prospect of being abroad with their famous and much admired son, but because a very special honor would be bestowed upon him by the Principality of Monaco. For his execution and donation of a large mural painted in the maternity ward of the Princess Grace Hospital in Monte Carlo, Keith, among other honorees, would be given an award—a title and a medal—for his contribution to the principality. We were told that it was quite unusual for a non-Monegasque to be honored by the princely family.

With his usual generosity, Keith also invited his office staff, Margaret Slabbert and me, to be present at the Monaco ceremony, which would take place in Prince Rainier's palace on November 18th, at *precisely* 11:30 A.M. Naturally, Keith was the object of much ribbing as the day of his "coronation" approached.

Before Monaco, Keith took his parents to visit his friends, Roger and Monique Nellens, in Knokke-le-Zoute, on the Belgian coast and then traveled with them to

Düsseldorf, where Keith was scheduled to attend the opening of an exhibition of new drawings and collages at the elegant Hete Hünermann Gallery. In Düsseldorf, Keith would also confer with his regular German dealer, Hans Mayer, who together with Tony Shafrazi and Roberto and Piergiorgio Castellani, was just then beginning to work on a ten-year Keith Haring retrospective, to open in 1991 in museums throughout Europe, the Middle East, the Soviet Union, and the United States.

The Hete Hünermann opening was a real gala, but Keith was now getting quite antsy over our trip to Monaco as the famous palace ceremony would be taking place on the very next morning and it was now well into the evening. As bad luck would have it, all regularly scheduled transportation out of Düsseldorf would make it impossible to get to the ceremony on time. A call was placed to the palace. Judith Mann, Princess Caroline's private secretary, offered the only possible solution: "You'll simply have to charter a private jet!" Keith was entirely cool about it. "Of course! We'll charter a private jet," he said.

For a very large sum of money, a six-seat Citation II jet was placed at our disposal the following morning. We left Düsseldorf Airport at 7:30 A.M. and landed at Nice-Côte d'Azur Airport at 10:10 A.M. It took twenty minutes to get from Nice to Monte Carlo by taxi, which left us exactly one hour to get ready for the palace ceremony.

We had booked rooms at the gorgeous Hôtel de Paris, but Keith's suitcase—the one containing his palace outfit—was misplaced. In the meantime, Keith's parents,

Margaret, and I scrambled to get changed, and the plan was for all of us to meet in the hotel lobby by 11:00. But Keith was nowhere near the lobby by 11:30! Finally, he appeared, fuming. It had taken the hotel twenty minutes to locate his lost suitcase. But there he was, looking totally adorable in his blue pinstripe Giorgio Armani suit, his Armani shirt and tie, and spotless white Nike high-top basketball sneakers—his daily footwear!

Two cars took us to the palace. An irate gentleman greeted us with the words: "You are extremely late. We're all waiting for you!" Practically on the double, we climbed stairs, entered corridors, and turned corners until we came to the Blue Room, a stately, highly ornate Louis XIV salon, dripping with chandeliers, glittering with gold furniture and gleaming marble floors.

Some two dozen men and women, elderly Monegasques, stood at one end of the room. All eyes turned as we arrived, and an almost audible intake of breath could be heard as Keith's white sneakers suddenly stood out amidst the princely surroundings.

The irate gentleman presently announced the Princess Caroline. She entered the room, a beautiful young woman with shoulder-length light brown hair, wearing a collar-

Keith Haring with Her Serene Highness Princess Caroline of Monaco in front of the mural she commissioned for the Princess Grace Maternity Hospital. (The mural is dedicated to Yves Arman, who was killed in an automobile accident in 1989.) Monte Carlo. 1989.

212

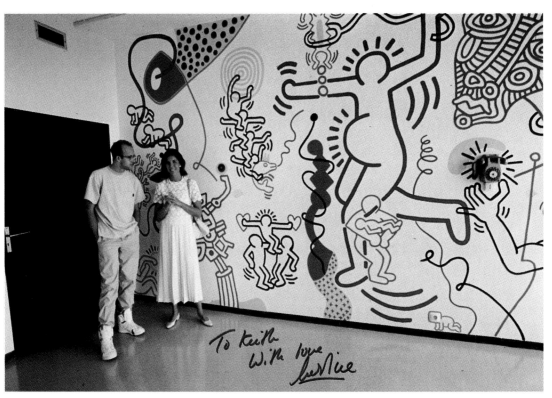

less suit jacket of dove gray and a slightly darker short skirt. She welcomed us all and proceeded to distribute the medals to each of the honorees as they were presented to her.

When the name Keith Haring was announced, the princess smiled broadly in happy recognition of Keith's presence. And then, Keith, the boy from Kutztown, Pennsylvania, the only American, the youngest person in attendance, and the only one to kiss the princess on the cheek, was handed a medal that would henceforth make him a *Chevalier de l'Ordre du Mérite Culturel.*

HER SERENE HIGHNESS, PRINCESS CAROLINE OF MONACO We are so very happy to present Keith with his honor—he richly deserves it. Thanks to Yves Arman, I met Keith when Yves was working on a project to bring various artists to Monaco. Of course, Yves and his wife, Deborah, have lived in Monaco for quite a while. Their daughter, Madison, was born in the Princess Grace Hospital. When Yves was tragically killed in an automobile accident in 1989, Keith came and painted a mural in the maternity ward. Somehow, it seemed the right place for a work dedicated to Yves . . . the place where babies are born. Of course, I'm not an art critic, and it would be very pretentious of me to analyze Keith's work. All I can say is that when I look at it, it makes me happy—it's just bursting with life!

JULIA GRUEN When we returned to New York, Keith immediately flew to California, where he had accepted an offer to paint a mural at the Art Center College of Design in Pasadena. This was in conjunction with the World Health Organization's second annual AIDS Awareness Day and "A Day Without Art," which was commemorated by more than 600 art institutions nationwide on December 1st, 1989.

PHILIP HAYS It was my idea to invite Keith to come and paint a mural at the Art Center. As the head of the illustration department, I thought the students would really relate to him—and they did. In fact, Keith is a major hero to them. They're all familiar with his work and they think of him as the Jimmy Dean of art!

213

JULIA GRUEN From Pasadena, Keith flew to Atlanta, Georgia, where he attended a dual opening at the Fay Gold Gallery with the photographer, Herb Ritts. The works Keith made were collages employing cut-out and cut-up photos of Ritts. They were amazing! After Atlanta, he only came back to get ready to again travel to Düsseldorf where two projects awaited him: One, to inspect ongoing foundry work on a large number of his sculptures, and the other to paint a car for BMW.

The BMW commission was fun for Keith, because Andy Warhol, Roy Lichtenstein, Robert Rauschenberg, Frank Stella, and Alexander Calder had all been asked to

paint cars for the company's BMW Museum. Keith chose a bright red car and proceeded to cover it from top to bottom in black calligraphic designs. It's quite something to behold! Actually, Keith and Andy were the only two artists who ever "hand painted" the cars.

When Keith returned to New York you could see that he wasn't feeling particularly well. It was now mid-December and Christmas was always a very big deal to Keith. He always spent the month of December making Christmas presents for people—making art for all his friends. But

in 1989 there just wasn't enough time. And he *did* seem to feel tired. All of a sudden it seemed as if the virus started to completely overtake Keith's system.

I can't reconstruct the real sequence of events, but I know that he was doing very well on the drug AZT. There was really no reason for him to stop taking it. But I think he wanted to try a drug called interferon, which required him to get off AZT. Well, interferon depletes your energy and it was horrible to see Keith, who was *made* of energy, come into the studio and immediately have to lie down. This was nonsense—and he stopped taking the drug.

Keith painting a 1990 BMW convertible commissioned by Bavarian Motor Works. Düsseldorf. December 1989.

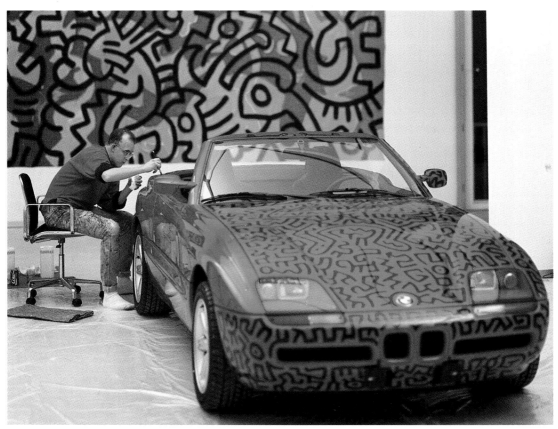

He then went back onto AZT. A bit later, Keith heard of something called Compound Q, which had just been discovered. We tried to get him on that, but it was the very early days of the drug. Even though we appealed directly to the hospital in San Francisco where original research was being conducted, we couldn't get accepted into the program. So he was looking for all sorts of possibilities—not really out of desperation, but in the spirit of "Let's give this a try" or "Let's give that a try." Of course, Keith was in the hands of extremely competent doctors, and he always consulted with them.

After further blood tests were taken, the doctors decided that Keith had the tolerance to switch to a drug called DDI—another new possibility. To do this, Keith would again have to go off AZT. Well, only two or three days after taking this new drug, the doctors said, "Whatever DDI is supposed to be doing, it's *not* doing it." They told Keith to drink lots and lots of liquids in order to flush the drug out of his system.

Now things started happening rather fast. We all knew Keith had developed Kaposi's sarcoma. The doctors ran a bone marrow test, which now confirmed that he had also developed lymphoma, another variety of cancer. Well, for someone who basically has no immune system to be struck with yet another invasive disease just doesn't have a chance in hell!

So within a period of a week, Keith began getting weaker and weaker. It went from his coming to the studio very late, say four o'clock in the afternoon—he usually came in around noon—to just staying home.

Well, Keith had a very beautiful new place to call home. Months earlier, he had decided to move out of his apartment on Sixth Avenue and Third Street. He needed more room, and so he purchased a duplex apartment on La Guardia Place—just a couple of blocks from his studio on Broadway. Keith wanted more wall space to hang his personal collection of art—not his own, but that of others. So he hired this terrific designer, Samuel Havadtoy, who is also Yoko Ono's friend and companion, to design this really swank place. It's funny, because Keith asked Sam to design his bedroom in the style of the very ornate bedrooms he had stayed in at the Ritz in Paris!

Anyway, Keith wasn't in any way laid out or helpless at this point. He was just very weak. So he stayed home, being totally bored in his fabulous new apartment. Of course, we all went to see him. His studio assistant, Adolfo, spent a lot of time over there. And his friend Gil Vazquez went to see him. His friend Lysa Cooper was a constant presence. And I believe he again saw Juan Rivera, with whom he had earlier parted company.

JUAN RIVERA By the time Keith and I split up, I already knew he was sick. I felt it was coming. It was great to have been part of his work—part of *him!* But when you're dealing with a person who is full-speed-ahead, there are bound to be changes. And, you know, he likes younger guys . . . so this guy, Gil, came along. He's nineteen . . . he's just a kid. He's also straight and has a girlfriend. But Keith has

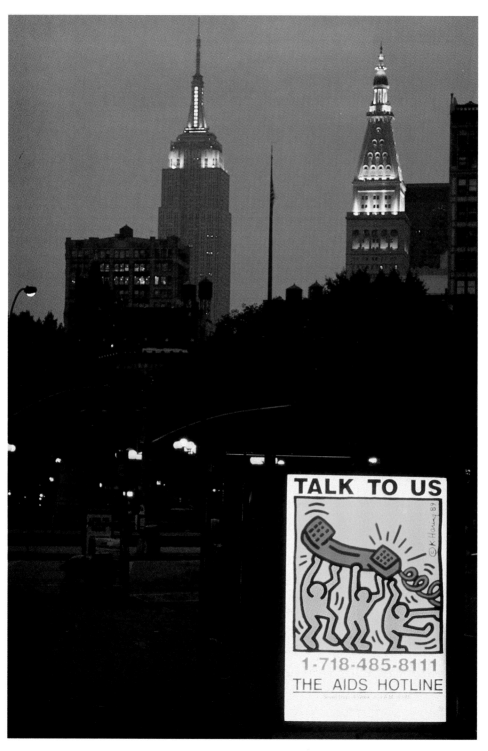

Poster for the New York City Department of Health's AIDS Hot Line, displayed in a New York City bus shelter. July 1989.

(Left) Keith's bedroom designed by Sam Havadtoy to emulate the bedroom decor of the Ritz Hotel in Paris. *(Right)* Living room of Keith's Greenwich Village duplex decorated by Sam Havadtoy. New York. June 1990.

always been like that. He's always wanted something he couldn't really have.

What kills me is that once Keith slammed the door on me, he began deteriorating, and I wasn't there to take care of him. But I was glad when out of the blue he called me. He said, "Juan, would you like to come and cook dinner for me?" I said, "Sure!" And I went over and cooked dinner, and it was nice. But then he didn't ask me to stay over . . . you know, not to fool around . . . just to stay over. He'd say, "You have to go home now." And I'd feel devastated, and I'd go home and freak out.

But when he first began staying home from the studio, he called me again and said, "Juan, I want you to keep me company." And that night I stayed over. The next morning he said, "Would you like to go for a ride?" I said, "Yeah! That'd be great!" But I said, "Where do you want to go?" And he said, "Why don't we visit your mother?" I thought it was wonderful of Keith to want to do that. So we took a drive up to Connecticut to see my mother—and my mother was totally thrilled.

Yes, I'm categorized as being ill. I've been tested HIV positive. But I refuse to take medication. I'm relying more on faith. I'm religious toward myself . . . I mean, I pray to a God. If I go into a church, it's the nearest church that looks nice—from Pentacostal to Catholic to Gospel. So I'm leaving it all up to faith.

I've got good memories. I mean, when I think back on my affair with Keith . . . and all the people I met, and all the things I saw . . . it was really first-class all the way.

JULIA GRUEN I think there came a day when Keith must have said, "To hell with it! I'm going in to work!" So he came in—this was in early February—but it was hopeless. He tried to draw a little. He certainly couldn't paint. He was just too weak. By this time, he had also developed an unbearable laryngitis, which may have been a tumor in his throat, because you just don't speak like that for two weeks. I mean, not only was he not producing art, but he wasn't able to communicate verbally. When he tried to speak, he was sort of scratching and screeching, with no sound coming out. It was heartbreaking.

Keith never went into the hospital. It was suggested, but not by the doctors. They felt that basically all they could do for him in the hospital was more diagnostic work, and whatever might be discovered would be untreatable, because he was too weak to withstand any additional medication that might be prescribed.

It became progressively apparent that Keith was indeed deteriorating. Within days, word had gotten out that Keith was quite sick. There were endless, endless phone calls, from every corner of the earth. There were many, many visitors. The doctors came daily. There were nurses. Keith's parents and his three sisters came from Kutztown, and remained in the apartment. Gil Vazquez seldom left Keith's bedside. There were now periods when Keith would be in a delirium. He just didn't know who anybody was. He didn't know who his mother was. It was unbearable.

I was called the minute Keith died. It was 4:40 A.M. on Friday, February 16, 1990. I was at his house at 5:00 A.M. I did not look at his body. There was the usual horror of hanging around the apartment while we waited for the body to be picked up. Tony Shafrazi came, Kenny Scharf, Alba Clemente . . . and others. Finally, the body was taken away. After a while, I made the arrangements with the funeral home for Keith's cremation. It was what he wanted. It was what his parents wanted.

Then we all just stood there . . . in Keith's apartment . . . and it was a misery.

On March 3rd a memorial was held in Kutztown. Keith's parents didn't want his ashes to be strewn. They said, "Keith is gone. We don't want his ashes. We want to remember him as he was." But a few people thought this was not right. There was a consensus among Keith's friends and two of his sisters that the ashes were important. So since there was to be a ceremony in Kutztown, we decided to bring the ashes. I went to the funeral home and picked up this box—a black plastic box—which seemed to weigh a ton.

What the family had arranged was quite wonderful. There was a short religious ceremony just for the family at the Hope Evangelical Lutheran Church of Bowers, Pennsylvania, which is Keith's father's birthplace. Then the church, which has a lot of little community rooms, became the site of a Keith Haring display, with every room showing videotapes and slides of Keith's work. A large New York contingent was in attendance.

There was a gathering at Kermit Oswald's home—Kermit, his wife Lisa and their three little children, live in Kutztown, where the Oswalds also have a very successful jewelry design firm. From there, we all drove to

a particular field on a hill where Keith used to go when he was quite young and where he used to just think and meditate. In the summertime it's a cornfield, but as it was only March, it was completely bare except of hay.

So we all climb this hill, and I'm carrying this box of Keith's ashes. Keith has a very, very large family, with aunts and uncles and nieces and cousins and all *their* children—babies, little kids, big kids! And they all came. What was wonderful was that after objecting to this notion of the strewing of the ashes, the entire family agreed that it was the right thing to do.

Kermit made a wonderful impromptu speech—not a religious speech, but one that thanked God for Keith Haring. Then it was time to distribute the ashes. I undo the package, but I can't open the damned box! Kermit and I look at each other. Kermit fails to open it also. Finally I said, "Kermit, do you by any chance have a can opener?" Unbelievably, he had one along. So we pried the box open. In it was a plastic bag, with what looked like gray-white gravel—it wasn't the cigarette ashes one imagines.

There were forty or fifty of us on top of that hill. Each of us took a handful and walked off in various directions, strewing the ashes. It was absurdly emotional. And it was an absurdly beautiful setting, because the sun was just going down and the sky was bright red, and there were geese flying overhead.

Exactly one week later, on March 10, one of Keith's closest friends and collaborator, Tseng Kwong Chi, died of AIDS in New York. He was thirty-nine. Kwong Chi had taken thousands of photographs of Keith all over the world. With the deaths of Keith and Kwong Chi a big part of my world had come to an end . . . as indeed had two great friendships.

SEAN KALISH I'm eight years old and I'm a friend of Keith's. I used to go to the Pop Shop all the time with my mom. One time, when I was five years old, this very nice man in the shop asked if my mom and I would like to meet Keith. He took us to Keith's studio.

Keith was very nice. I thought he drew his art especially for kids. I liked the baby the best. The dog is my dad's favorite. In the studio, Keith said, "Let's draw!" and that was neat. Later, Keith and I worked together on some etchings. There were these big metal plates. I would be working on one, and he would be working on one. Then we would switch and keep on drawing. I like drawing, because it's something you can do with someone else. I like to draw with Keith, because he draws like a kid.

I heard Keith was sick and that he might die. I cried when I heard that, because if he dies, there won't be any more Keith Haring drawings. I want him to be drawing for his whole life. One of my friends said that if Keith dies, he might be reincarnated. Well, I don't believe in reincarnation. But then, anything might be true.

JOHN GRUEN On May 4, 1990, Keith's thirty-second birthday, a memorial service was held at the Cathedral of St. John the Divine in New York City. Attended by more than 1,000 people and organized by friends and family, the service included performances by dancer Molissa Fenley, soprano Jessye Norman, Heather Watts and Jock Soto, principal dancers of the New York City Ballet, members of Citykids, and the Frances Jackson & Company gospel group. Speakers included the mayor of the City of New York, David Dinkins, former New York City Parks Commissioner Henry J. Stern, Jeffrey Deitch, Freddy Brathwaite, Tony Shafrazi, Dennis Hopper, David Galloway, Ann Magnuson, Kenny Scharf, and Sean Kalish.

All the speeches were heartfelt, but Kay Haring's tribute to her brother perfectly encapsulated his personality and spirit:

> Over the years, people have often questioned me—What was it like growing up with Keith? What's it like to have a brother that's famous? Was he always like this?
>
> Well, I think that my memories of growing up with Keith are very much like remembering what he was just like yesterday.
>
> I remember, when we were kids, every summer we'd have penny-fairs in our backyard. We'd invite the whole neighborhood, charge admission, and run carnival games and contests. At the end of the day we'd divide our profits, and while my sisters and I were thinking of saving our money for future goals, Keith was inviting all the neighborhood kids to come downtown with us, and he'd treat everyone at the local ice cream shop.
>
> I remember that Keith was always the leader of our latest exclusive "club" where we'd make up secret coded messages, have meetings, and plan ways to upset our parents.
>
> I remember that Keith was always drawing . . . it was his hobby, his pastime, his vehicle of expression, his very being. So, you see, it has always seemed to me that the brother that I grew up with is the same brother that all of you know.
>
> Only the neighborhood get-togethers became the Manhattan club scene; the art projects with kids grew to include thousands and thousands of youths; his generous nature reached to touch virtually millions; and the canvas on which he drew became the whole world.
>
> I learned a lot from my big brother: That a wall was meant to be drawn on, a Saturday night was meant for partying, and that life is meant for celebrating! Keith showed me that it is possible to *live* what you believe.
>
> Keith's battle with AIDS taught me that every day is worth living. When he tested HIV positive, instead of complaining about the burden of the disease and in answer to a comment on how hard it must

be to live with that knowledge, he replied, "No, it just makes everything that happens *now* so much better, because you never know when you're doing something for the last time. So you live each day as if it were the last."

Two days before he died, Keith was lying on the edge of his bed, and we had the window open so he could see the city rooftops all the way to the Empire State Building. Keith couldn't hold a marker anymore, so he took my hand and with those smooth, graceful strokes we all know so well, we painted in the sky with all of New York City as our backdrop.

Spectacolor Billboard—a thirty-second animated drawing repeating every twenty minutes for one month. This part of the sequence depicts Keith's Radiant Child image. Times Square. New York. 1982.

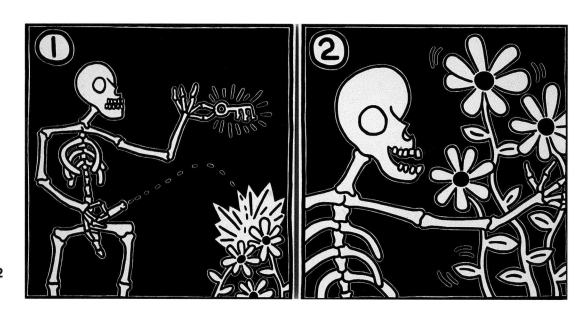

Untitled (for James Ensor). 1989. Acrylic on canvas. Two panels. 3′ × 3′ each.

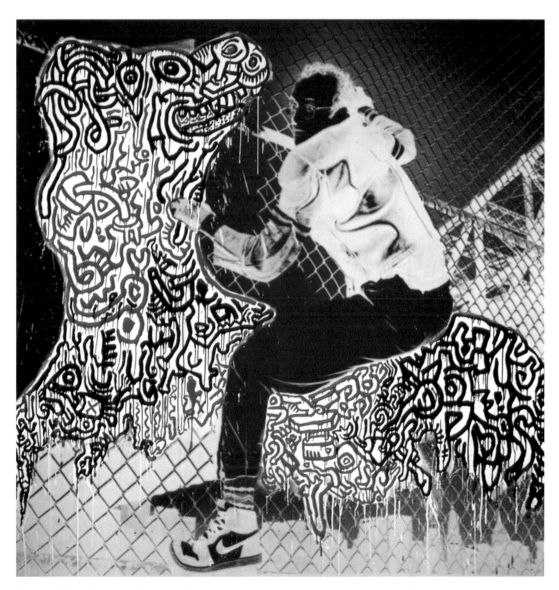

Portrait of Keith Haring by Gianfranco Gorgoni. Transferred to canvas and painted by Keith Haring. 1987. Acrylic on canvas. 8′ × 8′.

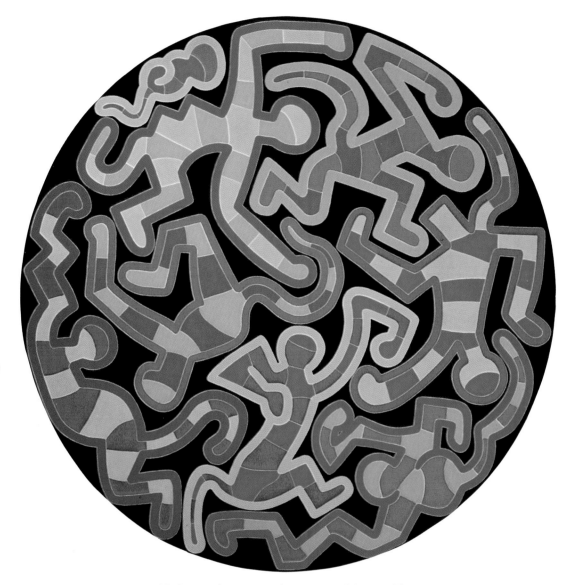

Monkey Puzzle. 1988. Acrylic on canvas. Diameter 10'.

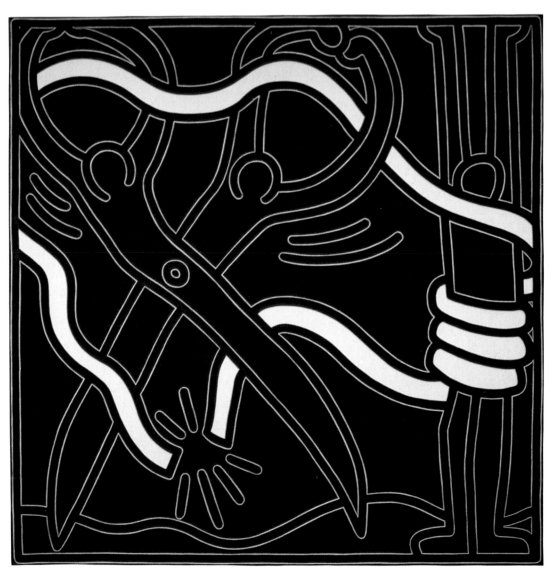

225

Untitled. 1988. Acrylic on canvas. 10′ × 10′.

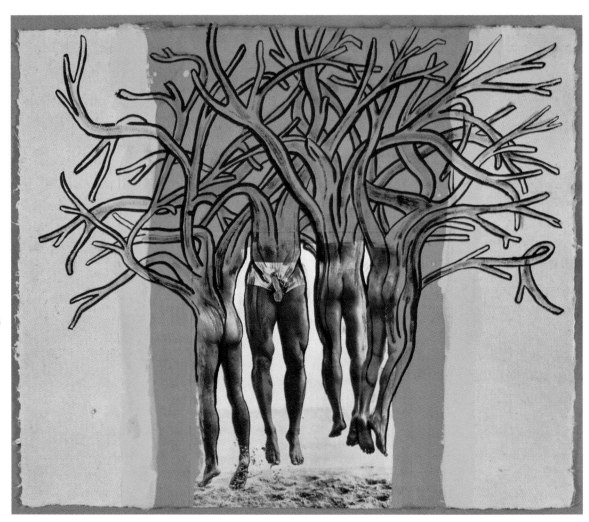

Untitled. With Herb Ritts. 1989. Collage, ink, and gouache on handmade paper. 25″ × 30″.

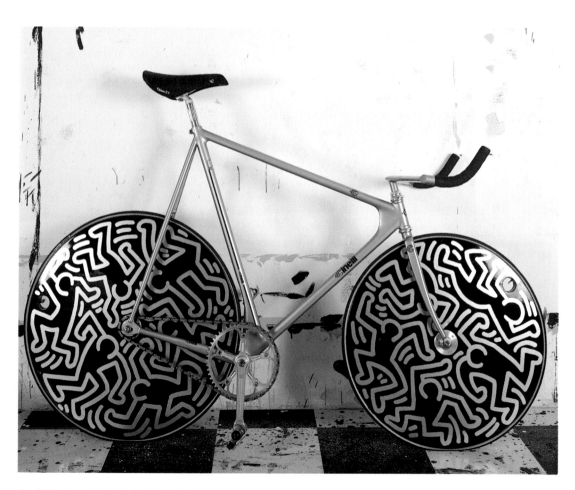

Cinelli Bicycle. 1989. Acrylic on bicycle.

Alligator Vase. January 1990. Acrylic and black marker on terra cotta. 24″ high.

Hollywood African Mask. 1987. Enamel paint on aluminum. 48″ × 33″ × 11″.

Red Dog. 1987. Lacquered steel. 6′ × 6½′ × 7′ (approximate).

Red Room. 1988. Acrylic on canvas. 8′ × 15′.

Red Yellow Blue #16 (Portrait of Adolfo). 1987. Acrylic and oil on canvas. 3' × 3'.

232

Untitled. 1988. Acrylic, enamel, and collage on canvas. 10′ × 10′.

Silence = Death. 1989. Acrylic on canvas. 3′ × 3′.

Unfinished Painting. 1989. Acrylic on canvas. 3′ × 3′.

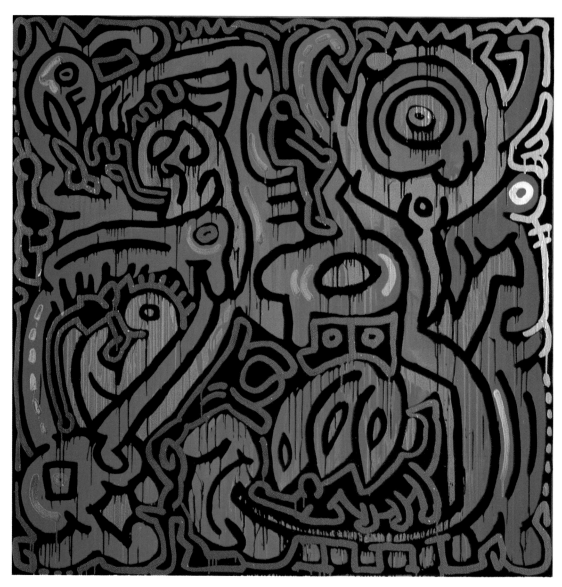

236

Untitled. 1989. Acrylic on canvas. 6′ × 6′.

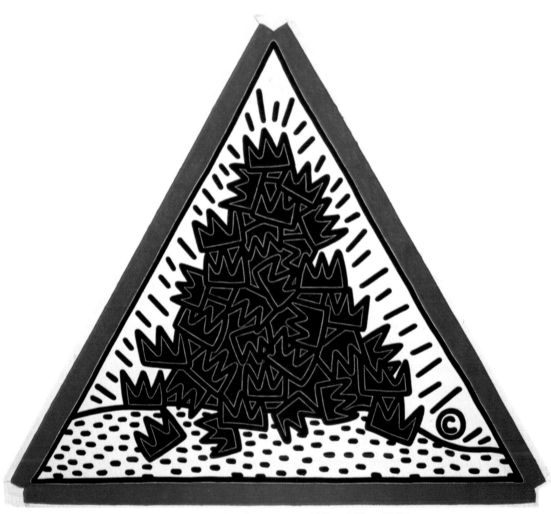

A Pile of Crowns for Jean-Michel Basquiat. 1988. Acrylic on canvas. 119″ × 119″ × 107½″.

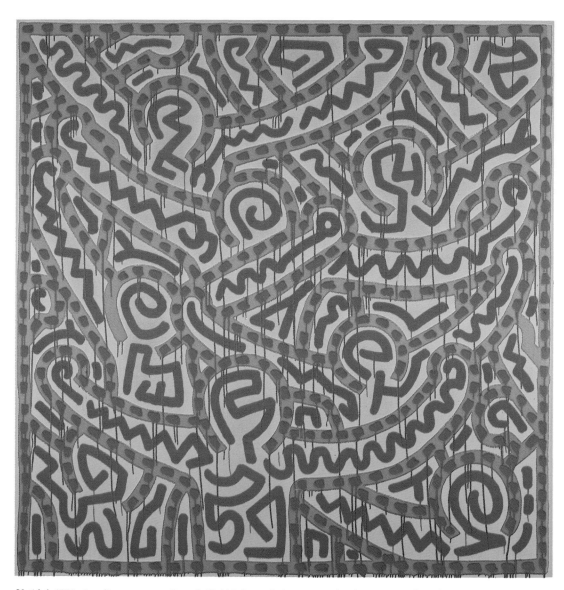

Untitled. 1989. Acrylic on canvas. 6′ × 6′ (Keith's last painting executed in his New York studio).

CHRONOLOGY

ONE-MAN EXHIBITIONS

1 9 7 8 Pittsburgh Center for the Arts, Pittsburgh, Pennsylvania

1 9 8 1 Westbeth Painters Space, New York City
P.S. 122, New York City
Club 57, New York City

1 9 8 2 Rotterdam Arts Council, Rotterdam, Holland
Tony Shafrazi Gallery, New York City, with LA II

1 9 8 3 Fun Gallery, New York City, with LA II
Galerie Watari, Tokyo, Japan, with LA II
Lucio Amelio Gallery, Naples, Italy
Gallery 121, Antwerp, Belgium
Matrix 75, Wadsworth Atheneum, Hartford, Connecticut
Robert Fraser Gallery, London, U.K., with LA II
Tony Shafrazi Gallery, New York City

1 9 8 4 University Museum of Iowa City, Iowa
Paul Maenz Gallery, Cologne, West Germany
Salvatore Ala Gallery, Milan, Italy, with LA II
Paradise Garage, New York City
Galerie Corinne Hummel, Basel, Switzerland
Semaphore East, New York City, with Tseng Kwong Chi

1 9 8 5 Schellmann & Kluser, Munich, West Germany
Tony Shafrazi Gallery, New York City
Leo Castelli Gallery, New York City
Museum of Contemporary Art, Bordeaux, France

1 9 8 6 Hammarskjöld Plaza Sculpture Garden, New York City
Stedelijk Museum, Amsterdam, Holland
Whitney Museum of American Art, Stamford, Connecticut, *Art in the Park*
Galerie Daniel Templon, Paris, France

1 9 8 7 Tony Shafrazi Gallery, New York City
Galerie Kaj Forsblom, Helsinki, Finland
Gallery 121, Antwerp, Belgium
Casino Knokke, Knokke, Belgium
Kutztown New Arts Program, Kutztown, Pennsylvania
Galerie Rivolta, Lausanne, Switzerland

1 9 8 8 Michael Kohn Gallery, Los Angeles, California
Hans Mayer Gallery, Düsseldorf, West Germany
Tony Shafrazi Gallery, New York City
Hokin Gallery, Bay Harbor Islands, Florida

1 9 8 9 Gallery 121, Antwerp, Belgium
Casa Sin Nombre, Santa Fe, New Mexico, with William Burroughs

1 9 9 0 Fay Gold Gallery, Atlanta, Georgia (with Herb Ritts)
Hete Hünermann Gallery, Düsseldorf, West Germany
Galerie 1900–2000, Paris, France
Charles Lucien Gallery, New York City
Philip Samuels Fine Art, St. Louis, Missouri
Tony Shafrazi Gallery, New York City
Galerie Nikolaus Sonne, Berlin, Germany
Tony Shafrazi Gallery, New York City

1 9 9 1 Hete Hunermann Gallery, Dusseldorf, Germany
University Galleries, Normal, Illinois, "Keith Haring: Future Primeval;
Museum of Modern Art, Ostende, Belgium
Phoenix Art Museum, Phoenix, Arizona "Haring, Disney, Warhol"
Keith Haring: Future Primeval, Tampa Museum of Art, Tampa, Florida
Chase Manhattan Bank, Soho Branch, New York
Erika Meyerovich Gallery, San Francisco
Molinar Gallery, Scottsdale, Arizona
Steffanoni Gallery, Milan, Italy
Hete Hunermann Gallery, Dusseldorf, Germany

1 9 9 2 *Haring, Disney, Warhol,* Tacoma Art Museum, Tacoma Washington
Haring, Disney, Warhol, The Corcoran Gallery of Art, Washington, D.C.
Haring, Disney Warhol, The Worcester Museum, Worcester, Massachusetts

SPECIAL PROJECTS

1979 *Video Clones,* video-dance performance with Molissa Fenley, New York City
Organized group shows at Club 57, New York City
Began drawing on blank advertising panels in New York City subway stations

1982 *Spectacolor Billboard,* Times Square, New York City, a thirty-second animated drawing repeating every twenty minutes for one month
Installation, Paradise Garage, New York City
Print and distribute 20,000 free posters for June 12 antinuclear rally, Central Park, New York City
Paint fluorescent mural on cement handball court Houston Street at Bowery, New York City

1983 Artist-in-residence, Montreux Jazz Festival, Switzerland
Fabric design for Vivienne Westwood, London, U.K.
Computer graphics album cover for New York City Peech Boys
Paint Fiorucci, Milan, Italy, with LA II
Paint choreographer Bill T. Jones, London, U.K., photographed by Tseng Kwong Chi
Paint murals, Marquette University, Milwaukee, Wisconsin
Paint building in Tokyo, Japan, with LA II
Paint Mural on Avenue D, New York City

1984 Paint mural at National Gallery of Victoria, Melbourne, Australia
Paint mural at Collingwood Technical School, Melbourne, Australia
Paint mural at Gallery of New South Wales, Sydney, Australia
Artist-in-residence, Ernest Horn Elementary School, Iowa City, Iowa
The Kutztown Connection, performances to benefit the New Arts Program, Kutztown, Pennsylvania
Children's Festaville, artist-in-residence and mural, Walker Art Center, Minneapolis, Minnesota
Artist-in-residence, poster and sticker design, Le Mans, France

Paint candy store murals, Avenue D, New York City

Anti-Litterpig Campaign, create logo for New York City Department of Sanitation
On-site painting, Museum of Modern Art, Rio de Janeiro, Brazil
Paint fishermen's houses, Ilheus, Brazil
Paint mural, Children's Village, Dobbs Ferry, New York
Body-paint Grace Jones, New York City, photographed by Robert Mapplethorpe
Create sixty-second animated commercial for *Big,* a store in Zurich, Switzerland
Design set for *Secret Pastures,* Brooklyn Academy of Music, New York, choreographed by Bill T. Jones and Arnie Zane
Paint 4′ × 300′ mural for Asphalt Green Park, New York City
Create First Day Cover and limited edition lithograph to accompany United Nations' stamp issue of 15 November commemorating 1985 as *International Youth Year*

1985 Organize and curate *Rain Dance,* a benefit party and exhibition for the U.S. Committee for UNICEF's African Emergency Relief Fund
Design set for *Sweet Saturday Night,* Brooklyn Academy of Music, New York
Paint set for *The Marriage of Heaven and Hell,* choreographed by Roland Petit, for the Ballet National de Marseille, France
Create cover illustration and centerfold for *Scholastic News,* reaching an audience of 3 million American school children, grades one through six
Collaborative poster with Brooke Shields and Richard Avedon
Create 25′ × 32′ backdrop for permanent installation at *The Palladium,* New York City
Create mural and distribute free T-shirts and balloons for *Keith Haring Day* at Children's Village, Dobbs Ferry, New York
Host painting workshop and distribute free coloring books at the first *Children's Worlds Fair* celebrating *International Youth Year,* Asphalt Green Park, New York City
Print and distribute 20,000 *Free South Africa* posters

Create painting at *Live Aid* July 13, J.F.K. Stadium, Philadelphia, Pennsylvania, to be auctioned with proceeds donated to African Famine Relief

Paint mural on handball court, P.S. 97, New York City

Body-paint Grace Jones for performance at Paradise Garage, New York City

Paint St. Patrick's Daycare Center, San Francisco, California

Design four watches for *Swatch Watch U.S.A.*

Children's drawing workshop, Museum of Contemporary Art, Bordeaux, France

1986 Paint set on MTV during guest appearance of Duran Duran's Nick Rhodes and Simon Le Bon, New York City

Paint permanent murals at Mount Sinai pediatrics ward, New York City

Collaborate with Brion Gysin on *Fault Lines*

Collaborate with Jenny Holzer on billboards for *Vienna Festival '86,* Australia

Body-paint Grace Jones for feature film, *Vamp,* Los Angeles, California

Paint 90′ × 90′ outdoor mural, Amsterdam, Holland

Children's drawing workshop, Stedelijk Museum, Amsterdam, Holland

Open *Pop Shop,* retail store, 292 Lafayette Street, New York City

Create background art for *RUN DMC/ADIDAS* tour poster

Design set for *The Legend of Lily Overstreet,* featuring Rhodessa Jones, Limbo Theatre, New York City

Drawing workshop, Children's Museum of Manhattan, New York City

Collaborate with 1,000 New York City youths on six-story *Citykids Speak on Liberty* banner, dedicated on July 2 for Statue of Liberty centennial celebration, organized by Network International

Create Mural for Club DV8, San Francisco, California

Paint *Crack Is Wack* murals, New York City

Paint permanent murals at Woodhull Hospital, Brooklyn, New York

Collaborate with Grace Jones on *I'm Not Perfect* video, Paris, France, and New York City

Paint mural at Jouets & Cie toystore, Paris, France

Paint 300′ mural on Berlin Wall, West Germany

Collaborate on outdoor mural with Phoenix, Arizona school children, Washington and Adams streets, Phoenix, Arizona

1987 Lecture at Yale University, New Haven, Connecticut

Drawing workshop and lecture, Whitney Museum of American Art, Stamford, Connecticut

Drawing workshop with finalists from WNET/13's *Student's Art Festival,* New York City

Set design and costume concept for *Interrupted River,* choreography by Jennifer Muller, music by Yoko Ono, Joyce Theatre, New York City

Paint permanent outdoor mural at Necker Children's Hospital, Paris, France

Design carousel for *Luna Luna,* a traveling amusement park and art museum organized by André Heller, Hamburg, West Germany

Judge *Nippon Object Competition,* and design street signs for Parco Company, Tokyo, Japan

Body-paint model for cover of *Schweizer Illustrierte,* Monte Carlo, Monaco

Paint permanent mural at Casino Knokke, Belgium

Participated in *Art Against AIDS,* a benefit exhibition curated by Steven Reichard

Paint mural at Museum of Contemporary Art, Antwerp, Belgium

Paint mural for Channel Surf Club, Knokke, Belgium

Paint mural at Team BBD&O European Headquarters, Düsseldorf, West Germany

Children's drawing workshop at Institute of Contemporary Art, London, U.K.

Paint mural at Carmine Street public swimming pool, New York City, sponsored by New York City Parks Department

Collaborative mural with Philadelphia Citykids, Pennsylvania, sponsored by Brandywine Arts Workshop

Paint permanent mural, Boys Club of New York, 135 Pitt Street, New York City

Permanent murals and sculpture commission, Schneider Children's Hospital,

New Hyde Park, New York
Artist-in-residence and mural installation, Cranbrook Academy of Art Museum, Bloomfield Hills, Michigan
Drawing workshop, Brookside School, Bloomfield Hills, Michigan
Collaborate on two murals and painting workshops with 500 children, Tama City, Japan. Paintings donated to permanent collection of Tama City
Design album cover, posters and limited edition silkscreen for A&M Records' *A Very Special Christmas,* proceeds donated to Special Olympics (Platinum album, cassette, and compact disc)

1988 Open *Pop Shop Tokyo,* retail store, Tokyo, Japan
Design sets and costumes for *Body and Soul,* choreographed by George Faison and produced by André Heller, Munich, West Germany
Artist-in-residence, Toledo Museum of Art, Toledo, Ohio
Create poster and do public service announcement for *Literacy Campaign,* sponsored by Fox Channel 5 and New York Public Library Associations
Easter at the White House: paint 8′ × 16′ mural erected on White House lawn, and donated to the Children's Hospital, National Medical Center, Washington, D.C., sponsored by Crayola Company
Lecture and drawing workshops, High Museum of Art, Atlanta, Georgia
Permanent mural, Grady Hospital pediatrics emergency room, Atlanta, Georgia
New York City Ballet 40th Anniversary/ American Music Festival: Create image for use as poster, program cover, stage projection, and T-shirt
Create First Day Cover and limited edition lithograph to accompany United Nations' stamp issue commemmorating 1988 as *International Volunteer Year*
Paint "Don't Believe the Hype" mural Houston Street at FDR Drive, New York City

1989 Paint mural in "Barrio de Chino"—*Together We Can Stop AIDS*—Barcelona, Spain
Design invitations and plates for Gloria von Thurn und Taxis' birthday celebration, Regensburg, West Germany

Design mural to be executed by students at Wells Community Academy, Chicago, Illinois
Artist-in-residence for Chicago Public Schools and Museum of Contemporary Art mural project: paint 520′ mural with 300 high-school students, Chicago, Illinois
Paint two murals at Rush Presbyterian–St. Luke's Medical Center, Chicago, Illinois
Design logo and T-shirts for "Young Scientist's Day" at Mt. Sinai School of Medicine, New York City
Artist-in-residence and mural project, Ernest Horn Elementary School, Iowa City, Iowa
Paint mural at The Center, a lesbian and gay community services center, New York City
Keith Haring Progetto Italia—Commissioned by the City of Pisa to paint permanent mural on exterior wall of Sant'Antonio Church, June 14–20
Paint permanent mural at Princess Grace Maternity Hospital, Monte Carlo, Monaco
Paint banner intended for airship to be flown over Paris as part of Galerie Celeste, a project with Soviet painter Eric Bulatov commemorating the bicentennial of the French Revolution. Complications eventually prevented the launch of the airship.

1990 Create First Day Cover and limited edition lithograph to accompany United Nations' stamp issue of 16 March commemorating 1990 as *Stop AIDS Worldwide Year*

SELECTED BOOKS
AND CATALOGS

1 9 8 2 *Keith Haring.* Text: Robert Pincus-Witten, Jeffrey Deitch, David Shapiro (Tony Shafrazi Gallery, New York)
Rotterdam Arts Council. Essay: Richard Flood
Marlborough Gallery. Essay: Diego Cortez
Appearances Press. Drawings: Keith Haring
Documenta 7.

1 9 8 3 *Champions.* Essays: Tony Shafrazi
Tendencias en Nueva York.
Back to the U.S.A. Text: Klaus Honnef (Rheinisches Landesmuseum Bonn und Rheinland-Verlag)

1 9 8 4 *Pittsburgh Center for the Arts.* Text: Fidel Marquez; photographs: Tseng Kwong Chi
The Human Condition. Text: Henry Hopkins (San Francisco Museum of Modern Art Biennial III)
Terrae Motus. Interview: David Robbins (Lucio Amelio Foundation, Naples, Italy)
Arte di Frontiera. Text: Francesca Alinovi (Nuove Edizioni Gabriele Mazzotta, Milan, Italy)
Content: A Contemporary Focus 1974–1984. Text: Phyllis Rosenzweig, Howard Fox, Miranda McClintic (Smithsonian Institution, Washington, D.C.)
Primitivism. Editor: William Rubin (The Museum of Modern Art, New York)
New Art. Editors: Phyllis Freeman, Eric Himmel, Edith Pavese, Anne Yarowsky (Harry N. Abrams, New York)
Untitled 84. Introduction: Robert Pincus-Witten; text and photos: Roland Hagenberg (Pelham Press, New York)
Hip-Hop. Text: Steven Hager (St. Martin's Press, New York)
Art in Transit. Introduction: Henry Geldzahler; text: Keith Haring; photographs: Tseng Kwong Chi (Harmony Books, New York)
Art at Work: The Chase Manhattan Collection. Text: various authors (E.P. Dutton, New York)

1 9 8 5 *Beyond the Canvas.* Introduction: Leo Castelli; text and photos: Gian Franco Gorgoni (Rizzoli International Publications, New York)
America. Text and photos: Andy Warhol (Harper & Row Publishers, New York)
Notes from the Pop Underground. Editor: Peter Belsito (The Last Gasp of San Francisco, Berkeley, California)
Keith Haring: Peintures, Sculptures et Dessins. Text: Jean-Louis Froment, Brion Gysin, Sylvie Couderc (Musée d'Art Contemporain de Bordeaux, France)
New York 85. Text: Roger Pailhas, Jean-Louis Marcos, Marcellin Pleynet (ARCA Centre d'Art Contemporain, Marseille, France)

1 9 8 6 *An American Renaissance: Painting and Sculpture Since 1940.* Text: various authors (Abbeville Press, New York)
Keith Haring: Paintings, Drawings and a Vellum. Text: Jeffrey Deitch (Stedelijk Museum, Amsterdam, Holland)
Art After Midnight: The East Village Scene. Text: Steven Hager (St. Martin's Press, New York)
Input/Output. Editors: Time-Life Books (Time-Life Books, Alexandria, Virginia)
What It Is. Editor: Wilfried Dickhoff (Tony Shafrazi Gallery, New York)
Art in Transit (Japanese Edition). Introduction: Henry Geldzahler; text: Keith Haring; photographs: Tseng Kwong Chi (Kawade Shobo Shinsha, Tokyo, Japan)

1 9 8 7 *Avant-Garde in the Eighties.* Text: Howard N. Fox (Los Angeles County Museum of Art, Los Angeles, California)
Kunst aus den achtziger Jahren. Text: Sabine Fehlemann, Raimund Thomas (A II Art Forum Thomas, Munich, West Germany)
Comic Iconoclasm. Text: various authors (Institute of Contemporary Art, London, U.K.)
L'Epoque, La Mode, La Morale, La Passion: Aspects de l'Art d' Aujourd'hui, 1977–1987. (Centre Georges Pompidou, Paris, France)
Digital Visions: Computers and Art. Text: Cynthia Goodman (Harry N. Abrams, New York)
Skulptur Projekte in Münster 1987. Text: Klaus Bussman, Kasper Konig (Dumont Buchverlag, Cologne, West Germany)
Luna Luna. Essay: Hilde Spiel (Wilhelm Heyne Verlag, Munich, West Germany)

1988 *Keith Haring 1988.* Introduction: Martin Blinder; essay: Dan Cameron (Martin Lawrence Limited Editions, Van Nuys, California)
Collaborations: Andy Warhol, Jean-Michel Basquiat. Introduction: Keith Haring (Mayor Rown Gallery, London, U.K.)
The Dog in Art from Rococo to Post-Modernism. Robert Rosenblum (Harry N. Abrams, New York)

1989 *Eight Ball.* Keith Haring (Kyoto Shoin, Tokyo, Japan)

1990 *Keith Haring.* Introduction: Tony Shafrazi (Tony Shafrazi Gallery, New York)
Future Primeval. Barry Blinderman and others (University of Illinois, Normae, Illinois)
K. Harding. Introduction: Sam Havadtoy (Gallery 56, Geneva, Switzerland)
Subway Drawings. Introduction: Nikolaus Sonne and Christian Holzfuss (Edition Achenbach, Galerie Nikolaus Sonne, Berlin, Germany)
The Last Decade: American Artists of the 80's. Essays by Robert Pincus-Witten and Collins & Milazzo (Tony Shafrazi Gallery, New York)

244

1991 *Keith Haring: The Authorized Biography.* John Gruen (Prentice Hall Press, New York)
Echt Falsch. (Arnoldo Mondadori Arte, Milan, Italy)
Myth and Magic in America: the Eighties. Editor: Guillermina Olmedo (Museo de Arte Contemporaneo de Monterrey, Mexico)
The Art of Mickey Mouse. Introduction: John Updike (Hyperion, New York)
Textile Designs: 200 Years of European and American Patterns. (Harry N. Abrams, Inc., New York)
Les Couleurs de L'Argent. (Musee de la Poste, Paris, France)
1991 Biennial Exhibition. (Whitney Museum of American Art, with W.W. Norton & Co., New York)
Devil on the Stairs: Looking Back on the Eighties. Robert Storr (Institute of Contemporary Art, University of Pennsylvania, Philadelphia)
Compassion ad Protest. (Cross River Press, New York)
Cruciformed: Images of the Cross Since 1980.

(Cleveland Center for Contemporary Art, Cleveland)

1992 *From Media to Metaphor: Art About AIDS.* Robert Atkins and Thomas W. Sokolowski (Independent Curators, Inc., New York)
Future Primeval. Barry Blinderman (Abbeville Press, New York)
Allegories of Modernism. Bernice Rose (The Museum of Modern Art, New York)
The Power of the City/The City of Power. (Whitney Museum of American Art, New York)
Haring, Warhol, Disney. Editor: Bruce D. Kurtz (Prestel, Munich, Germany)
Keith Haring. Editor: Germano Celant (Prestel, Munich, Germany)

PHOTO CREDITS

Courtesy of the Salvatore Ala Gallery: 160 (bottom)

© Frank Oleski, Cologne

© The Estate of Tseng Kwong Chi: 45, 69, 71, 97, 100 (bottom), 112, 123, 136, 137, 142, 143, 146, 147, 149, 150, 153, 154, 172, 174, 176, 179, 180, 181, 184, 186, 196, 198, 199, 204, 205, 206, 209, 216

© Joseph Coscia, Jr.: 99, 101 (top), 104 (bottom), 128, 132, 155, 202, 228, 233, 237

Courtesy of Molissa Fenley: 41

© John Gruen: 200

Courtesy of B. Gysemburgh, *Paris Match*: 208

Courtesy of Allen and Joan Haring: 3, 4, 5, 8, 11, 13, 21, 23

Courtesy of The Estate of Keith Haring: 37, 42, 49, 52, 64, 75, 78, 79, 81, 90, 92, 105, 118, 119 (bottom), 127, 139, 151, 152, 178, 185, 189, 221

© Jansen, Dusseldorf: 192

© Nancy Hill: 217

Courtesy of the Hokin Gallery: 183

© Jean Kallina: 59

© Pierre Keller: 170

© The Estate of Robert Mapplethorpe: 117

© Andre Morain: 173

© Maria Mules: 121

© Lisa Orophallo, 1990: 119 (top)

Courtesy of Kermit Oswald: 73

© Dianna Patisse: 134

© Klaus Richter: 230

Courtresy of Service Presse, Palais de Monaco: 212

© Jacques Straesslé, Lausanne: 177

Courtesy of Swatch SA, Switzerland: 130

© Joseph Szkodzinski: 46, 47, 55

© Ivan Dalla Tana: 100 (top), 101 (bottom), 102, 103, 104 (top), 106, 107, 108, 115, 133, 156, 157, 158, 159, 160 (top), 161, 162, 163, 164, 165, 166, 222, 223, 224, 225, 226, 227, 229, 231, 232, 234, 236, 238

© Wolfgang Wesener: 141

INDEX